Sport in the USSR

PICTURING HISTORY

Series Editors
Peter Burke, Sander L. Gilman, Ludmilla Jordanova,
†Roy Porter, †Bob Scribner (1995–8)

In the same series

Sport in the USSR

Physical Culture – Visual Culture

Mike O'Mahony

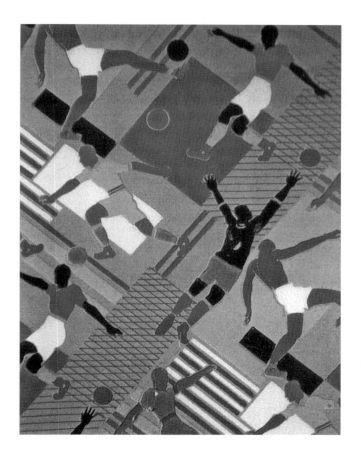

REAKTION BOOKS

For Claire and Pudding

Published by Reaktion Books Ltd
33 Great Sutton Street, London EC1V 0DX, UK

www.reaktionbooks.co.uk

First published 2006

Printed and bound in Great Britain
by Cromwell Press Ltd, Trowbridge, Wiltshire

British Library Cataloguing in Publication Data

O'Mahony, Mike
 Sport in the USSR : physical culture – visual culture. – (Picturing history)
 1. Sports – Soviet Union 2. Sports – Soviet Union – Sociological aspects
 3. Sports in art – Soviet Union
 I. Title
 306.4'83'0947'0904

ISBN-10: 1 86189 267 5

Contents

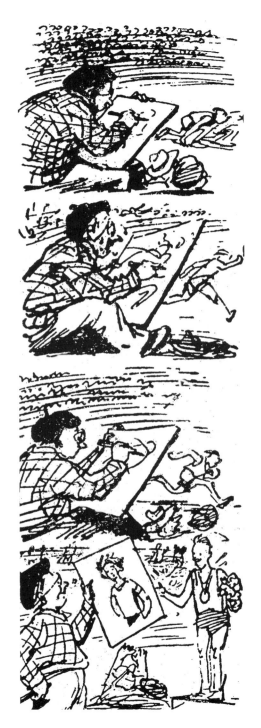

1 Yu. Uzbyakova, *The Sprinter
and the Artist*, cartoon published
in *Sovietskii Sport*, 6 August 1957.

Introduction

In 1957 the journal *Sovetskii Sport* published a cartoon entitled *The Sprinter and the Artist* (illus. 1).[1] In many respects the cartoon is unremarkable, deploying simple humour to highlight the limitations of the medium of drawing to capture the speed, movement and excitement of sport in action. Here, despite the artist's energetic response to the immediate experience of the event perceived, the final product is a conventional portrait emphasizing the outcome of sporting activity rather than the process that achieved this result. However, the cartoon can also be read as a highly revealing document. For example, the cartoonist has clearly established a symbiotic relationship between visual culture and sport. Hence the poise of the artist in the first frame reflects the poise of the sprinter on the starting blocks. As the race begins and the sprinter leaps into action, so too does the artist, signified by the sweat running down the side of his face. As the race and the production of the drawing advance, both artist and athlete are characterized by focus and concentration. The sequence concludes with the completion, and victory, of both artist and runner. Here, a bond is established between the two performers, whose hands are notably connected via the finished artwork. The fact that this work does not appear to be a representation of the competing athlete, but rather a portrait of an anonymous and victorious sportsperson, only serves to reinforce the notion that it is the general, rather than the specific, affiliation between sport and visual culture that is here being articulated.

This cartoon clearly highlights the vital role played by sport and physical culture within the social and cultural life of the Soviet Union. Throughout its existence the Soviet state regularly sponsored programmes promoting and supporting a whole gamut of sporting activities: competitions were organized at the local, regional, national and international levels, whilst theatrical manifestations of sport, including mass sports parades and gymnastic displays, were widely practised and became a regular feature of official festivities on public holidays. From childhood to adulthood, Soviet citizens were

7

constantly encouraged to partake of physical exercise. In schools, sport and physical education constituted a significant part of the curriculum, whilst at work factory employees were encouraged, sometimes even compelled, to take part in physical exercise programmes on the shop floor. During leisure time, sports clubs attached to unions, workplaces and residential centres also provided a whole host of facilities and activities for their members ranging from gymnastic training for toddlers to individual coaching for the nation's best performing athletes. Sport also played a major role within the popular media. Radio broadcasts and popular journals provided regular guidance on physical exercise programmes for listeners and readers alike. For the less participatory, the back pages of the daily newspapers, *Izvestiya* and *Pravda*, were joined by a whole host of specialist sports journals such as *Sovetskii Sport*, *Krasnyi Sport* and *Fizkultura i Sport*, all reporting on the latest developments and providing a lively arena for debate on sporting matters. The Soviet population, it would appear, embraced sport voraciously.

The growth and expansion of sport as a social practice throughout the twentieth century is hardly a circumstance unique to the Soviet Union. Indeed, sport developed at a similar rate throughout the modern industrial world. Few nations, however, embraced sport as a dominant theme within the broader cultural sphere with as much gusto and dedication as did the Soviet Union. Sport permeated the public consciousness not only through its practice but also through its representation in a whole host of cultural activities, including literature, film, theatre, music, painting and sculpture. Soviet sportsmen and sportswomen also made regular appearance on posters, stamps, badges and medals. They even featured prominently in designs for textiles, wallpaper, plates and teapots. During the 1920s the humble soccer jersey became a youthful fashion accessory worn on the streets, as much as in the sports stadia, of Soviet cities, towns and villages long before the replica sports jersey was adopted in the West, whilst the sports parade, fully developed during the 1930s, also provided audiences with a glittering spectacle, comparable, in many respects, to the filmic extravaganzas of Busby Berkeley in Hollywood. These performances, though physically confined to their urban settings, were frequently captured in both still and cinematic images and subsequently distributed to wide audiences, in city and countryside, both at home and abroad. The sports theme played a major role within the visual arts. Countless public exhibitions, as well as the pages of both popular and specialist journals, were inundated with representations of youthful Soviet sportsmen and sportswomen, whether executed in

the medium of photography, painting or printmaking. Further, sculptural monuments to the Soviet passion for sport adorned sports centres and stadia, public parks and even the more humble street corner. Several major artists even forged entire careers based upon their engagement with the sports theme. Cultural representations of sport and physical culture in the Soviet Union were truly ubiquitous.

This study sets out to explore this phenomenon. It is not my intention, however, simply to provide a straightforward, encyclopaedic survey outlining a host of cultural responses to sports activities. Rather, I intend to analyse the complex relationship between sport as an officially approved social practice and as a subject for cultural production. Far from simply reflecting contemporary activities, representations of sport frequently addressed important and complex issues regarding not only the practice of sport itself, but also its wider significance for Soviet society. As such they can provide a microcosmic barometer measuring the shifting attitudes and tensions prevalent in Soviet ideology and culture at different moments within the history of the Soviet Union.

The expansion of sport as a social practice during the Soviet era is frequently described in the West as a symptom of totalitarian command. Here, state coercion is regarded as impacting upon an unwilling but compliant public. However, such a view problematically denies any agency for the public at large. Throughout the Soviet era the state harnessed considerable authoritarian powers. Nonetheless, it desired, and frequently needed, broad-scale popular support to implement its policies successfully, and persuasion was always a far more useful tool than coercion. To take one example, throughout the interwar period both the trade unions and supporters of the Proletarian Culture movement known as Proletkult consistently advocated the practice of production gymnastics as a part of the working day. Here the regular practice of specific physical exercises was seen to enhance the capability of the individual worker to engage in productive labour. Other sporting activities, such as playing soccer or tennis, were dismissed as irrelevant or even counter-productive, the risk of injury threatening, rather than enhancing, the potential for increased productivity. Accordingly, brigades of physical culturists were sent to factories to instigate production gymnastic programmes on the factory floor. These programmes, however, often proved highly unpopular and were dropped as soon as the brigade moved on.[2] This did not necessarily mean that sport and physical culture were generally unpopular. Rather, it was the specific nature of the practice that mattered. On the whole, the organized sports and games that took place outside work, in the

9

evenings and weekends, proved far more popular than performing mechanistic physical jerks on the factory floor, despite the strictures laid down by theorists. Throughout the early Soviet era, the state both recognized and exploited this popularity of sport, particularly amongst urban youth. Pragmatically, it supported the rationale of production gymnastics, yet it could not afford to alter the popular aspects of sport and physical culture too much without running the risk of losing that popular support. Therefore, rather than focusing on altering practices, the state looked instead to develop the conventional values and meanings associated with them. And it is precisely this point of interception between the production of ideology surrounding sport and physical culture, as articulated within the cultural arena, and its popular consumption, that this study seeks to explore. Some of the material examined in this study will be wide-ranging, variously including literature, film, music, fashion, ceramics and badges. A significant emphasis, however, will be placed upon the visual arts, and particularly painting and sculpture. This is not intended to prioritize these forms of cultural activity as intrinsically more significant than other forms. The distinction between so-called high art and popular culture, so redolent of Western cultural approaches, never did carry the same weight in the Soviet Union. Indeed, the notion that all cultural production, in whatever medium, should ultimately be accessible to, and serve, the masses tended at least to undermine, if not entirely eradicate, such distinctions. Rather, this emphasis reflects the fact that it was in these media that some of the most compelling and challenging engagements with the sports theme were produced. Moreover, the emphasis on sport within these particular media highlights a significant departure from Western conventional practices. Again, one example might serve to highlight this anomaly. In 1953 the English Football Association sponsored a National Exhibition to celebrate its ninetieth anniversary. It invited several major artists of the day to contribute works to the show, including members of the Royal Academy of Arts, the New English Art Club and the Royal Watercolour Society. Reports in the popular press were less than positive and much emphasis was placed upon the notional incompatibility of the subject and the medium. Thus one critic pointed out that the show 'irritated those who knew about football and failed to satisfy those who knew about art'.[3] The tensions generated by the Football Association exhibition served, in many ways, to highlight the gulf that existed between art and sport as forms of social practice in 1950s Britain. Within the Soviet Union, such distinctions were present, but rarely so pronounced. Sport was as likely to provide a fitting subject for a poem, a symphony

or a monumental sculpture as was any other more conventionally represented theme. Artists, writers and musicians regularly attended sports events and openly participated in physical culture programmes. Support for sporting activities was both promoted and practised as a crucial component within the so-called cultured life of the Soviet citizen. And it is within this context that representations of sport and physical culture ultimately provided a fascinating arena in which the values and meanings associated both with the practice of sport itself and with cultural production more broadly could be explored, articulated and debated.

The history of sport as a social practice in the Soviet Union has received considerable coverage in the West. Amongst the plethora of published material addressing this subject, however, three crucial texts stand out. First published in the wake of the Cuban Missile Crisis and at the height of Cold War tensions, Henry Morton's *Soviet Sport: Mirror of Soviet Society* of 1963 effectively offered the first extensive sociological analysis of sport as an integral aspect of Soviet ideology.[4] Morton effectively set out to explore the conditions that had enabled the Soviet Union to become the dominant sporting nation during the 1950s and early '60s. It remains far from clear, however, whether his objective was to enable the West to learn from the Soviet Union and thus produce athletes better able to compete at the highest level, or to reinforce the already popularly held Western myth of the Soviet sports machine. Without doubt the most important publication to outline the development of Soviet sport is James Riordan's *Sport and Soviet Society*, first published in 1977 and still the seminal text for students of the subject. Riordan, like Morton, adopts a 'top-down' approach, analysing the organizational structures and ideological imperatives central to the development of sport since the pre-revolutionary period. More importantly, Riordan highlights the debates and shifts in policy adopted by the Soviet state at differing moments of its history, thus positing the notion that the official attitude to sport was one of complexity and pragmatic flexibility. More recently, Robert Edelman's *Serious Fun: A History of Spectator Sports in the USSR* of 1993 adopted a new approach to the subject, focusing less on the notional production of sport and far more on its popular consumption. In particular, Edelman explores the diverse ways in which Soviet spectators frequently engaged with sport, highlighting what he describes as 'the basic incongruence between the goals of the state's sports system and the interests of Soviet fans'.[5] The popular consumption of sport, Edelman argues, provided a cultural context in which the official commands of the state were modified by the demands of

the masses, albeit in a predominantly non-political arena. Both Riordan and Edelman have contributed to a significant debunking of the conventional mythology surrounding Soviet sports. Ultimately they have shown that both sports practice and sports spectatorship in the Soviet Union were complex sociological phenomena and that the values ascribed to such activities, far from being simply and unproblematically defined from above, were in fact frequently the cause for much debate and controversy.

Western studies of Soviet visual culture were also abundant throughout the twentieth century. These, however, have tended to give a very particular view of Soviet cultural practices, frequently informed by ideological agendas that have selectively highlighted certain practices at the expense of others. Thus, through much of the twentieth century, emphasis was placed upon the activities of the early Soviet avant-garde, frequently described as conforming to the Western modernist paradigm, whilst relatively little attention was given to cultural practitioners associated with the realist trend. This can be evidenced in such influential publications as Louis Lozowick's *Modern Russian Art* of 1925, Alfred H. Barr's coverage of Russian visual culture in the catalogue to the Museum of Modern Art's *Cubism and Abstract Art* exhibition in 1936, and Camilla Gray's *The Great Experiment: Russian Art, 1863–1922* of 1962.[6] A handful of publications, such as the special issue of *Studio* in 1935, Jack Chen's *Soviet Art and Artists* (1944), Cyril Bunt's *Russian Art: From Scyths to Soviets* (1945) and George Loukomskii's *History of Modern Russian Painting, 1840–1940* (1945), did offer alternative views of contemporary Soviet cultural practices.[7] These were far less widely read, however, and, in the case of the latter three, were largely the product of the brief anti-Fascist alliance between the West and the Soviet Union during the Second World War. As the new political tensions between East and West generated by the Cold War increasingly took hold, the paradigm of a notionally heroic early Soviet avant-garde cruelly overthrown by the retrogressive cultural policies of Stalin and his cohorts launched at the Soviet Writers' Congress of 1934 once more dominated Western models of Soviet cultural history. Following the death of Stalin in 1953, cultural relations between the Soviet Union and the West began to improve, facilitating a number of cultural exchange exhibitions. These included the exhibition *Russian Painting* staged at the Royal Academy of Arts in London in 1959, the *Exposition Lénine, 1870–1924*, held at the Grand Palais in Paris in 1970, and *Russian and Soviet Painting* at the Metropolitan Museum of Art in New York in 1977.[8] Whilst all these shows included examples of official Soviet culture,

they were widely regarded in the West as politically motivated exhibitions of little aesthetic worth. Far more attention was focused upon the activities of Soviet collectors such as Georgii Costakis, whose promotion of Soviet avant-garde works generated a number of exhibitions and publications throughout the 1970s and '80s.[9]

In recent years, however, Western scholars have embarked upon a concerted effort to examine the long ignored body of work that constitutes official Soviet culture, what Paul Wood has referred to as 'the ossified Other of Modernism'.[10] Inspired, in part, by a renewed interest in figuration in contemporary art practices and specifically enabled by the political circumstances that brought about the end of the Cold War, these studies have drawn attention to a huge body of work, mostly unfamiliar to Western eyes. Amongst these studies, Brandon Taylor's study of *Art and Literature under the Bolsheviks, 1917–1932* re-examined the early Soviet period preceding Socialist Realism and reintroduced the diversity and complexity of art practices, theories and debates during this period.[11] His analysis of officially supported art groups such as AKhRR (Association of Artists of Revolutionary Russia) introduced a wider social and political context in which to examine Soviet visual culture. Focusing more on the post-Leninist years, Matthew Cullerne Bown's *Art under Stalin* offered an introductory overview of Socialist Realism up to the mid-1950s, whilst his more detailed and nuanced *Socialist Realist Painting* of 1998 has provided a much more comprehensive and thorough survey of the whole Soviet period.[12] Equally significant is the broad selection of essays edited by both authors under the title *Art of the Soviets: Painting, Sculpture and Architecture in a One-Party State, 1917–1992*.[13] These projects marked a major step in the expansion of scholarly interest in official Soviet visual culture, a subject that, it is hoped, will be further developed in the future.[14] Special mention should also be made of two other publications addressing Socialist Realist culture: Igor Golomstock's *Totalitarian Art in the Soviet Union, the Third Reich, Fascist Italy and the People's Republic of China* (1990) and Boris Groys's *The Total Art of Stalinism: Avant-Garde, Dictatorship and Beyond* (1992).[15] Significantly, both texts were written by Russian emigrés and originally completed before the collapse of the Soviet Union.[16] Whilst these studies undoubtedly bring much historical information to light for Western audiences, the, perhaps understandably, staunch anti-Soviet agendas informing the central arguments risk obscuring a more critical, less polemical analysis. Furthermore, the specific publication of these texts in the West, particularly in the dying stages of the Cold War, cannot be entirely divorced from an attitude of Western triumphalism,

condemnation being much more effective when delivered, as it were, from the 'horse's mouth'.[17]

More recently, a number of major exhibitions have contributed to this expanding interest in official Soviet visual culture by bringing the works themselves into the light of day. Most of these shows, including *Agitation for Happiness: Soviet Art of the Stalin Epoch* (Kassel and St Petersburg, 1993–4), *The Tyranny of Beauty: Architecture of the Stalin Era* (Vienna, 1994), *Berlin–Moscow* (Berlin and Moscow, 1995–6) and *Dream Factory Communism: The Visual Culture of the Stalin Era* (Frankfurt, 2003–4), have notably been organized as exchanges between Russian and German/Austrian institutions.[18] The cultural dialogue between these nations doubtless reflects a courageous, and highly contentious, attempt to confront their difficult and opposing pasts. For a reunified Germany, in particular, this public exposure of official Stalinist culture, sometimes alongside official National Socialist culture, can facilitate a greater awareness and understanding of cultural developments during the inter-war years. At the same time, these exhibitions have drawn attention to the fact that a broader neo-classicism informed much cultural practice throughout Europe and the United States during this period. Closer to home, the Council of Europe's fiftieth anniversary exhibition, *Art and Power: Europe under the Dictators, 1930–45*, held at the Hayward Gallery in London (and subsequently in Barcelona and Berlin), included a significant number of Socialist Realist works, some of which will be further examined in this book.[19] The official sponsorship, broadly positive press coverage and significantly large public attendance at the exhibition perhaps epitomize the increasingly established position of official Soviet art within cultural studies.

To date, most publications and exhibitions addressing official Soviet culture have cast their nets wide, focusing their attentions on either the whole of the Soviet period, or a wide range of cultural artefacts produced within a particular period. Such an approach has been both useful and necessary, particularly considering the unfamiliarity of much of the work, and indeed history, concerned. At this point in time, however, it might be more useful to focus closely on specific areas and themes that characterize Soviet culture and distinguish it from other forms of production. Therefore, in this study I do not propose to offer a comprehensive analysis of Soviet culture in its breadth. Nor do I plan to concentrate on the origins of Socialist Realism as a label, or examine the copious definitions of the term as published in both the Soviet Union and the West. These issues have already been given considerable attention elsewhere.[20] Rather, I want to focus in

closer detail on one particular, but prominent, theme – namely, representations of sport and physical culture – and consider how this might conform to, or indeed contradict, broadly held assumptions about Soviet ideology, society and culture.

From Sport to Fizkultura

During the early years of Soviet power, the practice of sport and physical culture was transformed in the Soviet Union. When the Bolshevik Party seized power in 1917, the social development of sport in Russia was in its infancy. Whilst several sports clubs and societies had emerged in the late Tsarist period, hierarchical social restrictions, prohibitive membership fees and a strict amateur code all ensured that most sporting activities were confined to the wealthy, leisured classes.[21] The future leader of the Soviet Union, Vladimir Ilych Lenin, however, held notably strong views on the social significance of sport and physical exercise and advocated its broader promotion. A keen sportsman himself, Lenin specifically recognized the transformatory potential of physical culture, identifying it 'as a means of obtaining the harmonious all-round development of the individual'.[22] Lenin's views here did not depart radically from the nineteenth-century philosophy of 'Muscular Christianity', recognizing in sport a potential for character building. By October 1920 these views were enshrined in a resolution passed at the Third All-Russia Congress of the Russian Young Communist League, notably attended by Lenin himself:

The physical culture of the younger generation is an essential element in the overall system of communist upbringing of young people, aimed at creating harmoniously developed human beings, creative citizens of communist society.[23]

In the harsh climate of the early years of Soviet rule, however, this idealistic vision needed to be supplemented with somewhat more pragmatic objectives. Thus, the resolution continued: 'Today, physical culture also has direct practical aims: (1) preparing young people for work; and (2) preparing them for military defence of Soviet power.'[24]

To fulfil the requirements of this resolution the leisurely practice of sport needed to be transformed into a civic duty. The leisure principle, however, was never completely abandoned, not least of all because most sports and games were practised outside working hours. The association of physical culture with leisure was highly expedient for the Soviet state. Whilst the official view, that such

activities constituted a civic duty, was widely promoted, there can be little doubt that for many Soviet citizens, especially those of the younger generation, participation in such activities as soccer, athletics and gymnastics was far more pleasurable than dutiful.

To distinguish this new activity from its pre-revolutionary origins, a new term was coined: *fizkultura*, deriving from *fizicheskaya kultura*, or physical culture.[25] Here it is worth considering what was understood by the term *fizkultura*, and why it proved to be such an attractive prospect to the Soviet authorities. In definition, *fizkultura* tends to encompass a broader range of activities than its equivalent Western term, thus making its boundaries somewhat difficult to define. Here an entry under the heading 'Physical Culture' in the *Great Soviet Encyclopaedia* of 1936 might help to elucidate an understanding of the term:

Physical culture (*fizkultura*) is a network of methods and means applied to the physical development, increased health and improvement of every individual, and of the whole collective. Only the Proletarian Revolution has enabled the necessary development of F.k. (*Fizkultura*), in its widest sense, in the interests of the working class. In the USSR, the organization of the means of F.k. (*Fizkultura*) directly addresses issues of communist education and the preparation of the masses for labour and defence. Physical (bodily) development, physical culture and education, better health, and the improvement of the individual, are all achieved by following a strict regime of hygiene, by strengthening the organism through natural means (sun, air, water), and by the practice of physical exercises; gymnastics, sport, games, etc. Physical exercise, and sport in particular, is the most active, effective and interesting aspect of physical culture.[26]

This entry offered an official definition of the scope, objectives and means of the Soviet *fizkultura* programme.

In scope, *fizkultura* was promoted to reach as wide an audience as possible. Incorporated into education programmes for students and workers alike, 'every individual' within the 'whole collective' was targeted as a potential participant. The objectives of *fizkultura* were equally clearly defined and based upon rational and material goals. By improving the health and strength of the entire population, every individual would become better equipped to contribute first in the field of labour, further developing the nation's industrial superstructure, and second in the military defence of the Soviet borders. The means of achieving such objectives, however, were wide-ranging and, as shall be seen, not always agreed upon. Whilst sport itself was identified as a vital component within *fizkultura*, it essentially constituted but one component within a broader range of practices. Not only physical

exercises and gymnastics, but also hygienic practices, such as bathing in sun, air and water, were regarded as integral components in any *fizkultura* programme. In practice, a host of wider activities, such as industrial or military training – production gymnastics, tank driving and even aviation – were all at some point deemed to be significant aspects of *fizkultura*. The breadth of this definition often led to a shift in emphasis according to the specific ideological needs of the state under any given circumstance. Thus, during the Civil War years of 1918–21 *fizkultura* was emphatically perceived as a crucial component in military training. As such, *fizkultura* programmes were organized solely by military institutions. During the mid-1920s, however, once Soviet power had been consolidated, *fizkultura* took on a more civilian identity, seen as an appropriate leisure activity for workers during their free time. In the consumer-oriented years of the NEP (New Economic Policy) era, major debates were conducted as diverse groups attempted to redefine the role of *fizkultura* for the new state.

The immediate consequence of these debates, which will be discussed in greater detail later, was that the state recognized the huge potential of two crucial aspects of *fizkultura*, namely competitive sport and the theatrical sports parade, to entice the population into participation in wider programmes encouraging fitness, healthiness and clean living. With the introduction of the First Five-Year Plan in the late 1920s, the huge demand for a physically fit and healthy workforce loosened the military organizations' grip on the reins of *fizkultura*, increasingly linking it to labour and trade union societies. By the mid-to late 1930s, however, as the threat of international invasion hovered over the Soviet Union, the pendulum swung back again and *fizkultura* was once more seen primarily as a means to encourage military training. It was not until after the Soviet victory over Nazism in 1945 that Soviet sport entered the international arena in a major way. In 1952 the Soviet Union participated in the Olympic Games for the first time and, at its first attempt, shared the honours with the previously dominant sporting nation, the United States. For the next quarter of a century the Soviet Union would continue to dominate the Olympic sporting programme. During this period, the concept of *fizkultura* as a programme of mass sporting participation gave way to sports specialization as the Soviet Union poured much of its time and energy into producing champions in a wide variety of sports. Now *fizkultura* became a crucial weapon of foreign policy, a means to gain victory on the international stage in an attempt to make explicit, if ultimately metaphorical, claims for the superiority of communism over capitalism. By 1980 the utopianism that had characterized *fizkultura* in the

early Soviet era was largely a thing of the past. Since its primary object-
ive was now solely to gain international victory, *fizkultura* itself became
a victim of the very Cold War diplomacy it had earlier embraced.
Indeed, the US boycott of the Moscow games of 1980, followed by the
Soviet Union's tit-for-tat withdrawal from the Los Angeles games of
1984, effectively removed the possibility for Soviet sport to prove itself
in any meaningful way. Finally, the new liberalism brought about by
Mikhail Gorbachev's perestroika reforms resulted in top Soviet sports-
men and sportswomen increasingly abandoning the Soviet Union in
search of lucrative financial deals in the West. This so-called brawn
drain rang the death knell for *fizkultura*.

As the significance of *fizkultura* shifted according to the needs of a
given era, so too did representations of *fizkultura*. In chapter One
attention is given to the initial development of the *fizkultura* theme in
the first decade or so of Soviet power. At this time representations of
fizkultura were largely confined to the work of the cultural left and
particularly those involved with photography, photomontage and film.
By the late 1920s, however, painters and sculptors were also embrac-
ing the theme for the first time. Style was a crucial issue here and a
fusion of modern and traditional styles was developed specifically to
articulate the emergence of a new type of citizen in the new post-
revolutionary age. This fusion of modern and traditional styles is
further examined in chapter Two. Here, however, the focus is upon
the ways in which both the style and the function of the Russian icon
tradition were redeployed to develop a new kind of hero, literally a
sporting icon, in the period immediately prior to the official launch of
Socialist Realism as the official cultural doctrine of the Soviet Union.

Chapter Three begins with a comparison of two major sports
events that took place in the summer of 1937: a soccer tour of the
Soviet Union undertaken by a team of international players from the
Basque region of Spain and the Annual Fizkultura Parade. These
events highlight two crucial issues within both the practice and the
representation of *fizkultura*: first the tensions between participation
and spectatorship as appropriate engagements with *fizkultura*, and
second the competitive and theatrical modes of *fizkultura* practices.
Here special attention will be given to representations of the sports
stadium and to the sports parade. The Reconstruction of Moscow
during the mid- to late 1930s facilitated a whole-scale transformation
of the Soviet capital. From the beginning, however, this transforma-
tion was planned to be sociological as well as architectural. As an
essentially urban practice, *fizkultura* was also to play a major role here,
not least of all as a means of conflating the labour requirements of the

project with the leisure potential of sport. In chapter Four this confla-
tion of labour and leisure is explored with reference to one of the major
successes of the 1930s: the building of the Moscow Metro. Represen-
tations of *fizkultura* were widely deployed within the decorative
schemes for the various metro stations specifically to reinforce the
notion that *fizkultura*, as a civic duty, was a vital component within the
overall development of the Soviet state.

By the late 1930s, military conflict between Nazi Germany and the
Soviet Union looked increasingly inevitable. Despite the signing of
a non-aggression pact by both nations in 1939, the Soviet Union
remained conscious of the very real threat of invasion and looked to
fortify its frontiers. During this period, *fizkultura* programmes adopted
a much more militaristic approach. Similarly, the representation of
fizkultura increasingly emphasized concepts of defence, invincibility
and endurance. Chapter Five analyses these shifting emphases, with
particular reference to the border as the metaphorical last line of
defence, a concept that was frequently applied in sporting terms to
reinforce the notion that defending the borders was the duty of all
Soviet citizens. Victory in the Second World War launched a new era
in Soviet history, transforming the international status of the Soviet
Union and generating an unabashed mood of triumphalism. As
tensions re-emerged in the Cold War era, however, the Soviet state
increasingly looked to secure and further enhance this status in non-
military contexts. Thus, in 1952 the Soviet Union joined the Olympic
movement and aimed to use sporting victory as a means to promote
communist ideology. However, this shift inevitably generated prob-
lems for the Soviet authorities back home. In order to compete at the
highest level the Soviet state now needed to abandon its ideal of *fizkul-
tura* for all and focus attention on the development of an elite of top-
class athletes. This shift from the idealism of the 1930s to the pragmatic
international sporting strategies of the 1950s and '60s inevitably
transformed the significance and value of sport in society, a factor that
can be clearly discerned in the cultural products addressing *fizkultura*
produced during this era. Chapter Six thus analyses cultural repre-
sentations of *fizkultura* in relation to these major shifts in policy.
Finally, in chapter Seven, consideration is given to the rise of dissident
culture in the Soviet Union during the last two decades of its existence.
At this time, the previous idealism associated with representations of
sport and *fizkultura* was largely abandoned. The prominence of the
fizkultura theme within the Stalinist era, however, facilitated a rede-
ployment of such images in a critical or ironic manner. Thus repre-
sentations of sport and *fizkultura* increasingly signified political and

ideological conformity in an era when such values were in stark decline.

The rise and fall of the *fizkultura* theme in Soviet culture reflects a genuine love of sport, particularly amongst the urban Russian population throughout the twentieth century, a factor much emphasized in the recent, though failed, bid by the post-Soviet Moscow city authorities to stage the Olympic Games in 2012. Yet it also reveals the ways in which this popularity could be embraced and exploited in diverse ways to promote the ideological interests of a dominant group at specific moments in the history of the Soviet Union.

1 Visualizing *Fizkultura*

Representations of sport and physical culture constituted a significant genre within official Soviet culture. State-sponsored practitioners produced numerous works extolling the virtues of fit, young Soviet sportsmen and sportswomen, many of which were shown at official venues, published in approved journals and even sent abroad to exemplify contemporary Soviet culture. To this day they stand as crucial historical examples of both avant-garde practices and officially approved Socialist Realism. One notable feature of many representations of *fizkultura* is that the stylistic approaches adopted were frequently diverse. More importantly, this remained true even during the mid- to late 1930s and beyond, after the official rejection of the avant-garde by the Soviet state and the installation of Socialist Realism as the only officially acceptable form of practice. Indeed, many official engagements with the *fizkultura* theme produced during the 1930s and later do not conform to the common Western paradigm of Socialist Realist 'style'. Neither photographically realistic nor explicitly dependent on nineteenth-century academic models, many of these works draw more on the immediate avant-garde past, as well as older traditions, than is usually acknowledged. This anomaly needs to be explored by considering not the simplicity and uniformity of Socialist Realist culture, but rather its complexity and diversity. Indeed, many artists engaging with the *fizkultura* theme, far from simply pandering to state dictates and producing simplistic and uniform works, were genuinely attempting to develop a rich visual style, conflating elements from a host of diverse historical sources, in order to express what they believed to be the glories of the new epoch. Ultimately, the *fizkultura* theme offered artists a fascinating way to engage not only with the growing significance of sport itself, but also with the thorny question of what might be the best way forward for Soviet culture.

The seeds for much of this work, however, were sown in the first decade and a half of Soviet rule. This period witnessed dramatic changes in all aspects of society and culture. As the new state struggled,

and sometimes muddled, its way through revolution, foreign invasion, civil war, the death of its leader, economic disasters and, finally, a mass industrialization drive, continual change and transformation seemed to be the only constant in the lives of Soviet citizens. Within the cultural sphere, too, battles were fought as disparate individuals and groups strove to align their particular form of practice with the needs and aspirations of the new Soviet state. This chapter sets out to explore the diversity of engagements with the *fizkultura* theme in visual culture during this period. Underpinning many of these works, however, lay a concept central to Soviet ideology in the early post-revolutionary era: the transformation of the Soviet citizen into what came to be known as the *novyi chelovek*, or New Person.

The Transformation of the Soviet New Person

The prototype of the *novyi chelovek*, as has frequently been pointed out, lay not in the immediate post-revolutionary era, but in the mid-nineteenth century, most notably in Nikolai Chernyshevskii's novel of 1864, *What Is To Be Done?*, originally subtitled *Tales about New People.*[1] Written in the immediate aftermath of the Emancipation of Serfdom Act, Chernyshevskii's text, more a manifesto of revolutionary social-ist utopianism than a novel in the traditional sense, records the lives of individuals clearly inspired by a desire to overthrow conventional bourgeois strictures. One of the most interesting characters for the subsequent formation of the Soviet New Person is that of Rakhmetov, the revolutionary hero whose dedicated and ascetic life proved an inspiration to many of the early Bolsheviks.[2] The principal link between Rakhmetov and the Soviet New Person lies in the capacity of both to perform outstanding labour tasks. Rakhmetov, for example, whilst working as a boat-hauler on the Volga, gains the respect of his peers and is nicknamed in honour of a former worker whose physical capabilities enabled him to earn four times the usual rate. Significantly, Rakhmetov's physical strength is not a natural condi-tion, but the result of the transformation of his body and will through a strict regime of diet, physical exercise and labour practices; notably, Rakhmetov regularly practised gymnastics as a form of personal improve-ment. James Riordan has further highlighted the importance ascribed to physical education by other nineteenth-century theorists such as Vissarion Belinskii and Nikolai Dobrolyubov.[3]

Once in power, the Bolsheviks set about turning the myth of the New Person into reality. Ever-changing needs and circumstances, how-ever, resulted in diverse interpretations of what precisely constituted

this new being. The general consensus was that he or she would be young and physically fit. This condition would facilitate successful participation in both labour programmes and the military defence of the nation. The *novyi chelovek*, however, was always intended to be much more than just a willing and able worker or soldier. Indeed, the ideal Soviet citizen was also required to conduct his or her leisure time according to carefully laid out moral rules and strictures. Thus, the director of a Urals machine-tools factory emphasized the all-round development demanded of the new type of worker:

Many of us consider that the shock worker is one who works night and day in the shop or factory . . . and who does not live for other interests except those of production. It seems to me that it would be more correct to consider a shock worker as someone who works at the factory exactly seven hours, since Soviet power does not permit anyone to work more, who regularly goes to the cinema, visits others, engages in sport and at the same time fulfils all production tasks. Our Soviet worker must live in a cultured manner and take advantage of all the good things in life that Soviet power offers him.[4]

This shift in emphasis away from the ubiquity of labour and towards state-approved leisure proved highly expedient. Here, labour and leisure could be conflated usefully: increased leisure time, the reward for greater labour productivity, simultaneously provided opportunities to indulge in leisure pursuits such as *fizkultura* and thus potentially to improve fitness, health and the capacity to develop further labour potential. In this context the line of demarcation separating labour from leisure became very blurred indeed.

Lenin's support for the development of *fizkultura* ensured early on that it was readily accepted as a crucial aspect of the new, post-revolutionary life. Indeed the Soviet sportsman or sportswoman rapidly became an archetype of the *novyi chelovek*. As such, many of the more radical artists identified *fizkultura* as a potentially new and exciting subject, and a means through which they could explicitly signify an affinity with the new regime. The question of just how such a new figure might be represented within visual culture, however, remained vague and became one of the most hotly debated issues during the early Soviet period.

Fizkultura *in Visual Culture*

Before the Bolshevik Revolution sport played a relatively minor role in visual culture. Since sport itself was still a minority practice, cultural

engagements with the theme were themselves largely confined to photographic and illustrative material, variously documenting or promoting sporting events and activities. The initial promotion of sportsmen and sportswomen as figures symptomatic of the new Soviet age emerged and coincided with the rise of the cultural left in the early post-revolutionary period. More importantly, images of *fizkultura* first appeared in an entirely new medium: photomontage. In 1919 Gustav Klutsis, a student at the Vkhutemas (Higher State Art and Technical Studios) and a staunch supporter of the Communist Party, produced what he later declared to be the first photomontage produced in the Soviet Union.[5] Klutsis was not making a claim for having invented the medium; photomontage had already been widely exploited by European artists associated with Dada and Expressionism. Rather, he specifically identified the medium as ideal for the development of an agitational art form to serve the state. Photomontage enabled Klutsis to bring together the abstract, spatial ambiguities of earlier Constructivist-inspired experimentation and an easily identifiable subject matter, thus increasing the potential for the work to convey a straightforward political message. Accordingly, his earliest works in this medium, such as *Dynamic City*, promoted the new regime by envisioning a new utopian world both created and inhabited by the now fully enfranchised working class. In 1922, however, Klutsis departed from his emphasis upon labour to produce a photomontage entitled *Sport* (illus. 2). In this work, documentary photographs of male gymnasts are superimposed onto a background of simple geometric forms. These, at top and bottom, spell out the word 'SPORT' in the Cyrillic alphabet, whilst the concentric circles at the centre of the work bind the various components of the composition together. More importantly, however, this geometrical emphasis serves to reinforce the circular motion of the gymnasts variously performing upon parallel bars and the horizontal bar. Klutsis's shift from labour to *fizkultura* is here noteworthy. On the one hand, sporting activity is clearly presented as an equivalent to labour, and it is worth pointing out that the circular motions of the gymnasts unquestionably allude to the movement of wheels in a machine. Klutsis presents conventional gymnastic practices, however, rather than the newly introduced production gymnastics as performed on the factory floor. In this way, the leisure aspects of *fizkultura* are mapped directly onto notions of labour productivity and service to the state.

Klutsis's conflation of *fizkultura* with the new medium of photomontage was not a unique occurrence. Also in 1922 the young typographer and graphic artist El Lissitzky was commissioned to produce a

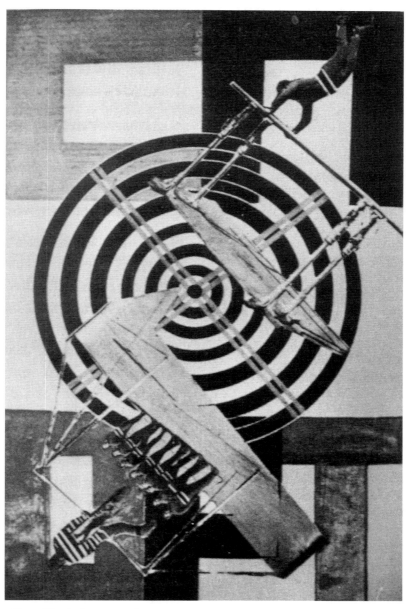

2 Gustav Klutsis, *Sport*, 1922, photomontage.

set of illustrations for Ilya Ehrenburg's *Six Tales with Easy Endings*. In one of these works Lissitzky similarly focused on a sporting theme, incorporating a documentary photograph of a soccer player into a complex composition of floating and intersecting geometrical forms

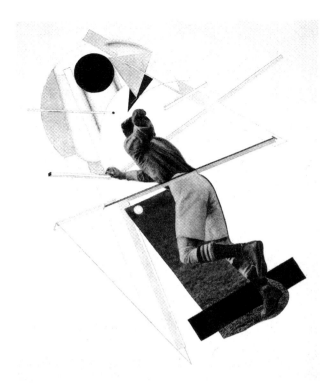

3 El Lissitzky,
Footballer, 1922,
collage.

(illus. 3). For both Klutsis and Lissitzky the reintroduction of what K. Michael Hays has described as 'affirmative iconic representation' was clearly a crucial element in the formulation of a new visual vocabulary suitable for agitational purposes.[6] Moreover, the deployment of photography also served to emphasize the mechanical and technological aspects of image-making and the possibility for mass-reproduction, thus suggesting the important role that such works would now play as a component of popular, rather than elitist, culture.[7] These works, however, also suggest the ways in which *fizkultura* at this time operated as a signifier of modernity, post-revolutionary socio–cultural transformations and, more broadly, the *novyi chelovek*. Moreover, the *fizkultura* theme became uniquely associated with the avant-garde, experimentalist wing of cultural production.

During the mid-1920s other individuals associated with the early Soviet avant-garde also emphasized *fizkultura* in their work. For example, in 1923 the Constructivist artist and designer Varvara Stepanova turned her attention specifically to the design of sports costumes, or *sportodezhda* (illus. 4). Like *prozodezhda*, or production clothing, *sportodezhda* constituted a new type of costume for the new,

post-revolutionary era. Stepanova, along with fellow Constructivist designer Lyubov Popova, supported the notion that all costume design should now be 'determined by the demands of the job for which it is predestined'.[8] Utilitarianism, however, was not the sole concern. In the journal *Atele*, published at the same time as Stepanova was developing her *sportodezhda* designs, Mikhail Kuzmin argued that costume design also had a transformatory potential. As the design of a costume could clearly impact upon physical movement, attitude and gesture, so, Kuzmin argued, could it contribute to the transformation of the personality.[9] Clothes, it seemed, would make the Soviet New Person. *Sportodezhda* designs also made appearance in the work of other costume designers of the 1920s. In 1925 the fashion designer Nadezhda Lamanova published her designs in the album *Art in Everyday Life*, an illustrated volume designed to encourage Soviet citizens to make their own clothes from the designs set out in simple form, whilst Aleksandra Ekster and Natalya Kiseleva were also active in the design of sports costumes (illus. 5).

4 Varvara Stepanova, *Sports Costumes*, 1924, gouache and indian ink on paper.

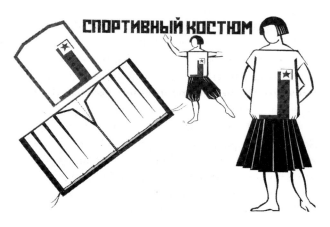

5 Nadezhda Lamanova, *Design for a Sports Costume*, 1925.

6 *Students at the Lesgaft Institute of Fizkultura*, *c.* 1920s, photograph.

This emphasis on sports costumes also served usefully to deflect attention from the labour to the leisure arena. Whilst the *prozodezhda* costumes designed by Stepanova, Popova and others were undeniably practical for a working environment, they hardly constituted the kind of clothes that the masses ideally wished to wear outside work hours. The introduction of the NEP in 1924 also helped to alter attitudes towards leisure and consumption, a factor that had some bearing on the development of the sports costume as a fashion item for urban youth. Indeed, throughout the later 1920s and well into the 1930s, sports costumes, and soccer jerseys in particular, were popularly embraced by Soviet youths, replacing the more austere stiff leather jackets and military boots of the Civil War period. In particular, the black and white vertically striped shirt, known as the *futbolka*, now made regular appearance in all manner of contexts. For example, students at the Lesgaft Institute of Fizkultura in Leningrad were frequently seen wearing the *futbolka* in lessons and on the street as much as on the playing field (illus. 6). The *futbolka* also made appearance in less likely arenas. For example, it was adopted as a signifier of pro-Bolshevik youth culture by the Blue Blouse Theatre troupes, many of which toured the city and countryside staging propaganda plays in support of the Soviet regime (illus. 7). Throughout the 1920s and '30s sports costumes became a clearly definable sign of commitment to the new regime, the outer shell, as it were, of the *novyi chelovek*.

The reappearance of a consumer economy during the NEP era also stimulated a market for a wide range of cultural products, many now

7 Blue Blouse
Theatre Company,
Us and Henry Ford,
no date.

associated with sport. For example, textile designs regularly turned to *fizkultura* for inspiration, as can be seen in the *Water Sports* designs produced by Raisa Matveeva (1926), Darya Preobrazenskaya (illus. 42) and Marya Anufrieva (both late 1920s).[10] Wallpaper designs also picked up on the sports theme, seen in F. Antonov's *Football Wallpaper* of the 1930s (frontispiece), whilst ceramics based upon sports themes were widely disseminated throughout the nation. The latter include ceramic figurines designed by Natalya Danko, such as her *Ink Stand with Fizkultura Figures* of 1933, whilst examples of *fizkultura* tea services can be found in both the Museum of Decorative and Applied Arts in Moscow and the Russian Museum in St Petersburg (illus. 8 and 44). Despite this diversity of activity, however, photomontage remained the dominant medium in which the *fizkultura* theme was visually articulated at this time. In 1926, for example, Lissitzky further developed his interest in the sports theme by producing a series of photomontages including *Runner in the City* and *Footballer*. The fact that these works were designed as part of a major commission to decorate the interior of the International Red Stadium in Lenin Hills reflects the growing importance of the *fizkultura* theme within official Soviet culture. Sadly, however, the commission was never realized.[11]

The year 1928 marked a major watershed in both *fizkultura* practices and representations of *fizkultura*. In August of that year, Moscow played host to the Soviet Union's first major international sporting event, the First Workers' Spartakiad. These games, specifically identified as a workers' sporting festival and held in honour of the inception of the First Five-Year Plan, were effectively staged in opposition to the Olympic movement of the West. Here, linguistic distinction was of much significance, for whilst the Olympic movement placed much emphasis on the mythical gods of ancient Greece, Soviet sports theorists championed a more down-to-earth figurehead: Spartacus, the gladiatorial slave who led a revolutionary rebellion against Rome in the first century BC. Sports festivals in the Soviet Union were thus designated as Spartakiads to distinguish them from the Western Olympiads. It was not only the nomenclature, however, that revealed the competitive edge adopted by the Soviet Union. During the summer of 1928 Amsterdam played host to the biggest Olympic festival yet staged, with 46 nations sending more than 3,000 athletes to participate. Moscow's response was unquestionably on a smaller scale, yet designed specifically to impact upon the sporting hegemony of the Western movement.[12] This competitive edge was notably emphasized in the press on the opening day of the Moscow games when *Izvestiya* published a front-page cartoon in which a Soviet sportsman symbolized

8 Natalya Danko, *Ink Stand with* Fizkultura *Figures*, 1933, porcelain.

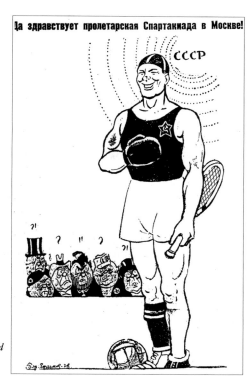

Да здравствует пролетарская Спартакиада в Москве!

9 *Long Live the Proletarian Spartakiad in Moscow!*, cartoon published in *Izvestiya*, 12 August 1928.

a range of activities including swimming, athletics, boxing, tennis and soccer (illus. 9). Here the presumed superiority of this Soviet sporting hero was contrasted with the looks of anxiety, envy and anger of stereotypical representations of Western capitalist nations.[13] The Soviet authorities were keen to exploit the international status of the Moscow Spartakiad. More than a dozen nations had sent worker teams to Moscow and the total number of competitors was claimed to be greater than that of the Amsterdam Olympics. On the opening day 30,000 athletes paraded through Red Square to the newly inaugurated Dinamo stadium, built that year with the Spartakiad in mind and effectively tripling the attendance capacity of the previously largest Moscow sports arena.[14] On the same day, crowds of up to 200,000 people were reported as attending the official opening of the Soviet Union's first Park of Culture and Rest, later renamed Gorkii Park, where many of the Spartakiad events were to be staged.[15]

The importance of the First Workers' Spartakiad might also be measured by the wide-scale promotion of the event both at home and abroad. And here, both Klutsis and the medium of photomontage were once again to play an important role. Klutsis spent much of 1928

working on a commission to produce a series of postcards celebrating the Spartakiad. In the nine works completed, he redeployed many of the compositional and spatial devices he had developed in his early photomontages such as *Sport* (illus. 10 and 45). In line with the activities of the games themselves, the works seek to reveal the diversity of sporting activity in the Soviet Union. Hence, tennis, soccer, athletics, cycling, swimming, showjumping and even motorcycling all feature. Documentary photography is here combined with typography and collage to emphasize dynamic movement and energy with both action and participation highlighted as integral aspects of the development of sport and, indeed, the *novyi chelovek*. Notably, several of the postcards also deploy scale discrepancy, one giant figure dominating an assemblage of smaller figures dispersed throughout the background. This approach, derived largely from compositional devices used in Russian icon painting and in traditional Russian popular prints known as *lubki*, serves to reinforce a central notion within the concept of the Soviet New Person. Here the sporting prowess of a dominant individual is highlighted and celebrated yet simultaneously presented within the context of wider collective activity. In this way, the achievements of one individual are seen as characteristics that are, effectively, accessible to all. Klutsis's figures are thus sporting heroes yet notably retain an anonymity, an identity simply as types of sports-figure – soccer player, shot-putter, javelin thrower, motorcyclist. Individualizing facial features are reduced to a minimum, either by the lighting, the angle of facial depiction or the printing process. Despite this anonymity, however, one individual is identifiable in several of Klutsis's Spartakiad photomontages: the now-deceased Soviet leader Vladimir Ilych Lenin. In these works, images of Lenin can be seen hovering, larger than life, on the margins, thus lending the authority of the state to the activities and potential successes of its *fizkulturniki*.

With the Soviet left's interest in the documentary form, photography and film remained the predominant modes for the depiction of sport and *fizkultura* in the wake of the 1928 Spartakiad. Thus, Aleksandr Rodchenko increasingly focused his camera upon sports events and parades throughout the late 1920s and early '30s. Similarly, the film-maker Dziga Vertov included a major section on *fizkultura* in his film of 1929, *The Man with the Movie Camera*. It is perhaps no coincidence that Vertov's emphasis on the ubiquity and diversity of sports practices, including athletics, soccer, gymnastics, swimming and even motorcycle racing, followed immediately on from the reported success of the First Workers' Spartakiad. Similarly, the unusual dynamic camera angles and effect of fragmentation generated by the

10 Gustav Klutsis, *Postcard for the First Workers' Spartakiad*, 1928, lithograph.

rapid editing technique deployed within Vertov's movie act as a cinematic analogue to Klutsis's Spartakiad postcards.

Despite the activities of figures such as Klutsis, Stepanova, Rodchenko and Vertov, however, the emphasis on experimentation in cultural production was facing increasing attack by the late 1920s. As easel painting returned to prominence, the *fizkultura* theme, first associated with the avant-garde, began to make its early appearances in the more traditional medium. *Fizkultura* first became a serious theme in painting in the works of Aleksandr Deineka and Yurii Pimenov. Both former members of the Vkhutemas, Deineka and Pimenov joined other ex-students in 1925 to form the group OSt (Society of Easel Painters). OSt effectively occupied the middle ground,

33

simultaneously opposing the more extreme abstract experiments of the Soviet left, in particular the rejection of easel painting as an appropriate cultural practice, and the anti-formalist stance of the realist group AKhRR. Even before the formation of OSt, however, Deineka had posited *fizkultura* as an appropriate theme for this new synthesis of representational easel painting influenced by formalist developments when he exhibited his work *Footballers* at the *First Discussional Exhibition of Associations of Active Revolutionary Art* in 1924. By April 1925 the first OSt group exhibition was held in the Institute of Artistic Culture in Moscow. The presence of the *fizkultura* theme here was sufficient to draw Anatolii Lunacharskii's specific attention in his *Izvestiya* article reporting the show.[16] The most significant fusion of avant-garde experimentalism and more conventional artistic practices came, however, in the work of another artist clearly inspired by the First Workers' Spartakiad: the sculptor Iosif Chaikov.

In 1928 Chaikov produced a small-scale work representing two soccer players, which he exhibited the following year at the *Third Exhibition of Sculpture* by the ORS (Society of Russian Sculptors) held at the Museum of Fine Arts in Moscow (illus. 11). Just 83 cm in height and sketchily defined, this plaster model was given a bronze patina-like finish, suggesting that Chaikov originally conceived of his *Football Players* as a work to be cast in bronze. Two years earlier the sculptor Yelena Yanson-Manizer had exhibited four small-scale bronzes on the *fizkultura* theme (*Female Swimmer*, *Female Basketball Player*, *Male Shot Putter* and *Male Footballer*) at the major AKhRR exhibition of 1926. These sculptures proved enormously popular and countless copies were cast in a cheaper metal and sold at the time of the exhibition.[17] On 10 August 1928 these bronzes were once more exhibited, this time at the Institute of Fizkultura in Moscow in celebration of the official opening of the First Workers' Spartakiad, and doubtless encouraged Chaikov in his choice of subject matter.[18] Chaikov's emphasis on soccer at this crucial date is also indicative of the dominant role that the sport played at the 1928 Spartakiad. Soccer certainly drew the largest crowds and gained the most press coverage, perhaps not least of all due to the participation of international teams from both England and Uruguay – identified at the time as two of the world's strongest soccer nations – and the ultimate victory of a team from Moscow. Chaikov's *Football Players* was a clear response to the ever-growing popularity of soccer in the Soviet Union. However, it simultaneously deployed the *fizkultura* theme as a means to address some of the principal cultural anxieties of the era. By the late 1920s the rise to cultural dominance of the right-wing group AKhRR was

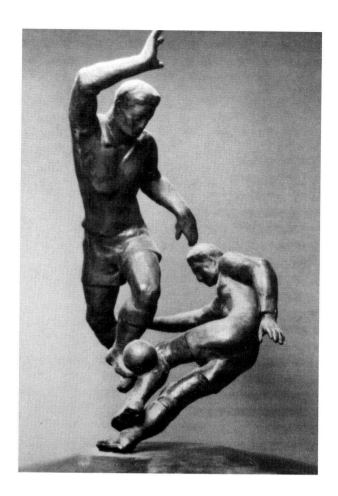

11 Iosif Chaikov,
*The Football
Players*, 1928,
plaster.

partially predicated upon its denunciation of the Soviet avant-garde
and support for a so-called realistic, monumental art. Chaikov, in many
respects, was precisely the kind of artist that AKhRR were here target-
ing. In the pre-revolutionary period he had studied and exhibited in
Paris. Here, amongst a Russian emigré community including Aleksandr
Arkhipenko, Osip Zadkine and Jacques Lipchitz, Chaikov produced
numerous Cubist-inspired sculptures and illustrations. Back in Russia
after the Bolshevik Revolution, he joined the teaching faculty of the
Vkhutemas and continued to develop his work within a Cubist idiom,
as can be seen in works such as *Bridge Builder* of 1921. Whilst adopting
the external stylistic vocabulary of his Parisian experiences, however,
Chaikov nonetheless maintained a strong commitment to themes
promoting proletarianism and the new Soviet state. *Football Players*
epitomizes, in many respects, the tensions between the formalism of

35

the avant-garde and the traditionalist figuration of AKhRR. The work is an unusually open composition concerned far more with movement, structure and grace than with solid monumentality. The composition is vertical, yet a crucial emphasis is placed upon a spiral running from the lower player's right foot, up through his arm and continuing into the right leg of the upper player until the whole concludes in a raised hand. Two main pivotal points, the football, being the only point of contact between the two players, and the right boot of the lower player, the point at which the whole work connects with the pedestal, seem designed to emphasize balance, fragility and weightlessness. The work effectively declares itself as a significant feat of mathematical and engineering ingenuity, and space is as central an element as are the figures themselves.[19] Thus, Chaikov's work incorporates formal influences from Cubism and Constructivism, but deploys these within a figurative, representational work based predominantly upon the modern practice of *fizkultura*. The Soviet art critic Aleksandr Romm was later to articulate this duality by coining the phrase 'constructive realism' when discussing Chaikov's work of this period.[20]

In thematic terms, Chaikov's works also made significant allusion to both tradition and modernity. Sculptural representations of athletes and sports figures clearly date back to antiquity, and Chaikov's familiarity with the Louvre collection from his Paris student days would undoubtedly have made him aware of these classical precedents. Further, it is also plausible that Chaikov was here making a reference to a more specific genre, namely that of the small bronzes depicting male combatants popularized in fifteenth- and sixteenth-century Italy by Antonio del Pollaiuolo and Giambologna. These Renaissance bronzes were widely known throughout Europe due to their mass distribution in innumerable castings and copies, and were certainly known in Russia. As early as 1805, for example, the Russian sculptor Stepan Pimenov had produced a version of the *Hercules and Antaeus* subject, the work subsequently becoming part of the collection of the Russian Museum in St Petersburg.[21] The similarities between Chaikov's *Football Players* and the Renaissance bronzes are obvious enough. The *Hercules and Antaeus* bronzes produced by both Pollaiuolo and Giambologna use the subject of male combat to emphasize the tension between graceful balance and extreme physical exertion. Despite the sense of fast, powerful and aggressive movement, the spiralling bodies and extended limbs within these works ultimately resolve into a compositional balance and harmony. Chaikov's *Football Players* adopts a similar approach. Once again the representation of a moment of physical extremity between two male competitors, this time sportsmen,

results in a remarkably fluid, graceful and balanced composition, belying the sense of energy and power implicit in the subject. By alluding to this historical precedent Chaikov additionally lent the authority of the Italian Renaissance to his particular form of representation. Maintaining his fascination with contemporary Soviet themes, however, he substituted the ancient mythological figures with modern Soviet sporting heroes. Chaikov's *Football Players*, produced at the same time as the First Workers' Spartakiad of 1928, reveals the ways in which the very modernity of the *fizkultura* theme, and its association with the transformation of the Soviet New Person, attracted artists who were not simply seeking a new subject matter. Rather, the theme lent itself to a new exploration of the very vocabulary used to represent the subject. As *fizkultura* itself was promoted as a practice based upon historical precedents, yet adapted to meet the demands of the new Soviet age, artists too sought to represent this new practice by looking not just to the present but also to historical sources, not simply to plunder but to adapt in order to create a new synthetic style. Ultimately, Chaikov's *Football Players* captures well the ambiguities and uncertainties of the cultural moment in which it was produced whilst simultaneously identifying the *fizkultura* theme as an appropriately modern and potentially heroic subject matter. As shall be seen in chapter Five, however, he was later to rework his *Football Players* in a new and distinct socio-cultural context.

The First Workers' Spartakiad was the biggest and most important sporting festival to take place in the Soviet Union to date. As such it acted as a major catalyst for artists to develop further the *fizkultura* theme in official culture. Much as the event suggested a huge step forward for Soviet sport, cultural responses too increased and intensified their engagement with the subject. By the early 1930s, however, the *fizkultura* theme was no longer the preserve of the avant-garde alone and began to take on a new, but equally complex, identity.

2 Sporting Icons

The success of the First Workers' Spartakiad of 1928 spawned a host of similar sports competitions throughout the Soviet Union over the next few years, significantly raising the profile of *fizkultura* practices. In visual culture, too, representations of *fizkultura* acquired a more elevated status, the adoption of the subject notionally conferring a political orthodoxy and support for the state on the part of the producer. Style, however, was still a much-disputed issue. By the early 1930s a cultural climate had developed in which frequently malicious infighting between rival factions had resulted in debate dominating actual practice. By April 1932 things had so deteriorated that the state issued an official decree on the Reconstruction of Literary and Artistic Organizations. This decree liquidated existing rival groups in all fields of culture. Primarily, the decree of 1932 proclaimed the successes of recent Soviet cultural developments, linking these intrinsically to the economic and industrial progress of the nation. At the same time it announced the end of one period of Soviet cultural history and the start of a new era in which centralized, organizational procedures would now be deployed to advance further the march forward of Soviet culture. In this way, both the structure and language of the decree of 1932, based upon self-reflection on past achievements and self-assessment as to the best way forward, were very much in line with the ethos of the First Five-Year Plan era. In the visual arts this was made most evident in two arenas. First, in 1933 the state launched a new art journal, *Iskusstvo*, to be the primary vehicle for discussion of art matters.[1] During its first year of publication *Iskusstvo* effectively reinforced this mood of self-reflection and self-assessment. Several articles set out to summarize achievements in the fields of painting, graphic arts, theatre design and sculpture during the first fifteen years of Soviet rule, whilst a number of crucial practitioners were highlighted as indicative of the current strength of Soviet art. Perhaps significantly, the artists highlighted at this point were not exclusively drawn from the previously dominant right-wing groups such as AKhRR, but were more reflective

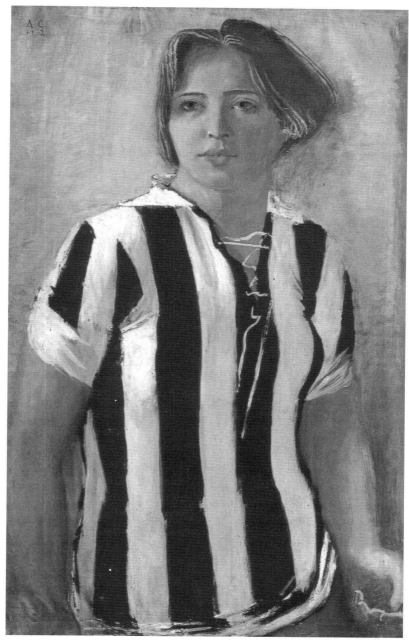

12 Aleksandr Samokhvalov, *Girl Wearing a Football Jersey*, 1932, oil and tempera on canvas.

of a centrist point of view.[2] The second major arena in which the concept of self-reflection and self-assessment was explored was the jubilee exhibition of 1933, *Artists of the RSFSR during the Last Fifteen Years*, held consecutively at the Russian Museum in Leningrad and the Historical Museum in Moscow. The exhibition comprised almost 1,000 works by 245 artists. Official reports claimed a quarter of a million visitors, making this exhibition a major cultural event.[3]

Interestingly, two crucial representations of *fizkultura* played a major role at this event. Both were produced by Aleksandr Samokhvalov and represented Soviet sportswomen. *Girl Wearing a Football Jersey* of 1932 and *Girl with a Shot Put* of 1933 (illus. 12 and 46) were both well received in the press and acquired by the state shortly after the exhibition closed. To this day they hang, respectively, in the Russian Museum in St Petersburg and the Tretyakov Gallery in Moscow. These works were also reproduced in *Iskusstvo*; *Girl Wearing a Football Jersey* was included in the very first volume, published in early 1933, whilst *Girl with a Shot Put* accompanied a seventeen-page article on Samokhvalov in issue five.[4] Following this exposure, both works were selected by the state for promotion abroad; *Girl with a Shot Put* was included in the Venice Biennale of 1934, whilst *Girl Wearing a Football Jersey* was later exhibited at the Paris International Exhibition of 1937.[5] Produced, exhibited and initially promoted during the period between the Decree of April 1932 and the Soviet Writers' Congress of 1934, these two works are indicative of how an engagement with the *fizkultura* theme attracted official approval during the period when a Socialist Realist mode was still far from being clearly defined. Notably, both *Girl Wearing a Football Jersey* and *Girl with a Shot Put* constitute a marked contrast to the pro-nineteenth-century realist, anti-modernist aspirations that gradually came to dominate official Soviet culture in the late 1920s and early '30s. Here, for example, an interesting comparison can be made between Samokhvalov's images and those of the AKhRR artist, political activist and fully signed-up member of the Communist Party, Georgii Ryazhskii. During the mid- to late 1920s Ryazhskii, like Samokhvalov, produced a number of works focusing on the improved conditions notionally brought about for Soviet women by the Bolshevik Revolution. These included his *Female Delegate* of 1927 and *The Chairwoman* of 1928 (illus. 13). In 1928 Ryazhskii even prefigured Samokhvalov's later focus on the *fizkultura* theme in his representation of a young woman posed in a stadium setting in full sports costume and holding a ball.[6] In the works of both artists, women are represented performing new and dynamic roles in the post-revolutionary age. Yet there are clear distinctions between the two artists' approach

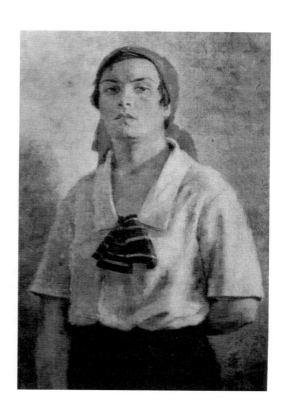

13 Georgii Ryazhskii, *Female Delegate*, 1927, oil on canvas.

to this subject. Whereas Ryazhskii's characters are usually viewed from below, and given a dynamism metaphorically associated with the Revolution itself, Samokhvalov's figures are seen straight on and appear more passive and still. This contrast of mood is further accentuated by the agitated and thick-impastod brushstrokes adopted by Ryazhskii. His lush, rich oil surfaces contrast strikingly with the dry, fresco-like appearance of Samokhvalov's works, achieved by mixing the more traditional medium of tempera with oil. Whereas Ryazhskii's works look fresh and new, as if the paint has not yet dried, Samokhvalov's convey a sense of antiquity, their rubbed-down and worn surfaces seeming to bear the scars of the ravages of time. The characters represented in Samokhvalov's works also seem more distant, less individualized than those of Ryazhskii, their physical features and costumes defined in a simple, linear style with scant attention to detail.

Here, it could be argued that Samokhvalov's representations of *fizkulturnitsy* sit rather comfortably within the wider international context of the return to figuration that characterized much art practice in the inter-war years. The increase in international cultural exchanges would certainly have informed Samokhvalov of recent developments

throughout Europe and North America. Moreover, neither the emphasis on sport nor Samokhvalov's loosely defined figurative style was unique to artists in the Soviet Union at this time. Nonetheless, Samokhvalov's representations of *fizkulturnitsy* addressed a more specifically Russian agenda. In particular, *Girl Wearing a Football Jersey* and *Girl with a Shot Put* have frequently been described as invoking traditional Russian religious culture. In 1933, for example, soon after these works were first produced, the Soviet critic Natan Strugatskii highlighted the stylistic affinities between Samokhvalov's works and 'Russian frescoes and antique paintings'.[7] More recently, John Milner, in his *Dictionary of Soviet Art and Artists*, described *Girl Wearing a Football Jersey* and *Girl with a Shot Put* as 'stylized images of attractive, healthy young women depicted as ikons of vigour and well-being', whilst Wolfgang Holz, focusing more on the allegorical and functional dimensions of Socialist Realist culture, and specifically referring to Samokhvalov's *Girl with a Shot Put*, even proposed that these works be considered as 'socialist icons'.[8] There can be little doubt that Samokhvalov was here making a clear reference both to traditional religious mural painting and, more particularly, the icon. Like many typical icons these works focus on single figures, seen face on, and depicted in a simplified, schematic manner. Backgrounds are vaguely defined and a strange light both illuminates, and appears to emanate from, the central figures. Moreover, Samokhvalov's inclusion of specific costume details and attributes – the soccer jersey, the athletics vest, the shot put – designate the status of his figures as *fizkulturnitsy* in a similar way to the use of such details in icons to specify individual saints. By emphasizing the affinities between his modern works and traditional religious culture, Samokhvalov associated the spiritualism, authority and heroism of religious saints with a figure from the modern world, specifically the sportswoman, who now becomes a substitute figure of worship, a new image of devotion.

Despite the numerous affinities between Samokhvalov's *fizkultur-nitsy* and traditional religious painting, a number of broader questions remain here essentially unanswered. How, for example, was it possible for Samokhvalov to revive traditional Russian religious culture in an essentially atheistic, post-revolutionary state? Furthermore, what potential meanings were conveyed by the specific visual style of the icon tradition and what significances might these have for the perceived role of visual culture in the new society? Finally, why does Samokhvalov focus specifically on the sportswoman as the iconic example of the *novyi chelovek*? Samokhvalov's works here need to be considered as complex images, addressing a number of crucial, unresolved questions

symptomatic of the period in which they were produced. By adopting and fusing a wide variety of styles and approaches, often assumed to be paradoxical or mutually exclusive, Samokhvalov here attempted to develop a new kind of history painting for a new age. In the process his new sporting icons posited a way forward for Soviet visual culture.

Reviving the Icon in the Modern Age

Until the late seventeenth century the icon remained the principal form of visual culture deployed throughout the Russian Empire. During the reign of Peter the Great (1682–1725), however, European influences were increasingly embraced. In St Petersburg, the tsar's metaphorical window on the West, European architects, painters and sculptors were brought in to contribute to the westernization of the Russian Empire, a policy development that inevitably left its mark on all aspects of cultural production. In this pro-European climate, the visual simplicity of the icon gradually came to be associated with Russia's backwardness, its failure to have embraced the lessons of the Italian Renaissance. Throughout the eighteenth and nineteenth centuries the practice of traditional icon painting decreased dramatically, becoming more and more confined to small villages in remote districts of the empire. The late nineteenth century, however, witnessed something of a reversal of this pattern. Amidst ever-increasing fears that traditional Russian society and culture were rapidly losing their identity to this European invasion, a significant pro-nationalist movement emerged. One crucial demand of this lobby was the revival of traditional Russian culture. And nothing symbolized traditional Russian culture more than the icon.

It is, perhaps, ironical that one of the major figures at the forefront of the revival movement was himself an industrialist and railway magnate. From the 1870s onwards the staunch Slavophile Savva Mamontov set out to counter the decline of traditional Russian cultural practices by encouraging contemporary artists to adopt such techniques and to train local peasants. At his estate at Abramtsevo, 40 kilometres north-west of Moscow, Mamontov established an artists' colony and invited major cultural figures to produce work based on traditional practices. In 1881 he financed the building of a church at Abramtsevo, employing artists, including Viktor Vasnetsov, Vasilii Polenov, Yelena Polenova and Ilya Repin, to design and decorate the building, even commissioning a whole series of icons, an iconostasis, for the church interior. Icons also increasingly attracted the attention of Russian scholars, including Nikodim Kondakov and Nikolai

Likhachev, and specialist collectors, thus setting the pattern for the large-scale removal of many icons from their original church settings.[9] Formerly valued predominantly for their liturgical functions, as objects of religious devotion, icons came to be valued more for their intrinsic aesthetic qualities, their financial value and their nationalist associations. Furthermore, icons were now exhibited more frequently in purely secular arenas. For example, the 1890s saw the opening of both the Tretyakov Gallery in Moscow and the Russian Museum in St Petersburg, both of which possessed significant icon collections, whilst numerous private collectors, such as Ilya Ostroukhov, both studied and promoted the icon. By the early twentieth century, major exhibitions, including a huge-scale exhibition of icons shown in Moscow in 1913 to coincide with the tercentenary of the Romanov dynasty, generated widespread interest and, as has frequently been noted, marked a significant impact on the work of Russian avant-garde artists, including Natalya Goncharova, Mikhail Larionov and Kazimir Malevich.

It was not just the shifting arenas in which these works were seen, however, that was to impact upon Russia's own sense of its cultural past. In 1910 the painter N. I. Neradovskii established a major icon restoration workshop at the Russian Museum in St Petersburg. Until this time, the vast majority of icons remained in poor condition, their surfaces covered by centuries-old layers of dirt, candle smoke and previous over-painting. The new restoration workshops now embarked upon a large-scale project to clean the icon collection, restoring, as much as possible, the original appearance of objects often more than 500 years old. For many, the sight of these newly cleaned icons with their bright, glowing colours, simple lines and shining surfaces came as nothing less than a revelation. The late nineteenth- and early twentieth-century revival of interests in the Russian icon changed the public perception of this cultural form. Previously seen predominantly as a functional object serving a specifically liturgical role, the icon now acquired a broader and more prestigious reputation as an integral and aesthetically valued aspect of the national cultural heritage, a museum treasure to emulate, or even surpass, the cultural achievements of the West.

Following the Bolshevik seizure of power in 1917, the new regime's overt antagonism to religious institutions appeared to pose a major threat to any further expansion in the fields of icon production and icon studies. Even in this hostile environment, however, the traditional icon painters of the Vladimir district showed a remarkable resilience in adapting their traditional skills to the changing circumstances. In 1921 Ivan Golikov, an artist who had previously practised

his trade in the village of Palekh, applied his traditionally learned, tempera technique to the decoration of lacquered, papier-mâché boxes, substituting religious subject matter with scenes from Russian fairy-tales and legends. These decorative boxes proved remarkably popular and were soon widely distributed. By 1924 Golikov had even formed a collective known as the Artel of Early Painting, and increased the production of these decorated lacquered boxes. Fired by their early success, the Palekh painters introduced further subjects, including contemporary scenes such as the *Electrification of the Nation* and *Red Cavalry Soldier*.[10] Despite their adoption of modern themes, the artists of Palekh maintained the stylistic simplicity and bright colours of the local icon tradition and, significantly, gained much support for their simultaneous preservation and adaptation of past techniques. In particular, the Commissar of Enlightenment, Anatolii Lunacharskii, was lavish in his praise for the Palekh artists, claiming that 'the art of the Palekh craftsmen, far from being ruined, has expanded, consolidated, and [been] saved for the future'.[11]

Lunacharskii's recognition of the importance of the national cultural heritage was further bolstered by the rapid expansion in the state holdings of icons brought about by the closure of many churches and the confiscation of countless private collections following the Revolution. Indeed, throughout the 1920s new publications and exhibitions promoting the icon tradition continued to dominate the cultural agenda. The new Bolshevik regime's antagonism to religious institutions impacted less upon icon studies, and even the artistic development of the icon style, than might first have been imagined. Far from being rejected or abandoned as a vestige of a devalued past, the icon was now, more than ever, embraced as a resonant symbol of Russian cultural achievements, whilst the successful redeployment of the icon style was also posited as a potential way forward for the visual arts in the post-revolutionary age. And it is within this context that Samokhvalov's deployment of the icon style in his representations of contemporary Soviet sportswomen needs to be considered.

Having grown up at the height of the icon revival, Samokhvalov developed an early interest in icons. Whilst a student at the Academy of Arts in the newly renamed Petrograd prior to the Bolshevik Revolution, Samokhvalov regularly visited the Russian Museum to admire its collection of icons.[12] He even trained as an icon painter. After the Revolution, Samokhvalov's interests in the icon grew stronger, largely as a result of his familiarity with the work of the Russian painter Kuzma Petrov-Vodkin. By the mid-1920s his reputation as a specialist with a broad knowledge of traditional religious painting was well

14 King Solomon in a fresco at the Georgievskii Monastery in Staraya Ladoga, *c.* 1167.

established and in the autumn of 1926, as part of the broad-scale pro-
gramme of conservation introduced by the new regime, Samokhvalov
accompanied a restoration party to Staraya Ladoga in northern Russia.
Here he participated in repainting the frescos on the north and south
walls of the famous twelfth-century Georgievskii Monastery, which
had long fallen into neglect (illus. 14).[13] It was also at this time that
Samokhvalov produced the self-portrait entitled *The Man with a
Scarf*, one of the first major works in which he adapted the forms of
traditional religious culture to represent the contemporary world
(illus. 15).[14] Here Samokhvalov presents his own image in the form of
a traditional icon. The work adopts a still, frontal pose shown from
the waist up. The head is elongated and the facial features highly
schematic, emphasizing an elongated nose, large eyes and full lips. The
costume is similarly pared down to essentials, a green jacket with a
purple scarf hanging over the shoulders. Whilst this choice of costume
does not deny its modernity, it alludes far more strongly to simple
raiments, the *chiton* and *himation* usually worn by saints in icons. At
the same time, Samokhvalov places a bright red pencil in the breast
pocket, a clear attribute identifying the sitter as an artist. The pose of

46

15 Aleksandr Samokhvalov,
Man with a Scarf, 1927,
tempera on canvas.

16 School of Novgorod,
The Apostle Thomas, 15th
century, tempera on panel.

the left hand also invokes the traditional icon. Raised in a seemingly blessing gesture, and thus endowing the artist with a benevolent, yet authoritative, presence, this detail recalls numerous icons including *The Saviour Enthroned in Glory* (sixteenth century), *The Apostle Thomas* (fifteenth century) and *St Nicholas* (fifteenth–sixteenth centuries) (illus. 16). Above all, it is the style of execution that makes the strongest associations between this work and the icon tradition. Here Samokhvalov deployed the more traditional medium of tempera to give a dry appearance to the surface of the work. Using bright, simple colours and precise delineation, he set his figure against a vaguely defined and curiously lit orange-red background, reminiscent of the heavenly light suggested in the gold of traditional icon painting. Contemporary commentators were in no doubt about the associations between this work and ancient Russian religious painting. Strugatskii, drawing attention to Samokhvalov's recent involvement in the Georgievskii Monastery renovations, pointed out that, 'In this canvas [*Man with a Scarf*] the artist successfully makes use of the characteristic principles of ancient Russian art, co-ordinating colour with the beauty of the subject.'[15]

By the early 1930s Samokhvalov was turning his attention to the theme of officially approved leisure, culminating in the two works *Girl Wearing a Football Jersey* and *Girl with a Shot Put*. These modern icons celebrated the *fizkulturnitsa* as the archetypal Soviet New Woman, whose very image, replacing the saints of yesteryear, was designed to inspire devotion and veneration.

Secular Religiosity and the Traditional Functions of the Icon

Here it will be important to consider the ways in which Samokhvalov's adoption of the icon style functioned to express specific ideas about the very modern practice of *fizkultura*. Of particular importance is the relationship between the religious concept of the transfiguration of the saint and the more secular attitude towards the transformation of the Soviet citizen. The removal of icons from their original church, or domestic, settings unquestionably diminished their potential devotional significance. Placed on display in museums and exhibition halls and reproduced in the pages of scholarly publications, the former affinities of the icon with spiritualism were now, at the very least, deflected towards an identity with a more secular form of national cultural pride. After the October Revolution, and with the new state's official condemnation of religious ceremony, this growing secularization of the icon was further increased. This is not to say, however, that

contemporary audiences were unaware of the traditional meanings ascribed to icons within the Russian Orthodox Church. Religion held a powerful sway throughout the pre-revolutionary years and there can be little doubt that the fiercely fought anti-religion campaigns of the early Soviet period reflected the still considerable strength of the Church throughout the nation. Further, many scholars, including Kondakov, had devoted much time and publication space to the study of the liturgical role of the icon.

In the last two decades or so, historians of Soviet culture have raised important questions regarding the relationship between pre-revolutionary religious ideology and the emergence of Socialist Realism. Nina Tumarkin, for example, in her study of the cult of Lenin of 1983, has proposed that the post-revolutionary myths propagated about the Soviet leader were themselves founded largely upon pre-revolutionary religious beliefs.[16] This process began early on during Lenin's lifetime, assisted no doubt by his quasi-miraculous survival and rising, as it were, from the dead following an attempt on his life. Its real expansion, however, came after the leader's death in 1924. The immediate erection of a mausoleum in Red Square elevated Lenin to a saint-like status, his embalmed and publicly exhibited remains taking on the characteristics of pilgrim relics. By the early 1930s the cult of Lenin was in full swing, with countless depictions of the leader as saint dominating the sculpture, painting, graphic arts, photography and, later, film media. Thus, according to Tumarkin, St Lenin, the modern martyr, effectively replaced the former saints of the Orthodox Church, in the process becoming the new post-revolutionary icon. As such, images of Lenin frequently conveyed his status both as a human being, with all his physical characteristics, and as a heavenly apparition, a figurehead whose heroic deeds on earth had earned him immortality.

More recent work has drawn upon Tumarkin's examination of the religious dimension of the Lenin mythology and examined closely the relationship between traditional icons and official Soviet culture.[17] To cite one example, Ulf Abel, in his essay of 1987, 'Icons and Soviet Art', claimed that the devotional, political and ritualistic functions of the icon were redeployed in officially approved culture during the Stalinist era.[18] Abel's argument is generalized and he cites few examples of Socialist Realist art to reinforce his claims. His analysis, however, of the comparable functional roles of the icon and official Soviet culture might usefully be mapped onto Samokhvalov's representations of *fizkulturnitsy*. For example, Samokhvalov's works can be considered as specifically promoting the devotion of the *fizkulturnitsa*, and subsequently of the officially approved practice of *fizkultura*.

Moreover, this focus has obvious political motivations in that it proposes the sporting prowess of the Soviet Union at a time when the state was initiating international sporting contacts as a means of expressing national strength. In addition to outlining these functional similarities, Abel has made reference to another, more useful, parallel between icons and official Soviet culture, namely their similar quest to fuse notions of individuality and typicality within the one image.

Dual Reality: The Transfiguration of the Soviet Sportswoman

Traditionally, the icon was designed to inspire veneration and devotion amongst its viewers. Critically, its authority was to be drawn solely from its subordination to a dominant religious ideology. The icon was thus considered as a vehicle to a notional higher realm of thought, an aspect that was essentially not to be confused with the veneration and devotion of the object itself. As such, the icon was to be no more than the material manifestation of an abstract concept. Many icons were designed to represent specific saints, St Boris, St George, St Gleb, the Holy Mother, etc. Yet these saints were often promoted precisely because they symbolized more general qualities, the devotion of the Holy Mother, the courage of St George, the humility of St Sergius, the solicitude of St Nicholas. To emphasize further this duality, icon painters represented saints neither in their human condition, as earthly individuals, nor yet as heavenly, non-corporeal beings, symbolizing their more generalized qualities. Rather, they were represented in a transfigured state. As Abel has pointed out, this conflation of two seemingly contradictory states, or dual reality, is central to the very meaning of the icon. Drawing on Leonid Ouspensky's analysis of the role of the icon within Russian Orthodox culture, Abel has suggested that

The icon is not a realistic portrait of the saint depicted; it does not represent his or her actual physical appearance while living on earth. Instead we meet the subject of the portrait in his transfigured state, 'not out of human stock, but of God himself' (John 1:13). And in that state there are no bodily defects, no spiritual torment.[19]

The depiction of the saint in this 'transfigured state' is here vital to an understanding of the function of the icon. The saint represented is neither a humble human being, the mere clay from which he or she has been moulded by God, nor yet a spiritual being devoid of material existence. Rather, the figure stands at the margins between these two worlds, both past and future, materiality and spirituality. This very

marginality was further exemplified by the positioning of icons within the spaces of the church itself. The icon screen, or iconostasis, traditionally separated the holy sanctuary from the more secular space occupied by the congregation, and thus formed the boundary between two realms of existence, heaven and earth. Abel has claimed that this notional state of dual reality – the conflation of the present and the future, the particular and the general – had a critical bearing on the emergence of the ideology of Socialist Realism. At the Soviet Writers' Congress of 1934, for example, Andrei Zhdanov demanded that artists engage in precisely such a duality, to produce what he described as 'revolutionary romanticism', a notional conflation of the reality of the present with the claimed reality that was to come about as a direct consequence of Soviet power. As Brandon Taylor has indicated, however, this seemingly oxymoronic conflation of present reality and future aspiration can also be traced back to a much earlier period, indeed to Lenin's own views on the role of cinema expressed in 1922.[20]

This notion of dual reality has much significance for Samokhvalov's *Girl Wearing a Football Jersey* and *Girl with a Shot Put*. Both these works can be read as representing specific individuals, real Soviet sportswomen in the modern world. At the same time they can be read as representing more generally the type of *fizkulturnitsa*, an idealized symbol of the coming communist utopia. And here, Samokhvalov adopted particular stylistic features of the icon tradition to emphasize precisely the coexistence of these two states. As Ouspensky has indicated, certain features of the icon style, most particularly the treatment of corporeal features and light, made a significant contribution to the overall meaning of the icon. Describing the significance of the stylistic representation of saints in Russian icon painting Ouspensky, has claimed:

his whole image in the icon, his face and other details, all lose the sensory aspect of corruptible flesh and become spiritualized. Transmitted in the icon, this transformed state of the human body is the visible expression of the dogma of transfiguration and has thus a great educational significance. An excessively thin nose, small mouth and large eyes – all these are a conventional method of transmitting the state of a saint whose senses have been 'refined' as they used to call it in the old times. The organs of sense as well as other details, such as wrinkles, hair etc., all are subjected to the general harmony of the image and, together with the whole body of the saint, united in one general sweeping towards God. All is brought to a supreme order; in the Kingdom of the Holy Spirit there is no disorder . . . Disorder is an attribute of the fallen man, the consequence of his fall. This does not mean, of course, that the body ceases to be what it is; not only does it remain a body but . . . it preserves all the physical peculiarities of the given person. But they

are depicted in the icon in such a manner that it shows not the earthly countenance of a man as does a portrait, but his glorified eternal face.[21]

Thus the icon painter does not overlook individual particularities, but simultaneously employs simplification, refinement and harmony in order to express the saint's transfiguration or perfection. Samokhvalov's representations of *fizkulturnitsy* can be read as operating in a similar vein. Both works employ a less-than-full-length representation of a young, female figure, the former turned slightly to the left, the latter viewed straight on. Both convey a significant physical presence, dominating the frames that contain their images. Some individualizing traits are apparent. Both figures, for example, are depicted with identifiably distinct hair colour and styles, and slightly differing facial features. Yet in other ways they suggest the more generalized identity reinforced by the impersonal label *Devushka* (Girl) used in the title of both works. For example, their body types conform to the conventions deployed for the representation of the female worker; these images depict women of stocky build, broad-shouldered and thick-necked, yet posed in a manner to convey curvaceousness. No mark or blemish is revealed and, to repeat Ouspensky's point above, every detail appears to be 'refined' and 'subjected to the general harmony'. In effect, Samokhvalov is here presenting the 'glorified eternal face' of the *fizkulturnitsa* who, like the transfigured saints of the icon tradition, stands on the margins between the present, physical world and the idealized future, the new utopian age that is notionally about to dawn. This is the Soviet New Woman at the very moment of her 'transfiguration'.

Samokhvalov's allusion to transfiguration is reinforced by his treatment of light. According to Ouspensky, the representation of light played a critical role within icon painting. Since saints were to be depicted in a transfigured condition, when they, like Christ on Mount Tabor, were filled with a heavenly, transcendental light, it was critical for icon painters to give their works an extreme brightness and luminosity. To quote Ouspensky once more, 'an icon is an external expression of the transfigured state of man', in which 'we often meet with this manifestation of light, a kind of inner sunlike radiancy coming from the faces of saints at moments of high spiritual exaltation and glorification'.[22] Icon painters adopted various conventional techniques to render this unearthly, divine light. Haloes, for example, were often included to symbolize the transcendental qualities of transfiguration. Similarly, bright colours and gold backgrounds, glowing behind the image of the saint, could convey this sense of heavenly illumination.

Samokhvalov deploys neither haloes, nor gold leaf, in his representations of *fizkulturnitsy*. His treatment of light, however, is worthy of note. In *Girl Wearing a Football Jersey* a plain, silver-grey background defines the space inhabited by this *fizkulturnitsa* as neither interior nor exterior. The luminosity, however, suggests that this background is either a source of light or a highly reflective surface. The light that falls on the central figure seems similarly intense, picking out highlights in the hair and illuminating the left side of the face. In turn, the figure stares out directly towards this light source. Ultimately, the lighting of this work serves to compress the image, flattening contours and giving an impression of light emanating from the figure herself. In *Girl with a Shot Put* the light source is more clearly defined as sunshine in the open air. Falling from the upper left, this light draws attention to the curvaceousness of the body, emphasizing the exposed flesh, the shape of the breasts, hips and thighs. Its intensity, however, is such that it simultaneously appears to penetrate the figure, softening the contours of the left shoulder and right elbow. In both these works, a strange, almost ethereal light brightly illuminates the central figures, as if the utopian future notionally to be delivered with the victory of communism will itself be bathed in a divine aura.

In addition to the treatment of corporeal features and light, other elements of Samokhvalov's handling in these works associate them with the icon tradition. Icons frequently used costume as a means of identifying particular saints. St John the Baptist, for example, was more readily identifiable by his camel tunic than by any physiognomic features. Costume was also frequently used to signal what Ouspensky has referred to as 'the nature of the service of a saint'; whether he or she was an apostle, a martyr or a member of a particular religious order.[23] In both *Girl Wearing a Football Jersey* and *Girl with a Shot Put* costume similarly plays a significant role in identifying the nature of the characters represented. Both figures wear sports outfits, a black and white soccer jersey in the former, athletics shorts and vest emblazoned with the badge of the Dinamo Sports Society in the latter, costumes signifying the importance of *fizkultura* as service to the state much as traditional costumes in icons signified a saint's service to God.

Whilst Russian icon painters relied less on attributes for the identification of their saints than Western artists, saints were nonetheless commonly depicted bearing symbolic objects: the sword, the cross, the orb, books of Holy Scriptures, etc.[24] In Samokhvalov's works both *fizkulturnitsy* notably carry items of sports equipment. In *Girl Wearing a Football Jersey* a small tennis ball held in the figure's left hand

contributes to an identification of this figure less specifically as a soccer player than as a general participant in *fizkultura*.[25] The object held by the figure in *Girl with a Shot Put* certainly suggests a more specific activity. Its highly reflective surface and prominent position, however, also recall the frequent inclusion of the glass orb held in the hands of saints in icons such as those of the *Archangel Michael* (fifteenth century) and the *Archangel Gabriel* (sixteenth century).

There can be little doubt that Samokhvalov's *Girl Wearing a Football Jersey* and *Girl with a Shot Put* borrow much of their visual language and meanings from the icon tradition. Yet by introducing a new subject matter, namely the *fizkulturnitsa*, the artist has effectively reinvented the icon to produce new images of devotion applicable to the modern, revolutionary age. For adherents of the Orthodox Church, the Trinity of Father, Son and Holy Spirit were spiritual entities above and beyond the realms and experiences of mere mortals. Saints, on the other hand, were of human origin. As such they were read as exemplary figures, their holy deeds, theoretically at least, within the scope of human aspiration. Samokhvalov's *fizkulturnitsy* occupy a similar position: they too are of humble human origin. Their physical presence, confident postures and serious expressions, however, reveal their dedication to *fizkultura* and the new state. Accordingly, they acquire a new, heroic status as exemplary role models for Soviet society. The saints of medieval Russia were celebrated and promoted for their educational values in guiding the congregation in the conduct of their lives. Samokhvalov's *fizkulturnitsy*, in their day, played no lesser a role.

Finally, Samokhvalov's exclusive focus on women in these images should not be overlooked. In the late 1920s and early '30s Samokhvalov had produced a significant number of portraits of women labourers including *Woman with a File* (1929) and *Butter Maker Golubeva* (1931–2). In one sense, this emphasis reflected a real shift in society, not least of all because the industrialization drive of the First Five-Year Plan was heavily dependent upon women workers entering the factories.[26] To encourage such participation, women were increasingly heroized by the state and described as 'a great strength', 'the pride of the Soviet people' and 'a great army of labour'.[27] Positive images of women workers were also increasingly disseminated in literature, cinema and other visual media. For example, in 1934 a major thematic exhibition entitled *Women in the Construction of Socialism* was held at the Russian Museum to honour the role played by women during the industrialization drive. Frequently, the state trumpeted this expansion of women in industry as reflective of its emancipatory policies. In 1930, for example, the Moscow Party leader Lazar

Kaganovich even announced the liquidation of Zhenotdel, the official women's organization founded in 1919 by Inessa Armand and Aleksandra Kollontai, on the somewhat dubious grounds that equality of the sexes had now been achieved and thus a separate organization was an anachronism.[28] This, however, was hardly the full story, for in reality the increasing participation of women in industry was more a direct consequence of sociological and demographic necessity than emancipatory zeal. The devastating consequences of the First World War and the subsequent Civil War had had a devastating effect upon the labour population of the Soviet Union. Increased male mortality and a decrease in the birth rate resulted in a relative lack of young male labour and a subsequent need for young women to fulfil a growing number of industrial tasks. Furthermore, an inevitable increase in unmarried young women put pressure on this group to become the main providers both for themselves and their dependents. As Mary Buckley has pointed out, women, during the inter-war years, were predominantly regarded by the state as 'an economic resource rather than a category of human beings striving for personal fulfilment through creative work and financial independence'.[29] In this context, the public promotion of the heroic female worker served to turn a sociological necessity into a claimed achievement.

Sport, like labour, had historically been a predominantly male domain. Nonetheless, Lenin had early identified participation in sport as a potential means to the emancipation of women, and throughout the early post-revolutionary years the Soviet authorities regularly encouraged women to participate in both *fizkultura* training and education programmes.[30] Clearly, this policy was implemented in large part to develop further the fitness and strength of women for both labour and military ends. Accordingly, the heroic Soviet sportswoman, like her counterpart the female worker, now began to make regular appearance in both literary and visual culture during the late 1920s and early '30s. At the same time, the promotion of *fizkultura* was regarded as a crucial weapon in the fight to transform particular pre-revolutionary values. Here, it is worth noting, two specific 'types' of female were targeted: the Russian peasant woman, known colloquially as the *baba*, and notionally oppressed Muslim women from the southern republics. In both these cases, a perceived desire to cling to age-old customs and habits, particularly those associated with religion, was targeted by the state as a major obstacle to the further development of the *novyi chelovek*. In this context, the promotion of women as new sporting icons can be read as a secular alternative to traditional religious culture. Works such as Samokhvalov's *Girl Wearing a Football Jersey*

and *Girl with a Shot Put* were clearly designed to encourage women into participation in *fizkultura* as a civic duty. Unlike the emphasis on labour, however, the enticements now emphasized leisure and play, presenting powerful, attractive and heroic young women as exemplars. These works have subsequently become canonical images within the history of official Soviet art. One crucial question nonetheless remains. How successful were these images in attracting young women or, for that matter, men into participation in *fizkultura*? Indeed, the whole issue of who practised *fizkultura*, how and why, now needs to be addressed more fully.

3 Participants and Spectators

During the summer of 1937 the city of Moscow witnessed two major sporting events, the scale of which suggested just how far the popular expansion of sport and *fizkultura* had come. The first of these events began in mid-June. At the height of the Civil War in Spain, a team of all-star international soccer players from the Basque region arrived in Moscow. Here they took part in a tour, playing several matches against selected Soviet teams as part of a campaign to raise political awareness, sympathy and money for the Spanish Republican cause. The arrival of the Basque soccer players was a major news event. A huge official welcome was staged at the Belorus station and the press turned out in strength.[1] The tour started with two matches in Moscow, one against the cup holders Lokomotiv, the other against the highly respected Dinamo Moscow. Both matches were an instant sell-out, the two million applications for tickets far outweighing the over-capacity audiences of 90,000 that witnessed each spectacle.[2] In *Pravda* it was suggested that such overwhelming public interest and support reflected the political sympathies of the Soviet people for the Spanish Republican cause.[3] It need hardly be added, however, that most spectators were probably at least as interested, if not far more so, in seeing how Soviet soccer would fare against a class international opposition. Not surprisingly, the Basques won both games comfortably before going on to play another match in Leningrad. Yet the popularity of these meetings was so great that two more Moscow fixtures were hastily organized.[4] In a return match, Dinamo were once again defeated, before a team from the Moscow Spartak Society finally beat the Basques, by now a tired force after playing five games in two weeks (illus. 17). Once again, both fixtures were a sell-out with the Dinamo stadium packed to the rafters with enthusiastic Soviet soccer fans. Following their popular success in the capital and Leningrad, the Basques went on to play matches in Kiev, Tblisi and Minsk.

On 12 July, just four days after Spartak's famous soccer victory, Moscow was once again gripped with sporting fever as the second

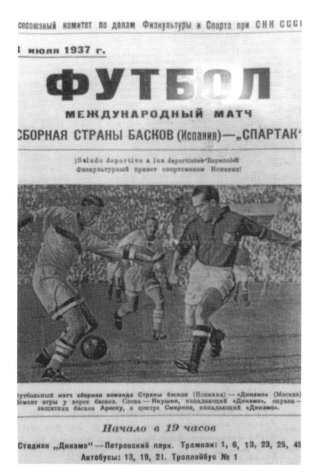

сесоюзный комитет по делам Физкультуры и Спорта при СНК СССІ

І июля 1937 г.

ФУТБОЛ

МЕЖДУНАРОДНЫЙ МАТЧ

СБОРНАЯ СТРАНЫ БАСКОВ (Испания)—„СПАРТАК‘

¡Saludo deportivo a los deportistas Espanoles!
Физкультурный привет спортсменам Испании!

Футбольный матч сборная команда Страны басков (Испания) — «Динамо» (Москва)
омент игры у ворот басков. Слева — Якушин, нападающий «Динамо», справа —
защитник басков Ареску, в центре Смирнов, нападающий «Динамо».

Начало в 19 часов

Стадион „Динамо“—Петровский парк. Трамван: 1, 6, 13, 23, 25, 45
Автобусы: 13, 19, 21. Троллейбус № 1

17 Poster advertising the soccer match between the visiting Basque team and Moscow Spartak that took place on 8 July 1937.

major event of the summer took place (illus. 47). The Annual Fizkultura Parade of 1937, staged that day in Red Square, proved to be one of the grandest, and most publicized, affairs yet. As *Pravda* proudly announced the following day:

Yesterday in Red Square forty thousand *fizkulturniki* from eleven union republics demonstrated their strength, their good spirits, their courage, their ardent love of the Motherland and their infinite devotion to the greatest friend of the *fizkulturniki*, Comrade Stalin.[5]

The importance of this event was particularly emphasized by the presence of several major political figures on the tribune of Lenin's Mausoleum. These included Kliment Voroshilov, Nikolai Yezhov, Andrei Zhdanov, Lazar Kaganovich, Vyacheslav Molotov and Mikhail Kalinin, but the centrepiece of the whole event was, inevitably, Stalin

himself. Banners with representations of the leader were carried in procession through the streets and, as many participants pointed out in the press the next day, the personal climax of the event was seeing the great leader in real life.

The Basque soccer tour and annual sports parade of 1937 can both be read as major manifestations of contemporary Soviet *fizkultura* and, as such, shared much in common. Both were official, state-approved events designed to attract popular support on a huge scale. The copious press reports frequently emphasized how the enormous crowds attending these events were a crucial part of the whole spectacle. Whilst both events could be enjoyed on a simple entertainment level, they simultaneously carried important political messages. The Basque tour, for example, was an overt expression of sympathy and support for Spanish Republicanism, the Annual Fizkultura Parade a homage to the Soviet leadership. But in other respects, these two events were dramatically different and here it is perhaps worth focusing on what separates rather than what unites them. The Basque soccer tour, for instance, was essentially a popular spectator event. Despite the huge attendant crowds, participation in *fizkultura* itself was effectively confined to the 22 players on the soccer pitch, the remaining 90,000 watching passively. As a competitive fixture, spontaneity played a vital role in the outcome. Thus, whilst the authorities could determine a number of organizational elements, such as choice of venue and opponents, timing of matches and pre-match build up, control was effectively relinquished once the starting whistle was blown. Results could certainly be influenced, but never guaranteed, and whether a match proved to be entertaining or dull, fair or unsporting, high or low scoring, was ultimately down to the performances of the two opposing teams. The *fizkultura* parade, on the other hand, was by definition a participatory festival. Here, rather than having the majority watch the performance of the minority, 40,000 participants performed for the somewhat exclusive audience of Stalin and his colleagues atop the Lenin Mausoleum. Furthermore, the strict stage management of the *fizkultura* parade effectively removed any possibility for spontaneity or unpredictability of outcome. Every movement and action was carefully orchestrated in advance and participants were encouraged to play their part in the event, much as an actor or actress played their pre-scripted role on stage. Theatricality was very much the order of the day and dominated any notion of spontaneity.

The almost simultaneous staging of these two major sports events raises a number of important questions. For example, how did such

diverse manifestations of *fizkultura* emerge historically? Further, what was the relationship between these two forms of practice and how did they manage to coexist successfully? Two crucial issues here need to be addressed, both of which impacted upon both the practice and the official image of *fizkultura*: namely, the tensions between spectatorship and participation, and the coexistence of competitive and theatrical modes of *fizkultura* practice.

But first it is important to outline the significance of these practices for early debates concerning the development of *fizkultura* in the immediate post-revolutionary years. Throughout the inter-war period the Soviet authorities promoted and supported widespread participation in *fizkultura*. With its rigid control over the principal means of disseminating information, the Soviet state was eminently capable of determining the cultural meanings attached to *fizkultura* practices. This, however, is not to say that the public necessarily appreciated or practised *fizkultura* according to the official dictates of the state. Even under the strict social controls of Stalin's regime the broad masses maintained a degree of agency, though this was not the radical agency of protest or opposition, but rather that of negotiation. Thus, whilst the public at large frequently adopted the cultural offerings of the state, this was not always for the 'right' reasons. Whilst state command reigned, it was, nonetheless, modified by public demand. Here, the question of who watched, who took part and how these two activities were broadly interpreted offers an interesting insight into the context in which the ideological parameters of *fizkultura* were determined, disputed and articulated in the cultural arena.

The official attitude towards sports spectatorship in the Soviet Union was somewhat ambiguous throughout the entire inter-war period, and deeply bound up with debates concerning the validity of competitive sports. Soccer continued to draw large crowds in the early post-revolutionary years. The question, however, of whether standing on the terraces and watching a soccer match could truly be defined as an appropriately socialist activity inevitably became an issue for much debate. The question was first addressed early on. In the mayhem of the immediate post-revolutionary and Civil War years, all sports clubs and societies fell into the hands of a new government agency, the Department of Universal Military Training, popularly known under the acronym Vsevobuch. Inspired by a chronic need to supply fit soldiers for the newly formed Red Army, Vsevobuch looked to take advantage of the pre-revolutionary popularity of sport to entice new recruits. Although the staging of many competitive events was necessarily curtailed by the Civil War, Vsevobuch continued to encourage

sports competitions to attract both participants and spectators alike. It was during the period of the NEP, however, that the issue of sports spectatorship really came to the forefront of discussion. In these more consumer-oriented years attendances at sports events, particularly soccer matches in the cities, began to swell. Whilst Soviet citizens avidly consumed soccer, ideologists and critics conducted widespread debates concerning which direction the practice of physical culture should now take under the new regime. Here, two powerful lobbies emerged, the Hygienists and Proletkult. The Hygienists, a group dominated by medical theorists and practitioners, perceived the value of *fizkultura* solely in terms of its potential to improve the physical condition of the population. Thus they advocated all forms of gymnastic exercises as beneficial to the physical constitution. Competitive sports, however, and especially contact sports, were seen as potentially harmful, any risk of injury being perceived as counter-productive. For the Hygienists, spectatorship was also dismissed, not on any moral or ideological grounds, but simply as serving no practical function. Proletkult effectively shared the Hygienists' condemnation of competitive sports and spectatorship, though on entirely different grounds. In their view, the continuing emphasis on pre-revolutionary bourgeois sports failed to recognize the importance of the Revolution in bringing about a new era and thus potentially obstructed the development of a true proletarian culture. Therefore Proletkult advocated an entirely new form of physical culture based predominantly upon theatrical spectacles and mass participation.[6] Despite their differences, both the Hygienists and Proletkult shared the view that active participation needed to replace passive viewing. Furthermore, both groups were so fervent in their condemnation of competitive sports that they advocated banning them altogether.

By all accounts, the Central Committee of the Communist Party appears to have taken a more circumspect view. Whilst it undoubtedly agreed that participation in some form of fitness training was indeed the ultimate goal, it was loath to bow to these pressure groups and impose any ban. Clearly this risked alienating the considerable popular support both for participating in and watching competitive sports. Instead, the state took the view that whilst sports spectatorship did not in itself constitute *fizkultura* practice, it could nonetheless serve as one of the strongest means available for promoting *fizkultura*. On 13 July 1925 the Communist Party took the decisive step of entering into the debate by publishing an official resolution expressing its views on the role that *fizkultura* should now play in society. Whilst this document did not directly mention spectatorship it did allude to the fact that any

form of popular support for *fizkultura*, and this implicitly included spectatorship, could only be beneficial. Thus, having advocated broad-scale participation, the resolution further added that *fizkultura*

should also be seen as a method of educating the masses . . . It must be regarded, moreover, as a means of rallying the bulk of the workers and peasants to the various Party, Soviet and trade union organizations, through which they can be drawn into social and political activity.[7]

Here, popularity was evidently a guiding principle. By 1925 many of the *fizkultura* programmes already implemented had not proved seductive to the masses. Whilst gymnastic displays and festivals were certainly what the Soviet doctors ordered, these were regarded as a bad-tasting medicine by a population who, broadly speaking, still preferred to watch a good old-fashioned soccer match. By the late 1920s Nikolai Semashko, the highly influential chairman of the Supreme Council of Physical Culture and an early supporter of the Hygienist movement, was forced to admit: 'If you keep the populace on the semolina pudding of hygienic gymnastics, physical culture will not gain wide publicity.'[8]

The Communist Party resolution on *fizkultura* of 1925 has frequently been read as an early example of authoritarian intervention into the cultural sphere, foreshadowing later interventions in the visual arts, music and cinema. Clearly the state was here imposing its will and riding roughshod over the views of influential cultural theorists and critics. Indeed, there can be little doubt that this intervention was read contemporarily as a riposte to the Hygienists and Proletkult, both of whom consequently fell out of favour. The resolution, however, might also be read as a strangely compromising piece of legislation, strategically implemented to maintain widespread public support. For, in effect, this intervention ensured that the gymnastic exercises and theatrical spectacles favoured by the Hygienists and Proletkult, far from being condemned, were now to coexist alongside the more popularly consumed spectator sports, thus ensuring, ideological contradictions apart, that all *fizkultura* interests were, in some ways, addressed.

Soviet Sports Spectators: Myths and Realities

Once it had been established that both competitive sports and spectatorship had a legitimate role to play, the question shifted towards defining precisely how such activities should be practised. The first problem encountered by the authorities concerned the imbalance of interest

amongst Soviet sports spectators. As the state advocated the broad expansion of a multitude of sporting activities, in theory the Soviet sports spectator too would share a wide interest in a variety of sports. In reality, however, soccer remained the only sport that continued to attract large-scale audiences throughout the entire inter-war period.

The first major state intervention into the issue of sports spectatorship came in 1928. The staging of the previously mentioned First Workers' Spartakiad in Moscow gained much publicity, and a wide campaign was launched early on to attract spectators to the multitude of sporting events. In June 1928, fully three months before the competition was due to begin, a special monthly journal, *Spartakiada*, was introduced. *Spartakiada* frequently addressed the question of spectatorship. In its first issue young Soviet citizens were particularly targeted, not only as potential spectators themselves, but also to encourage the older generation. Thus, in a light-hearted article, the following encounter between young and old was claimed as a common feature of contemporary life:

'Papa [or uncle], do you know what's happening in August?' Papa replies absent-mindedly, 'There'll be rain, apples, mushrooms . . . '
'And what else?'
'What else? Well, school term begins, there are earthquakes . . . Well, how should I know, you tell me, what else is happening in August?'[9]

What else but the Spartakiad. Issue two made a more direct appeal in an article by Boris Gromov entitled 'Think of the Spectator'. Here the author proposed that mass-propaganda methods, including the cinema, be used to encourage spectators to attend the games.[10] Significantly, Gromov focused on the problem of poor attendances at athletics meetings, suggesting that better information and scoreboard facilities could help to encourage bigger attendances. State support for athletics was always strong, yet, as Gromov bemoaned, this support was not always shared by the public. Even when reporting on the Amsterdam Olympics, with which the Moscow Games were openly competing for prestige, *Spartakiada* emphasized the problem of badly conducted ticket sales over any actual sports reports.[11] The new interest in encouraging broad spectatorship was also apparent in other activities building up to the Spartakiad. For example, new facilities were built in the city to stage the multiplicity of events, the most notable example being the Dinamo stadium built in northern Moscow and the opening of Gorkii Park of Culture and Rest.

From the Moscow Spartakiad onwards, sports spectatorship was increasingly encouraged as an integral aspect of the Soviet *fizkultura*

programme. Whilst the authorities looked to increase and diversify sports spectatorship, however, they also set out to redefine the notion of what constituted appropriate forms of spectator behaviour. The image of the Soviet sports fan was now to be reinvented officially. In essence, this new spectator was disciplined, well behaved, loyal to his or her own sports society and, most notably, as much a participant as a spectator. In the early 1930s the British journalist P. E. Hall (a rather obvious *nom de plume*) visited several sports societies in Moscow and Leningrad and reported back in glowing terms:

The big sports grounds like the Cheliuskin are fascinating places. For one thing you get every sort of game in one spot. You have the latest thing in shower baths, massage and electrical equipment, and such devices in the changing rooms as little lifts for whisking clothes aloft out of the way. There is actually a seat for every spectator. Entrance to big matches – you get in for nothing of course to your own trade union or factory activities – costs from about a shilling.[12]

Hall had clearly seen the very best of sports facilities, yet he also extended his praises to the dedicated and serious-minded involvement of Soviet youth in *fizkultura*. Describing a visit to a particular Moscow Sports Club, Hall continued:

I stepped into a world where 'match' and 'sprint' and 'goal' leaped the barrier of languages, and tennis whites, shorts, spiked shoes and the rest obliterated differences of dress. There were as many girls as men among the participants, and more participants than onlookers. A long-distance running race was in progress; high jumping was going on in one corner, dummy grenade throwing in another . . . More spectators appeared and in their factory clothes mingled with men and girls still in shorts and vests in the stand seats. A football was booted out. A sports girl kicked it and was warned off by a militiaman, to the enjoyment of her friends.

Two football teams came out. One eleven in red, the other in green jerseys, they ran precisely along the touch line, at right angles along the centre line and took up their positions, each in its own half, round the centre circle. The teams snapped out in turn the 'physcult' greeting. Then the game began.

A green tripped a red in the penalty area. 'Foul' shouted my neighbour. The inside-left took the kick nicely. Goal; clapping rattled along the stand; an undertone of exclamation, criticism, encouragement; little shouting but a tense swaying among the crowd.[13]

Hall's brief description of a day at a Soviet sports club reinforces the official version of the contemporary experience of *fizkultura*. Here a multitude of sportsmen and sportswomen participate simultaneously in a number of diverse sporting activities, all within the confines of the stadium arena. Spectatorship also takes place, although Hall is keen

to point out how a significant proportion of the spectators are regular *fizkultura* participants, and much attention is paid to the behaviour of both crowd and players. Organization and discipline are displayed by the almost mathematically orchestrated arrival of the players and the righteous, yet orderly, response of the crowd to the unfolding of the game itself. Hall's story does incorporate minor behavioural transgressions, both through the spontaneous enthusiasm of the female ball kicker and the offending green defender who concedes the penalty. However, both of these minor infractions are looked upon disapprovingly by the orderly majority and punished by the dual authoritarian figures of a militiaman and a referee. The general mood of Hall's description closely matches the aspirations of the Soviet authorities with regard to both player and crowd conduct.

Here it is important to consider how typical Hall's experience actually was. As Robert Edelman has pointed out, sport was both practised and consumed by contemporary participants and audiences in a variety of ways, many of which did not conform to official expectations.[14] To focus first of all on the question of spectatorship, the popular perception of sports, and most particularly soccer, fans at this time was in fact far from positive. Soccer in Russia, as in the rest of the world, had developed mostly within urban, working-class areas and came to be much associated with this social group. Post-revolutionary Soviet soccer fans, like their Western counterparts then and now, were vociferous and dedicated in their enthusiasm for the game, yet, as the Soviet press frequently pointed out, this form of partisan spectatorship often spilled over into ill behaviour, lack of discipline and even rioting. The most notorious example of crowd trouble at a soccer match during the early post-revolutionary years occurred in Odessa in 1926. During a particularly undisciplined contest between a visiting Moscow team and the local Odessa side, crowds invaded the pitch and eventually could be cleared only by mounted police. Despite the early date of this incident, soccer fans retained a reputation throughout the 1930s as a potentially unruly rabble and were frequently criticized for their 'uncultured' behaviour.[15] Whilst such conduct obviously ran counter to official objectives, the mass popularity of soccer made it a cultural practice far too valuable for the state to abandon or condemn excessively and thus, throughout the inter-war years, soccer maintained a dual reputation as both the belle and bête-noire of Soviet *fizkultura*.

When the behaviour of soccer spectators failed to live up to official expectations, the authorities were usually in little doubt as to where to lay the blame. To take the example of the Odessa riot of 1926, the cause of discontent was clearly ascribed to the particularly unsporting

conduct of the players involved, not least of all the actions of one member of the Moscow team in kicking an already prone opponent.[16] Moreover, such player ill-discipline, as Edelman has pointed out, was hardly an isolated incident:

Fights, dirty play, and other transgressions were not just products of the supposedly lower moral standards of the NEP period. Unnecessary roughness was still common in the thirties. In one game during the 1935 Moscow city championship, a player was disqualified for kicking an opponent in the head. A year before, a game in Leningrad dissolved into a mass brawl and had to be abandoned. At a game in Simferopol, two 'notorious hooligans', the Bolsenov brothers, began to beat up their opponents' goalie. When the referee intervened, the brothers punched the referee in the mouth. At other games in Simferopol, players showed up drunk and kicked opponents in the face.[17]

Nonetheless, by the early 1930s many of these less palatable aspects of individual behaviour in sport were broadly ignored as the Soviet authorities adapted their official attitude towards sportspersons. From now on *fizkulturniki* came to be promoted as the new heroes of the people alongside such figures as workers, soldiers and aviators. They came to represent a new elite, a group whose capabilities excelled those of the average citizen and who could act, accordingly, as suitable role models for society. The increased emphasis on results that characterized the ideology of the planned economy era here inevitably impacted upon *fizkultura* practices and, following the precedent set within the emerging Stakhanovite movement, sportsmen and sportswomen became more highly praised, highly respected and, increasingly, highly paid.[18] With the growing stratification of society into hierarchical spheres, sports specialization, and even professionalism, began to emerge. Officially, sport was still very much promoted as an amateur activity aimed at the general masses rather than specialist individuals. Indeed, a resolution passed by the Moscow Committee on Physical Culture and Sports Affairs as late as January 1937 reconfirmed this negative attitude towards professionalism, commonly condemned as symptomatic of bourgeois culture, by prohibiting payments to athletes.[19] Nonetheless, a tension existed within the Soviet Union between the ideals and realities of non-professionalism. Since the 1920s it had, in fact, been common knowledge that many sportsmen and sportswomen had profited either directly, through unofficial payments, or indirectly, through the allocation of privileges such as better housing, from their sporting activities. The supposed amateur status of many Soviet sports figures was generally understood to be little more than a mockery, and corruption was not only rife but, as both Riordan and Edelman have indicated, openly discussed in the

18 'Spring Transfers', 1928, cartoon published in *Fizkultura i Sport*, 5 May 1928.

sports and general press. One crucial area of contention concerned individual sportspersons' loyalties to their clubs. In theory, an individual's affiliation to a particular sports society was based upon his or her profession. Consequently, soldiers played for the Red Army teams, members of the Ministry of the Interior for Dinamo, transport workers for Lokomotiv, car manufacturers for Torpedo, aviation workers for the Krylya Sovetov (Wings of the Soviet), etc. Yet, each spring, the pre-season period for summer games such as soccer and athletics, numerous sportspersons were known suddenly and, as it were, inexplicably to change jobs and club affiliations. Soviet sports journals regularly condemned what were evidently unofficial 'transfer deals', *Fizkultura i Sport* even publishing a satirical cartoon as early as 1928 depicting this annual exchange of sporting commodities (illus. 18).[20]

Whilst such incidents were clearly a breach of official policy, the Soviet authorities appear broadly to have turned a blind eye. For herein lay a dilemma. Throughout the late 1920s and '30s the Soviet Union was beginning to use international sporting contacts as a tool of diplomacy. Between 1926 and 1937, for example, soccer teams from the Soviet Union either visited, or played host to, international worker teams from Austria, Czechoslovakia, England, Germany, Norway, Spain and Sweden, as well as establishing a regular annual international fixture against Turkey.[21] In 1935 a Ukrainian Republic soccer team visited France and secured a famous victory against Paris Red

Star, whilst, two years later, the Soviet Union for the first time sent a team of athletes, boxers, gymnasts, soccer players and weightlifters to compete abroad at the Antwerp Workers' Olympics.[22] The Soviet authorities now recognized a dual value in using sporting contacts to enhance diplomatic relations and to express national fortitude. For such a policy to prove effective, however, Soviet sport would now have to compete successfully against top-class international opposition. The level of fitness and skill required to match these standards demanded a great deal of time, commitment and specialist coaching, which could be achieved only if sportspersons were given financial support from the state's coffers and freed from the restrictions of full-time employment. Put more bluntly, this meant the very professionalism that the Soviet authorities so frequently condemned as symptomatic of bourgeois approaches to sport.

Without doubt, this increasing sports specialization led to a dramatic improvement in sporting performances, and many of the Soviet Union's best-known and best-loved sporting stars emerged during the 1930s. These included the four Starostin brothers, all members of the Spartak soccer team, the pole-vaulter Nikolai Ozolin, the high jumper Nikolai Kovtun and the sprinter Mariya Shamanova. An obsession with individual record-breaking came more and more to characterize Soviet *fizkultura*. Nonetheless, throughout this whole period the notion that mass participation dominated specialization was rigorously advocated. Professionalism was constantly denied, especially abroad where Soviet sporting successes were specifically promoted as the result of the Soviet economic and political system. Thus in 1939 the English-language publication *A Pageant of Youth* proudly declared:

This country knows and honours its champions . . . but all these champions are not professional sportsmen. They are workers in factory or office, they are Red Army men, collective farmers or students who devote their leisure hours to sports. Professional sport is unknown in the USSR. The Soviet sportsman has no need to exchange the seconds or centimetres of his records for coins; he has no need to 'make money' out of his football or his boxing gloves.[23]

The inevitable result of this sports specialization and focus on record-breaking was that the gap between the top sportsmen and sportswomen and general participants widened. Sports specialists were increasingly identified as the top-quality products of the state, whilst the general public, the paying spectator, became simply the avid consumer. Yet, the official line remained precisely the opposite: namely that spectatorship was not passive consumption, but inspiration to

participation. The newly heroized sportsperson, officially displaying values of discipline, teamwork, honesty and patriotism, was ostensibly acting as a spur to encourage the sports-loving spectator to participate within the broad spectrum of *fizkultura*. For the majority of Soviet citizens it was probably understood that most sportsmen and sports-women were as fired by the desire for personal glory and financial reward as they were for service to the state. Similarly, many spectators regularly enjoyed passive viewing without so much as a passing thought for participating in any aspect of *fizkultura*.

Inventing the Participant–Spectator

The tensions inherent in the gap between the official mythology and the reality of *fizkultura* practices were inevitably articulated within the cultural arena. Whilst debates raged regarding the value, or other-wise, of competitive sports and spectatorship, a new mythical character began to emerge, one who would dominate cultural representations of sport for the remainder of the Soviet era: the participant-spectator. The participant-spectator is essentially a conventional character who makes frequent appearance in literature, drama and the visual arts. A sub-category of the Soviet New Person, the participant-spectator acts as a cipher for the official importance ascribed to *fizkultura* practice and the popularity of sport more generally. The origins of this charac-ter can be traced to a novel of 1927 entitled *Envy*, written by the satirist and sometime sports writer Yurii Olesha. In this novel Olesha specifically juxtaposed characters from the new Soviet era with those still negatively associated with the past.[24] Significantly, one of Olesha's devices for revealing either the enlightenment, or indeed ultimate failure, of these negative characters revolved around an incident involving the surreptitious voyeurism of both male and female sportspersons in a quasi-arena setting. In a crucial scene the ostensible villains of the novel, Nikolai Kavalerov and Ivan Babichev, go to visit the latter's daughter, Valya, only to find her not at home. Kavalerov's attention is soon drawn to a bright, oasis-like arena amidst the drab-ness of the urban setting, a grass-covered courtyard where youths are participating in various sports and exercises. Intrigued by the general spectacle, and a suspicion that Valya is participating, both characters approach the courtyard and watch, unnoticed, through a gap in the wall. The view is described as seen through Kavalerov's eyes. At first he notices Volodya Makarov, the male hero and epitome of the Soviet New Man, as he performs a high jump:

a rope was stretched between two small poles, and a young man took off, tilting his body sideways over the rope, and almost glided as he stretched out parallel to the obstacle. It looked more like he was rolling over the obstacle, as though it were a mound. And as he rolled over, he threw his legs up and flicked them out, like a swimmer pushing himself off . . . Everyone on the lawn began shouting and clapping. The high jumper, wearing next to nothing, walked to one side, limping slightly, probably to show off his athletic prowess.[25]

In this scene the sporting hero is watched openly by a crowd of participant-spectators. Kavalerov's spectatorship, in contrast, is from a crouched and hidden viewpoint. Moreover, Kavalerov's reaction to the scene emphasizes the difference between the two characters. Whereas Makarov proudly, perhaps even arrogantly, performs his athletic feat, Kavalerov feels 'overwhelmingly ashamed and afraid'.[26] Then Kavalerov's attention is drawn to the heroine Valya Babicheva, Makarov's fiancée. Once again his reactions hardly match the officially approved notion of sports spectatorship:

Kavalerov sees Valya standing on the lawn, her legs firmly spread apart. She is in black, cut-away shorts, her legs are terribly bare, and can be seen all the way up. She is wearing white sports shoes without socks; and these flat shoes make her posture firmer still, more like a man's or a child's than a woman's. Her legs are dirty, tanned and shiny: a little girl's legs which have been exposed so often to the sun and air, to tumbles onto grass and bangs that they are coarse and covered with light brown cuts from prematurely torn-off scabs, and her knees are rough like oranges. Youth and an inner awareness of her physical beauty entitle her to treat her legs with such neglect. But higher up, under the black shorts, her skin is smooth and delicate, showing how lovely she will be when she becomes a mature woman, when she starts to take an interest in herself and wants to be attractive, and when the cuts heal, all the scabs fall off and her tan becomes even all over . . .[27]

At this point, and in mid-sentence, the authorial voice breaks off suddenly. Here Kavalerov's focus is entirely on the athlete Valya's exposed legs. Despite his attempt to associate her posture with manliness and her skin with childish innocence, a feeble and ineffectual effort to repress his obviously lustful feelings for her, Kavalerov ends up by undressing the athlete in his mind. Finally overcome by his own baser instincts, and fearful of being discovered peeping through the wall by the arrival of another character, Kavalerov takes to his heels in fear and despair.

In this episode, Olesha uses Kavalerov's responses to acknowledge the illicit and transgressive potentials inherent within the spectatorship of *fizkultura* in action. Yet such responses are here described as

symptomatic of the corruption of the bourgeois past. Indeed it is the very inability to control these emotional responses that ostensibly prove Kavalerov's alienation from the new Soviet life. Kavalerov is emphatically not a participant in *fizkultura*. By emphasizing the less honourable, and certainly less openly declared, aspects of watching young sportspersons in action, namely the voyeuristic gaze at the exposed body, Olesha thus highlighted one of the crucial tensions that problematized sports spectatorship: namely, that the motives for sports spectatorship were not universally determined or shared.

Interestingly, a similar tension can be discerned in Vertov's movie *Man with the Movie Camera*, produced just two years after Olesha's novel was first published. In the extended sequence showing *fizkultura* activity as part of after-work leisure activities, the camera focuses on athletes performing high jumps, much as Olesha's conventional hero Makarov does in *Envy*. Seemingly quoting Olesha, Vertov's editing quickly cuts from mid-distance shots of the performing athletes to close-up details of spectators. Here, as the film critic Yuri Tsivian has noted, Vertov alternates gender so that young women are seen admiring the exploits of young men and vice versa. To emphasize further the sense of staring at the body in movement, Vertov uses slow motion when showing the athletes to enable the viewer of the film, and, indeed, the surrogate viewer in the sequence, to linger over the sparsely clad, youthful bodies. In one shot, towards the end of the sequence, he even films a female athlete from directly below as she leaps over a hurdle, framing the shot to emphasize the spread of her legs as she passes directly over the camera. Notably, the sport sequence in *Man with the Movie Camera* is interspersed with the most voyeuristic section of the whole movie when the camera focuses on sparsely clad and nude figures sunbathing on the shores of Odessa.

It remains unclear in Vertov's movie whether or not the gaze of the sports spectators is legitimate. Within the binary structure of the movie as a whole, and its constant comparison of the old, unreformed pre-revolutionary life with that of the new conditions brought about by the Revolution, it is tempting to conclude that Vertov is here defining spectatorship as bourgeois consumption and contrasting this with the more active engagement of the Soviet New Person. Vertov's spectators, however, are themselves notably dressed in athletics costumes, thus identifying them as participant-spectators. In this way they conform more to the notionally legitimate spectators central to Olesha's literary episode. However, what is at stake here is less a question of whether the gaze is legitimate. Rather, Vertov's sport sequences problematize the voyeuristic potential of sports spectatorship, much as the voyeurism of the

19 Aleksandr Samokhvalov, *At the Stadium*, 1931, watercolour on paper.

cinematic medium is problematized throughout the whole of the movie.

The tension between participation and spectatorship is also highly evident in a number of paintings addressing the *fizkultura* theme. In 1931, for example, Samokhvalov produced a small-scale sketch representing a gathering of sportsmen and sportswomen on the day of an athletics meeting (illus. 19). The multi-figured composition, loosely executed in watercolour, is surprisingly busy in view of Samokhvalov's predominant focus at this time on single-figure subjects, incorporating sprinters, discus throwers and a sports parade. In this one, small image Samokhvalov has attempted to give an impression of the excitement, colourfulness and diversity of a major sports meeting. Many events, both competitive and theatrical, are depicted as if taking place simultaneously, although here they perhaps suggest the passage of a whole day, a factor further emphasized by the inclusion of a blood-red sun sinking below the distant grandstand. Whilst Samokhvalov's watercolour might be described as a valiant attempt to engage with a new and essentially modern subject, it also has to be admitted that it is broadly unsuccessful. Whilst the inclusion of a large number of diverse figures performing different activities was probably intended to express the breadth of Soviet *fizkultura*, the whole scene ends up looking more like an unsupervised and disorganized school sports day with several figures uncertain as to what is happening next. Samokhvalov did not

return to the specific theme of the sports stadium for another four years.

In 1935, however, at the *First Exhibition of Leningrad Artists* held at the Russian Museum, Samokhvalov exhibited a large-scale oil painting, 121 by 140 cm, commissioned by Izogiz and also entitled *At the Stadium* (illus. 48).[28] Illustrated in the exhibition catalogue and subsequently purchased by the Russian Museum, this work reached a much wider audience than the first watercolour. The second version of *At the Stadium* is, in many respects, a reworking of Samokhvalov's earlier study. The stadium setting is maintained; the female discus thrower still dominates the image; and once again several sporting activities are taking place simultaneously. Yet there are also crucial differences that distinguish this version from the earlier work. Perhaps the most obvious departure is the reduction in the number of figures depicted. Excluding the very distant parachutists and rowers, Samokhvalov has here focused his attention on a much smaller group of figures, three in the foreground, two in the middle distance and another three in the background. Nonetheless, he has managed to represent a wider scope of *fizkultura* activities than in the earlier image. Whilst the setting is still very much the stadium, Samokhvalov has also shifted the scene from the day of a competition to that of any day. The grandstand has been moved to one side to make room for the water sports taking place in the distant river, and has been emptied of the huge crowd depicted in the earlier work. It is important to recognize, however, that whilst Samokhvalov has here removed the audience, so evident a feature of the former work, and instead prioritized sports participation, he has not excluded the issue of spectatorship altogether. For example, only one of the three most prominent foreground figures, the female discus thrower, is directly engaged in sports participation, the two remaining figures casually watching the efforts of the former. Furthermore, in the distant grandstand, Samokhvalov has included a lone female figure leaning against the back wall and overseeing the activities of the whole stadium. Clearly, these figures are supposed to be read as participants; all are dressed in identifiable sports costumes and the foreground male additionally carries a discus in his left hand. Nonetheless, their inactivity, watching other figures within the context of the sports stadium and indeed the image itself, certainly raises the issue of spectatorship. Why, for instance, are these figures represented as watching rather than participating, and what messages are signalled by this conflation of the participant and spectator? Addressing the first part of this question, one might conveniently suggest that Samokhvalov is emphasizing the value of learning by observation. Here a close

analysis of the skills and techniques of a fellow performer can contribute towards the improvement of one's own abilities. Yet there also seems to be a much more voyeuristic dimension to this aspect of the work. Many of Samokhvalov's figures seem noticeably under-dressed, even for the activities they are pursuing. As if to further this notion of the undressed, Samokhvalov has also exposed a bra strap hanging from the right shoulder of the foreground seated female, clearly evident to the viewer. Such overt references to the voyeuristic gaze at the exposed body could have raised critical accusations linking Samokhvalov's work to the officially disapproved emphasis on eroticism commonly linked to bourgeois art of the past. But it is here, in particular, that the inclusion of spectators within the image served a valuable role. Samokhvalov's conflation of participation and spectatorship operates by offering the viewer of the painting a number of surrogates whose presence, and indeed voyeurism, is seemingly, though barely, justified by their additional role as participants. Far from fearing an illicit, non-participatory, voyeuristic role as mere spectator, the viewer of Samokhvalov's *At the Stadium* could conveniently project a legitimizing association with participation in *fizkultura*. Ultimately, the voyeuristic dimension in works such as Samokhvalov's *At the Stadium* lies fairly close to the surface, yet it is the very association of this scene with a modern and highly approved social activity, namely *fizkultura*, that enabled Samokhvalov to engage with the representation of the near nude body whilst at the same time potentially circumventing any potential criticism that might imply a less-than-pure moral purpose in his work.

Samokhvalov's emphasis on groups of sparsely clad sportsmen and sportswomen watching each other from within the legitimizing context of a sports arena was hardly unique. During the inter-war years Aleksandr Deineka also produced a significant number of works conflating sports participation and spectatorship; these included early drawings such as *Discus Thrower* (1922) and large-scale oil paintings such as *Running* (1933). This theme, however, is most evident in the series of watercolours that Deineka produced at the Dinamo Aqua-Sports Stadium during his trip to Sevastopol in 1934. One of these works represents a scene at the Dinamo Aqua-Sports Stadium on the Black Sea coast (illus. 20). Here a group of youths, all dressed in swimming costumes, are depicted enjoying a leisurely day by the tranquil waters of the Black Sea. The importance of Sevastopol as a military naval base is emphasized by the inclusion of a warship docked in the distant background and a helicopter, symbolic, as Deineka's biographer Vladimir Sysoev has pointed out, of the ultimate in contemporary aviation

20 Aleksandr Deineka, *'Dinamo' Sevastopol*, 1934, watercolour and tempera on paper.

technology.[29] Yet despite these references, the mood of the work is very much one of leisure. In the background a group of half a dozen figures gather on a series of diving boards, clearly a crucial part of the aqua-sports facilities. One figure is even depicted mid-dive, his or her leap into the sea echoing the flight of the modern aircraft overhead. Once again it is the activity, or rather inactivity, of the foreground figures that captures attention. Here six figures, three male and three female, stand, sit or lie with their backs to the viewer as they gaze out both towards the distant helicopter and the divers. Although all are dressed in swimming costumes, a reference once more to their status as *fizkultura* participants, they are depicted essentially as spectators. The compositional structure of the work is so organized that the steps on which the nearest figures stand extend to the very edge of the frame, thus situating the viewer on the same platform, watching over the same spectacle as the foreground figures themselves. Deineka's *Dinamo Aqua-Sports Stadium* images, executed rapidly in watercolour and tempera on paper to suggest both the veracity and immediacy of Deineka's own spectatorial experiences, once again place the sports spectator at the very centre of the image. By using the same devices as Samokhvalov would in his *At the Stadium* oil painting, Deineka

21 Nikolai Dormidontov, *The Football Match between the USSR and Turkey*, 1935, oil on canvas.

constructed the spectator intrinsically as a participant ostensibly waiting his or her own moment to dive into the fray.

The centrality of the participant-spectator can perhaps best be highlighted by comparing Samokhvalov's and Deineka's representations of sports arenas in the mid-1930s with the work of Nikolai Dormidontov, a less well-known, but contemporary proponent of the *fizkultura* theme. At the *First Exhibition of Leningrad Artists*, alongside Samokhvalov's *At the Stadium*, Dormidontov exhibited two works both set within a sports stadium: *Discus Thrower Comrade Arkhipov of 'Dinamo'* (1934) and *The Football Match between the USSR and Turkey* (1935) (illus. 21).[30] Dormidontov's more literal representations of the sports stadium also emphasize the audience in the packed spectator stands as much as the participants themselves. Yet, here the spectatorship carried no connotations of participation. It might also be noted that the art critics A. Pushchin and S. Korovkevich were highly critical of Dormidontov's literalness, claiming that it resembled little more than a film still.[31] Whilst Dormidontov's representation of spectators watching heroic individuals performing was certainly a more accurate reflection of the social circumstances of Soviet *fizkultura* practices, the mythologized image of the participant-spectator proved

to be far more ideologically useful. Significantly, Dormidontov's career drifted into relative obscurity during the later 1930s, whilst those of Samokhvalov and Deineka reached a pinnacle in 1937. That year both artists were commissioned to contribute major works for inclusion in the Soviet Pavilion at the Paris International Exhibition.

The Soviet Pavilion in Paris, designed by Boris Iofan, is much remembered for its grand, monumental exterior – a marble stepped pyramid crowned with Vera Mukhina's dynamic and thrusting stainless-steel statue of a *Worker and Collective Farm Woman*. The inside of the pavilion, however, was equally dramatic and extravagant in design, with no expense spared in creating a similarly dynamic image of communism marching ever onwards. The interior plan followed a promenade, advancing through spaces dedicated to Soviet Government, Economy, Science, Art, Transport and Industry and culminating in a Hall of Honour decorated with three large painted canvases surrounding a red granite statue of Stalin designed by Sergei Merkurov.[32] This room constituted the final destination, indeed a veritable altarpiece, of the exhibition space. With Stalin occupying a deity-like centrality within the Hall of Honour, the three surrounding works were planned to represent the hopes, achievements and joyousness of the new Soviet life, and *fizkultura* was notably to play its part in all three canvases.

The commission to design the interior of the Soviet Pavilion was won by Nikolai Suetin, a former student of Kazimir Malevich. For the Hall of Honour Suetin proposed that the three works to be executed represent *Honourable People of the Soviet Union*, *Children of the Soviet Union* and *Soviet Fizkultura*, the former occupying the central position whilst the two latter canvases were positioned on the right and left respectively. Three artists were commissioned to take charge of these works. Aleksei Pakhomov, a Leningrad-based artist formerly associated with the Krug group and with an established reputation for depicting children, was offered the right-hand canvas. Samokhvalov and Deineka were selected to execute the other two canvases, although it was by no means clear which artist would be offered the *fizkultura* theme. Deineka, following the success of his one-man shows in both Moscow and Leningrad, was certainly the more highly regarded artist, yet both specialized in representations of *fizkultura*. The problem was resolved by offering Deineka the larger and more prestigious central work, thus allowing Samokhvalov to undertake the *Soviet Fizkultura* subject (illus. 22 and 23).[33]

Deineka's canvas, entitled *Honourable People of the Soviet Union*, formed the principal backdrop to the Hall of Honour and linked the

22 Aleksandr Deineka, *Honourable People of the Soviet Union* (*Sketch for a panel*), 1937, oil on canvas.

23 Aleksandr Samokhvalov (and assistants), *Soviet Fizkultura (Panel Exhibited in the Soviet Pavilion at the Paris International Exhibition)*, 1937, tempera on canvas.

two side canvases. Positioned immediately behind Merkurov's statue of *Stalin*, the canvas represents workers, collective farmers, writers and engineers, all members of the Stakhanovite movement, alongside representatives from the Soviet Republics. It should be noted, however, that these two groups are separated by a central vertical axis formed by the representation in the background of the as yet to be built Palace of the Soviets. Furthermore, the figures from the Republics are some steps behind the prominent Russians, the latter decked out in their finest white holiday clothes. These figures march directly towards the viewer, although a low, wide-angled perspective gives an impression of the marchers on the margins of the image simultaneously moving towards the left and right. In this way, all three canvases are cleverly linked. In the left background a group of anonymous sportspersons march and, notably, lead the viewer towards the *Soviet Fizkultura* canvas, whilst in the right foreground a young woman holds aloft a child whose gaze focuses to the right and towards *Children of the Soviet Union*. Behind and above the whole scene the monumental image of Lenin raises his arm in both salute and command, his presence acting as a reinforcement of the authority of Stalin as expressed in the statue placed directly before the painting.

Samokhvalov's *Soviet Fizkultura* presents a packed composition more reminiscent of his *At the Stadium* sketch of 1931. Once again the setting is that of a sports stadium, yet every one of the three-dozen or more figures included is very much a participant. The centrepiece of the whole composition is a Soviet flag held aloft by a young female athlete balanced upon a huge ball, carried by six male athletes, and bearing the letters CCCP (USSR). Three more female athletes dance around in the foreground carrying bouquets of flowers. In the lower right-hand corner Samokhvalov included a new addition, a young family. Here a mother in a red athletics vest carries a smiling baby, also clad in a Dinamo sports outfit, whilst the father, wearing the popular black and white soccer jersey, carries a ball. Here the inclusion of a small child operates, once again, to link this canvas with that of Pakhomov on the opposite wall. Beside the mother another bouquet-carrying woman sits on the ground whilst a couple dressed in swimming costumes performs a gymnastic exercise immediately behind this group. Two separate grandstands constitute the background to Samokhvalov's canvas: that on the left un-peopled, and reminiscent of the 1935 version of *At the Stadium*, whilst the one on the right is occupied by a mixture of athletes, soccer and tennis players, once again participant-spectators.

The symmetrical arrangement and scale continuities of these three works, and in particular the thematic linkage made between the central

work and the two side canvases, notably reinforces the connections between *fizkultura* and the city. Deineka's citizens are clearly marching through central Moscow, one of the Kremlin towers in the left background augmenting the already noted presence of the Palace of the Soviets. This march takes us to the arenas of *fizkultura*, the stadia situated on the margins of the city. Yet it is the march itself that links all three spaces pictorially and dominates the mood of Samokhvalov's *Soviet Fizkultura*. For whilst this work retains the emphasis on the participant-spectator as seen in his earlier representations of sports stadia, here there is a shift of emphasis towards the festive, or theatrical, dimension of *fizkultura*. The sports stadium has here become the stage setting not for competition or training, but for the sports parade.

At this point it might be worth returning briefly to the summer of 1937 and the near-simultaneous staging of the Basque soccer tour and the Annual Fizkultura Parade. For here the emphasis on the *fizkultura* theme in the Hall of Honour at the Soviet Pavilion in Paris can be read within the context of an attempted conflation of the competitive and theatrical modes of *fizkultura* practice as outlined at the start of this chapter. With this in mind it will now be worth turning our attention to the *fizkultura* parade itself and to the ways in which its very theatrical nature generated its own set of problems.

Orchestrated Spontaneity and the Fizkultura *Parade*

During the 1930s *fizkulturniki* were frequently seen marching through the cities and countryside alongside the various ranks of workers and soldiers. From 1931 onwards, special holidays were even dedicated solely to the celebration of *fizkultura*. On such occasions Moscow's Red Square was transformed into a blaze of colour as tens of thousands of brightly dressed sportsmen and sportswomen marched, carried banners and performed exercises and routines in honour of the Soviet *fizkultura* movement. These festivals evolved from one of the most enduring of all cultural activities developed during the early Soviet period: the public street festivals staged to mark major revolutionary holidays. Here it will be valuable to explore the development and expansion of the *fizkultura* parade itself, and to analyse cultural representations of this relatively new phenomenon. It will also be important to explore a concept that I have called 'orchestrated spontaneity', an ultimately failed attempt by both the state and official artists to suggest the uncertainty and unpredictability so beloved of popular sports such as soccer, whilst maintaining the strict controls that typified the theatricality of parade culture. Ultimately, the grow-

ing theatricalization of sport, as manifested in the *fizkultura* parade, constituted a direct attempt to deflect widespread popular interests in unambiguous sports spectatorship back towards a desire to participate in *fizkultura*.

The Origins and Functions of Soviet Street Festivals

From the October Revolution onwards, mass public spectacles became a common sight throughout the former Russian Empire as the new Soviet state both adopted and adapted the culture of street festivals to promote the new regime. These events offered the new government a crucial means to convey, and to reinforce, its legitimacy. In the pre-revolutionary period, street festivals held on public holidays had constituted an integral aspect of urban popular culture.[34] Although officially state-organized, these events maintained remnants of a 'carnivalesque' atmosphere, in which traditional authorities were inverted, the ruled became the rulers, if only symbolically and solely for one day, and celebration manifested itself as a form of social transgression.[35] In practice this often meant little more than peasants getting drunk and involved in fights. Nonetheless, the concerns of both the state and ecclesiastical authorities alike towards even such minor social transgressions made the pre-revolutionary street festival a prime arena for political opportunism. Throughout the early twentieth century the pre-revolutionary Bolshevik Party saw such events as the ideal arenas in which to promulgate its own political ideology. By late 1917, however, this previous association raised something of a dilemma. Now, with the Bolsheviks having shifted their position from that of marginal opposition to central authority, the very meaning of the street festival needed to be redefined. For whilst public festivals and street demonstrations had been an essential weapon in the armoury of the pre-revolutionary Bolsheviks, the protest and civil disobedience that had essentially characterized these events might now prove more of a threat than an advantage. Thus whilst seeking to retain the celebratory functions of the carnivalesque, the new state now also sought to neutralize any potential for the very transgression that it had earlier promoted. In essence, it aimed to replace the dangers inherent within spontaneous celebration with a carefully orchestrated 'theatricality'.

The first few years of Soviet rule witnessed increasing state intervention in the organization of street festivals. Following the relatively ramshackle and disorganized first celebration on May Day 1918, the state instituted officially sanctioned Festival Committees to oversee

these events. By the time of the Third Anniversary of the October Revolution, celebrated in November 1920, a cast of 10,000 was enlisted and carefully choreographed to perform the famous dramatization of the Storming of the Winter Palace. Throughout the 1920s Soviet street festivals continued to develop a theatrical atmosphere and appearance, though the emphasis was very much on the activities of amateur workers' groups, which produced and paraded humorous floats and models representing huge-scale industrial machinery or caricatures of enemies of the state. With the advent of the First Five-Year Plan, however, both the appearance and the function of the Soviet street festival changed. May Day, as the official workers' holiday, was now closely associated with the industrialization drive, and the parades staged became little more than a paean to the year's achievements. Organization was more tightly controlled and the message conveyed more unified. Position within the parade came to be offered not as right, but as reward, as workers from factories that had exceeded the plan by the greatest amount took their place at the head of parades. The officially promoted values of excessive production and efficiency were now metaphorically reflected through the ever-increasing scale and choreography of parade culture.

It is within this context that the specific *fizkultura* parades performed during the inter-war years need to be examined. The first parade dedicated solely to *fizkultura* took place whilst Soviet power was yet to be consolidated. On 25 May 1919, the first anniversary of the military training organization Vsevobuch, a large group of athletes marched alongside military detachments through Red Square. Both Lenin, as leader, and Trotskii, as head of the Red Army, attended the event. Staged in the midst of the Civil War conflict, this parade was clearly planned to promote the dedication and military willingness of Soviet youth, and specifically male youth, to support the new political cause. The focus on sportsmen marching through Red Square was probably also planned to act as a huge recruitment drive associating the popularity of sport and leisure, in the mind of the spectator, with joining the Red Army. In the period after the Civil War and during the NEP era relatively few major sports parades took place.[36] With the staging of the First Workers' Spartakiad in 1928, however, the spectacle of a large *fizkultura* parade was again reintroduced. On 12 August of that year 30,000 athletes, this time both male and female, marched through Red Square with banners waving and bands playing the Internationale. From Red Square they proceeded northwards to the newly built Dinamo stadium where many of the Games' events would be held.[37]

It was not until 1931 that the authorities officially launched the first Annual Fizkultura Parade. That year, following the introduction by the All-Union Physical Culture Council of the GTO (Ready for Labour and Defence) programme, sport took on a new significance throughout the nation. In July a huge parade of 40,000 young men and women marched through Red Square to honour both *fizkultura* and the GTO organization. From this moment on, the Annual Fizkultura Parade became a regular event to compete with the holidays of May Day and the Anniversary of the Revolution. In 1932 the *fizkultura* parade nearly doubled in size, as 70,000 sportsmen and sportswomen marched through Red Square, many already recipients of the newly inaugurated GTO badge. Not surprisingly, the following year, 1933, saw yet another increase in the number of participants. This time 105,000 *fizkulturniki* marched past the leaders, the latter watching from the top of the Lenin Mausoleum. But it was not just the scale of the event that changed, for this year saw the introduction of a new practice that came to characterize all subsequent *fizkultura* parades: the official staging of a mass gymnastics display. Here 2,000 members of the Moscow Institute of Physical Culture provided the finale to the day's events by performing synchronized exercises set to music.[38] Responding to this innovation, *Izvestiya*, for the first time, gave extensive front-page coverage to the *fizkultura* parade, publishing several photographs, including one of the gymnastics display.[39] Its correspondent, Yevgenii Kriger, appears to have been much taken by this shift in practices. Having dedicated most of his report to listing the various participants amongst the 105,000 marchers (including athletes, boxers, gymnasts, oarsmen, parachutists, tennis players, as well as young pioneers dressed as all of the above), Kriger turned his attention enthusiastically to the finale, perhaps letting slip a sense of relief from earlier boredom:

For two hours and twenty-five minutes the Fizkultura columns march past. Finally the orchestras march off towards GUM. The Conductor of Free Movement silently waves the flags. The Square instantly fills, like a flutter of wings, with gymnasts from the Institute of Fizkultura. This is a symphony of synchronicity, unity and precision. The Square, more accustomed to military marches, is now filled with the light sounds of a waltz. The flags wave. The whole atmosphere shimmers with lightning movements, and the words ring out from the people 'Greetings Comrade Stalin'.[40]

There can be little doubt that the Annual Fizkultura Parade of 1933 constituted a major shift in the public perception of the event. The introduction of these mass theatrical displays served two crucial purposes. First, the deployment of large groups of performers aptly

restated the notion of mass participation. Second, this offered a new, and potentially popular, appeal. If the soccer-loving crowds were to be drawn to the *fizkultura* parade, they certainly needed a spectatorial incentive. Previously characterized by a relatively staid march, theatrical spectacle now became the order of the day, completely dominating any sense of carnivalistic celebration or spontaneity. Year after year huge groups of sportsmen and sportswomen marched through Red Square formed into highly choreographed 'living sculptures' representing aeroplanes and flags, or spelling out words and slogans.[41] Or they acted out their sport in miniature boxing rings and on miniature running tracks, driven through the parade on floats. On other occasions they stood stock still, as *tableaux vivants* representing statues or life-sized imitations of GTO badges. However they performed in Red Square, one thing was for sure: the script was already written and their role practised and perfected. From this moment on, the *fizkultura* parade truly entered into the spirit of the Hollywood musical.

All of this brings us back to 1937 and the Annual Fizkultura Parade performed just four days after Spartak's victory over the visit-

24 Photograph of the 1934 Annual Fizkultura Parade, published in *Izvestiya*, 24 July 1934.

25 Photograph of the soccer match staged in Red Square as part of the Annual Fizkultura Parade of 1937.

ing Basque soccer team. That year another new event was introduced into the proceedings. For the first time, a huge green carpet was rolled out in Red Square, goalposts set up and a soccer match played (illus. 25). The original proposal for this event had come from Nikolai Starostin, star player with the Moscow Spartak team. However, what Starostin had originally planned as a competitive match was soon re-orchestrated into a shortened, pre-scripted demonstration with seven goals planned lest Stalin, not a renowned soccer fan, get bored and shorten the game.[42] The decision to include soccer in the Annual Fizkultura Parade of 1937 was clearly a response to the popularity of the game, a concession to the love of the sport amongst Soviet workers, as witnessed by the huge crowds that attended the fixtures against the visiting Basques. At the same time, however, the state was attempting to appropriate soccer, to take it out of its stadium setting and transplant it into the middle of the politically symbolic arena of Red Square. This project was destined for ultimate failure since turning soccer into a carefully stage-managed theatrical performance was entirely missing the point. It was the very unpredictability, excitement and spontaneity so absent in the *fizkultura* parades that regularly drew huge crowds to the soccer stadia.

The Red Square soccer match of 1937 also raises another important question. For whom precisely were these spectacles performed? Clearly with so many participants, frequently exceeding 100,000 throughout the 1930s, the parades effectively filled the city of Moscow. The participants themselves formed one element of the audience and the event could be witnessed from a multitude of viewpoints. There can be little doubt, however, that Red Square itself constituted the main stage for the event. Whilst this space certainly formed a major public arena capable of facilitating large crowds, it was clearly not designed to offer spectators an ideal viewpoint. Indeed, contemporary photographs and film footage reveal that once the marchers entered Red Square there was relatively little room left for other spectators. The south-west side of the square, adjoining the Kremlin walls, was usually preserved solely for officials, whilst, each year, the Lenin Mausoleum, undoubtedly the best position from which to see and be seen, was occupied by Stalin and his main political allies. Thus the audience was, inevitably, exclusive with admission frequently by special invitation only.[43] In effect, the high point of the whole spectacle was actually witnessed by a limited number of individuals.

Representing the Sports Parade

This circumstance gave a lot of scope, and responsibility, to visual culture. As the *fizkultura* parades grew in both scale and spectacle, they naturally attracted widespread public attention. Here the press, and photojournalism in particular, played a crucial role in the broad dissemination of information. From 1933 onwards both *Pravda* and *Izvestiya* dedicated considerable editorial space for photographs and reports on the parades, with information often spread over several days. For more extensive coverage the public could also turn to the specialist sports journals such as *Krasnyi Sport*. Photographs of the *fizkultura* parades were not, however, confined solely to the sports and general press. They were also published in photographic journals such as *Sovetskoe Foto*, as well as more specialist albums, such as the English-language publication of 1939, *A Pageant of Youth*. In March 1938 the art journal *Tvorchestvo* also dedicated a whole article to coverage of the previous year's *fizkultura* parade, publishing photographs representing some of the 'living sculptures' incorporated in the festival.[44]

Without doubt the best-known photographer working in this field was Aleksandr Rodchenko. Much criticized in the early 1930s for his so-called formalist leanings, Rodchenko spent much of the remainder of the decade working as a photojournalist. In this capacity he under-

took official commissions to photograph major construction projects, such as the building of the White Sea–Baltic canal. During this period his works were published in *Sovetskoe Foto* and the international journal *USSR in Construction*, as well as being exhibited at the *Masters of Soviet Photographic Art* show (1935) and the *First All–Union Exhibition of Soviet Photographic Art* (1937).[45] In 1935 and 1936 Rodchenko was also commissioned to produce a set of photographs representing participants in the *fizkultura* parades in Moscow. His work on this theme interestingly addressed the tensions between participation and spectatorship that characterized Soviet *fizkultura* at this time. For example, in images such as *The Dinamo Column* Rodchenko selected a viewpoint high above the action, enabling him to grasp the overall theatrical effect of the spectacle (illus. 26). Thus distanced from the action the viewer is constructed as a spectator pure and simple, afforded a view usually reserved for the privileged few. Rodchenko, however, was also keen to get down amongst the action. Thus in *The Female Pyramid* and *The Installation 'Long Live the Constitution'*, both from 1936, the viewer in contrast is given a participant's viewpoint situated in close proximity to the performers themselves (illus. 27). Here the sense of the scale of the event is lost but this is substituted with an increased awareness of the efforts of real bodies in physical motion. Here Rodchenko has positioned the viewer as close to the performers as the performers are to each other, yet

26 Aleksandr Rodchenko, *The Dinamo Column*, 1935, photograph.

27 Aleksandr Rodchenko, *The Female Pyramid*, 1936, photograph.

simultaneously maintained his, and our, anonymity as seemingly unobserved. In these photographs the viewer is once again constructed very much as participant-spectator.

During the second half of the 1930s the cine joined the still camera in Red Square. Now the marches, parades and gymnastic displays were filmed for dissemination to a much wider audience. Along with the usual newsreel footage, the year 1938 saw the making of a special documentary entitled *The Song of Youth*. Described as a film 'about *fizkultura* in the USSR and the *fizkultura* parade held in Red Square, Moscow on the 24 July 1938', the film was broadly advertised in *Krasnyi Sport*.[46] When it opened, less than a month after the parade itself, it was shown daily in fifteen Moscow cinemas.[47] A year later, in 1939, it was one of the main features screened in the Soviet Pavilion at the New York World's Fair.

For painters in particular, the official promotion and expansion of *fizkultura* parades during the early 1930s offered a unique opportunity to develop a new subject. Yet, perhaps surprisingly, few artists took up the challenge. Amongst those who did were Sergei Luchishkin, Aleksandr Samokhvalov and Yurii Pimenov. Luchishkin's *Constitution Day*, produced as early as 1932, certainly constitutes one of the earliest works representing the *fizkultura* parade. Three years later Samokhvalov contributed to the development of the theme with his large-scale work *Kirov at the Fizkultura Parade*, whilst in 1939 Pimenov's huge-scale canvas *Fizkultura Parade* was exhibited at the New York World's Fair (illus. 28 and 50). Faced with a new and essentially modern theme, all three artists were at pains to present a positive, yet authentic, vision of the experience of the *fizkultura* parade. Each witnessed the events personally and consulted contemporary documentary photographs. Their works, however, also built upon the tradition of religious parade and festival scenes developed in the work of nineteenth-century Russian painters such as Illarion Pryanishnikov and Ilya Repin. Samokhvalov's *Kirov at the Fizkultura Parade* is perhaps the most interesting of these works. Although completed during the summer of 1935, this major painting was not to attract widespread attention for another two years, when it was shown at the *Exhibition of Leningrad Artists* staged at the Russian Museum. Shortly afterwards, the Leningrad State Purchasing Commission acquired the work for the museum's permanent collection, where it was prominently exhibited. Samokhvalov's *Kirov at the Fizkultura Parade* was also reproduced and discussed in *Iskusstvo*, and even gained exposure in the national daily newspaper *Izvestiya*.[48] More recently the work has attracted attention in the West. In 1995 it was

28 Yurii Pimenov, *Fizkultura Parade*, 1939, oil on canvas.

included in the exhibition *Art and Power: Europe under the Dictators* held at the Hayward Gallery in London.

Approximately 3 by 4 metres in scale, *Kirov at the Fizkultura Parade* was Samokhvalov's first, large-scale work.[49] During the period of its production, the artist was notably involved in negotiations concerning the decoration of a newly planned sports complex to be built in Leningrad. This, it would seem, was the planned destination for the work. The specific inclusion of the Leningrad chief, and recently assassinated, Sergei Kirov overseeing a *fizkultura* parade held in Leningrad's Palace Square, would have been highly appropriate for such a setting. In the end, however, the commission fell through and the sports complex was not completed to its planned schedule.[50]

The painting represents a large group of *fizkulturniki* parading through Leningrad's primary festival arena, Palace Square, on a bright summer's day. Entering from the north-east the parade files past the Winter Palace, the façade just visible in the top left-hand corner of the painting. In the right foreground, sportsmen and sportswomen march in orderly ranks carrying banners proclaiming conventional slogans, including 'Proletarians of All Countries Unite' and 'Long Live the Socialist Revolution'. In the background a group of oarsmen marches

in time, oars held rifle-like on their shoulders. High above in the clear blue sky a squadron of aircraft flies past in formation, echoing the military precision of the marchers below. Finally, in the left fore-ground, we see the primary focus of the whole event. Here the head of the Leningrad Communist Party, Sergei Kirov, waves at the parade from a specially erected platform placed before the main entrance to the Winter Palace.

Samokhvalov's decision to make Kirov the central focus of this work was of huge significance in 1935. Just a few months earlier, on 1 December 1934, a young communist by the name of Leonid Nikolaev had gained access to the third floor of Kirov's headquarters at the Smolnyi Institute in Leningrad and fired a single, fatal shot into Kirov's back. The assassination sent shockwaves throughout the entire nation and sparked off a major security clampdown. The very next day an anti-terrorist decree was issued giving the NKVD (People's Commissariat of Internal Affairs) extended powers of arrest and even execution. Within a few weeks thousands of Soviet citizens were arrested and more than one hundred executed under this new legislation.[51] A campaign of national mourning was launched and, from 1935 onwards, 1 December was marked annually by tributes to Kirov. At Kirov's funeral Stalin acted as principal pallbearer and the whole event was filmed for posterity. In Leningrad, streets, squares and even the famous Mariinskii theatre and ballet troupe were renamed to honour the former city leader, whilst in Moscow the newly opened metro system included a station named Kirovskaya. Kirov's life and achievements now became subject to a major historical reappraisal and were transformed into a legend of epic proportion. A veteran of the Bolshevik uprising, Kirov was described as universally popular, and officially praised for his openness, humanity and kindness.

The elevation of Kirov to the status of martyred hero afforded wide opportunities for many artists. In 1935 an All-Union competi-tion was launched for the commission to produce a major sculptural monument to Kirov. From amongst the 200 projects submitted, Nikolai Tomskii's proposal for a huge-scale bronze statue, 8 metres in height, won through. Versions of this statue were soon to be installed in cities throughout the Soviet Union. The following year, in June 1936, the Academy of Arts in Leningrad staged a special exhibition, *In Commemoration of S. M. Kirov*, in which 41 Leningrad-based artists, including Samokhvalov, each submitted a work produced to honour the former leader.[52] By January 1938 the 'Kirov theme' had estab-lished itself as a major subject for artistic production. At the same time *Iskusstvo* published an article by Izabella Ginzburg highlighting

the importance of this theme for contemporary artists:

A task of enormous difficulty has fallen onto the shoulders of Soviet artists; to set down, to preserve for the future, the fine image of a great Bolshevik . . . We must reconstruct for our contemporaries, and carry forward to our future descendants, his ardent form, we must record the passionate devotion he inspired in millions of people, and their terrible anger towards the enemy. We must create memorials to Kirov which would not only recall his congenial and much beloved character but, once and for all, would speak of the greatness of this Bolshevik leader, of the great events of his life.[53]

Whilst Samokhvalov's work predates this article, the sentiment was clearly already established.

In tracing the early development of works representing Kirov, Ginzburg pinpointed a number of emergent topics. These included *Kirov as Military Leader*, *Kirov in the Caucasus*, *Kirov as Orator*, *Kirov as Pupil and Comrade of Stalin* and *Kirov as Chairman of the Party*.[54] Ginzburg, however, also indicated a broad interest, amongst painters in particular, in representing Kirov at leisure, amongst children and amongst the youth. Samokhvalov's *Kirov at the Fizkultura Parade* fits well into this latter category, explicitly declaring a notional popularity for Kirov, particularly amongst the younger generation. Here the former Leningrad chief is clearly the focus of the whole event. Responding to popular adulation, he raises his hand to wave at the crowd, to all intents and purposes like a Hollywood matinee idol. As the ranks of *fizkulturniki* pass the platform they turn, eyes right, and each of their faces glows with a heavenly light seemingly emanating directly from the leader. In the left foreground this excitement is reaching fever pitch. Here Samokhvalov has represented seven young sportswomen who approach the platform and leap upwards in an attempt to shower the leader with a huge bouquet of roses. Immediately behind this group, and seen just below the bouquet, a young security guard watches this scene cautiously, but without hindrance or disapproval.

Whilst Samokhvalov has here presented Kirov as a heroic figure much beloved by all, he has also employed another device common to representations of the leader. For Kirov's own authority is reinforced by the ghostly presence of another leader whose image adorns a banner carried by the crowd of *fizkulturniki* through Palace Square. When this work was exhibited at the Hayward Gallery in 1995, the image of Lenin overseeing Kirov's public appearance seemed directly to link this work with other contemporary representations, not of Kirov, but specifically of Stalin. For example, in Grigorii Shegal's *Leader, Teacher, Friend*, a small version of which was also

exhibited at the Hayward Gallery, the authority of Stalin, here represented on a relatively human scale, is reinforced by the inclusion in the background of a colossal statue of Lenin. As Matthew Cullerne Bown has pointed out, the inclusion of Lenin served to identify Stalin as an intellectual and spiritual heir of the deceased leader, having inherited not only his political authority but also his notional virtues of wisdom and modesty, becoming the ostensible father of the Soviet state.[55] This comparison, however, raises an interesting question. For whilst Kirov was certainly highly praised, such a link between his authority and that of Lenin would appear to put him on a par with Stalin, an association unlikely to be approved by the current leader, despite Kirov's status as now deceased. A closer look at the surface of the painting, however, along with an examination of contemporary photographs of Samokhvalov's work, elicits an alternative interpretation. For the image of Lenin currently adorning the banner carried in the crowd is, in fact, a later addition covering an original representation of none other than Stalin himself, dressed in a military cap and looking outwards over Palace Square (illus. 29).[56] Thus, far from equating Kirov's authority with that of Stalin, Samokhvalov's original composition suggested, on the contrary, that the position of the former was very much dependent upon the latter. The mantle of

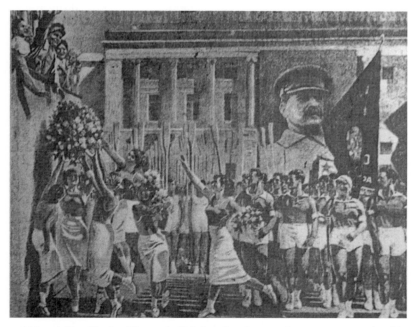

29 Aleksandr Samokhvalov, *Kirov at the Fizkultura Parade*, 1935, oil on canvas, as reproduced in *Izvestiya*, 30 December 1937.

93

ultimate authority, in other images ascribed to Lenin, was here handed down to Stalin, who now occupied the realm of the mythical father over the deceased son.

Samokhvalov's *Kirov at the Fizkultura Parade* also offers an interesting insight into the tensions between both participation and spectatorship, and orchestration and spontaneity within the sports parade. In line with the conventions of *fizkultura* parades, the multitudes are all very much presented as participants. The only audience for this event is, in fact, the small group gathered around Kirov on the platform. Even the viewer of the work is positioned, as in many of Rodchenko's photographs, at ground level and amongst the *fizkulturniki*. In another sense, however, the participants themselves are simultaneously spectators, their focus not on the parade, but on Kirov and his colleagues. Here it is difficult to define precisely who is performing and for whom.

Theatricality, so essential an ingredient in *fizkultura* parades during the 1930s, is also clearly evident within Samokhvalov's *Kirov at the Fizkultura Parade*. Its huge scale, cast of thousands and dramatic setting all contribute to a grand public spectacle. Yet it is notable that Samokhvalov was keen to incorporate a sense of spontaneity within the image. Here it is worth briefly returning to the small group of sportswomen represented in the left foreground. Since each of these young women is dressed differently to the rest of the marchers and each carries a bouquet of flowers, it is probably fair to assume that their actions in approaching the leader have, to a certain extent, been pre-planned. Youthful, attractive women have here been selected to lay flowers, as tribute, at the foot of the platform before the leader. Such an action additionally conveys a notional reputation for Kirov as himself physically attractive, even a youth idol. Whilst their offer of tribute may indeed have been a part of a pre-orchestrated programme, Samokhvalov has gone to some lengths to suggest that their specific actions are simultaneously motivated by uncontrollable spontaneity. Clearly these women cannot have planned to place their bouquets in Kirov's own hand, because the platform is considerably out of reach. It is also notable that the group has not moved forward in a unified manner. Each figure stretches and leaps upwards independently, and one of the women, seen towards the centre of the image, appears, momentarily, to have been left behind. Crushed flowers, presumably dropped or knocked from the bouquet in the excitement of the moment, lie beneath the feet of this group about to be trampled in the stampede. One of Kirov's colleagues, seen leaning from the tribune, even attempts to restrain the young women's enthusiasm, reaching his hand down in a calming gesture. Kirov, however, also acting

spontaneously, breaks ranks and leans forward to receive their gift.

Whilst focusing essentially on the theatricalization of *fizkultura*, Samokhvalov's *Kirov at the Fizkultura Parade* simultaneously introduced the sense of carnivalistic spontaneity so frequently lacking in the actual parades themselves. Like the pre-scripted soccer match staged in Red Square the same year as this painting was first exhibited, however, the result essentially ends up as self-contradiction, an oxymoron of 'orchestrated spontaneity'. Ultimately, Samokhvalov's *Kirov at the Fizkultura Parade* addressed a wide range of issues within a monumental representation of *fizkultura*. First the work engaged with current trends in the representation of the leader. Simultaneously including famous political figures such as Kirov and Stalin, and the anonymous *fizkulturnik* and *fizkulturnitsa*, Samokhvalov's work strove, by association, to reinforce the authority and popularity of both. Second, Samokhvalov here tacitly acknowledged the complexities and contradictions inherent within *fizkultura* practices during the mid-1930s. For artists and *fizkulturniki* alike, the coexistence under the general rubric of *fizkultura* of both spontaneous and pre-orchestrated practices was a part of everyday life. No doubt supporters generally favoured one practice over another, and by all accounts watching soccer appears to have been the most favoured activity, yet both were defined as central to the *fizkultura* programme. In *Kirov at the Fizkultura Parade*, Samokhvalov has attempted, successfully or otherwise, to fuse all these diverse elements, participation and spectatorship, orchestration and spontaneity, in his celebration of the *fizkultura* movement.

Samokhvalov's *Kirov at the Fizkultura Parade* essentially offered a positive vision of the *fizkultura* parade. Its predominant focus upon the mass participation and performances of young, beautiful, fit and healthy citizens projects a joyous, festival mood of fun and excitement and explicitly claims that contemporary life in the Soviet Union has a distinctly utopian edge. Nonetheless, as in the various cultural engagements with the sports arena outlined earlier, the very declamatory nature of these works perhaps makes them ring hollow and draws attention to the underlying tensions that characterized contemporary debates concerning *fizkultura*. Here visual culture played a vital role in the formulation of an officially approved notion of both the practice and the consumption of Soviet sport. Since *fizkultura* was deemed such a highly valuable cultural practice it needed to attract mass popular support. Heroic representations of the sports arena and the sports parade were certainly deployed to contribute towards gaining that support. The existing tensions between participation and spectatorship,

however, were simply negated by the conflation of the participant and spectator. Furthermore, the mood of excitement and spontaneity that attracted huge crowds to the soccer stadia to watch competitive sports was displaced from that arena onto the *fizkultura* parade. Attempting to present both sides of a complex equation was no mean feat, yet it was one that many cultural producers confronted on a regular basis.

4 Going Underground

For the Soviet authorities, universal participation in *fizkultura* was always a primary objective and all citizens were expected to play their part in the national programme, whether they lived in the largest cities or in the smallest and most remote villages. In reality, however, *fizkultura* was predominantly an urban phenomenon. Major sporting competitions, such as the Spartakiads, were largely confined to the cities and, whilst sports parades were organized throughout the countryside on official *fizkultura* days, the march through Moscow's Red Square was always seen as the principal national focus. Yet despite extensive propaganda campaigns, several factors inhibited the spread of *fizkultura* to the countryside. For example, provision of sports facilities was frequently poor, or even non-existent, outside the major urban centres. Added to this, the refusal by many rural inhabitants to reject traditional customs and adopt modern, approved activities inevitably hampered the ideological objectives of the Soviet state. A further obstacle was the still fundamentally Muslim outlook in many of the southern republics, a factor often resulting in the rejection of sport altogether, and especially as a practice for women.

By the early 1930s, and with the implementation of the First Five-Year Plan, the utopian and essentially anti-urbanist theories that had played a significant role in the early post-revolutionary period had effectively given way to an increasing autonomy of the city as the symbolic heart of the new regime. Stalin, himself, had played a leading role here, not least of all in his speech of 1929 at the conference of Marxian Agrarians:

The question of the relations between town and village (owing to the present rate of development of the collective farm movement) is assuming a new footing, and the effacement of the contrast between the town and the village will be accelerated. This circumstance, comrades, is of the utmost importance for our construction. It will transform the psychology of the peasant and will turn him towards the town . . . It will make it possible to supplement the slogan of the Party 'face to the village' by the slogan for the collective

farm peasant 'face to the town'. And there is nothing surprising in that, for the peasant is now receiving from the town machines, tractors, agronomists, organizers, and finally, direct aid in the fight to overcome the kulak. The peasant of the old type, with his barbaric mistrust of the city . . . is passing into the background. His place is being taken by the new peasant of the collective farm, who looks toward the city with the hope of obtaining from it real and productive aid.[1]

Stalin's notional 'new peasant', however, was not only looking towards the city. In many instances, he or she was actively leaving the countryside to find work in the expanding urban centres. Indeed, the period between 1926 and 1939 saw 23 million peasants moving from the country to the city, a population migration previously unprecedented anywhere in the world.[2] Nowhere was this shift more evident than in the city of Moscow. At the Plenum of June 1931 of the Central Committee of the Communist Party, the newly appointed Moscow leader Lazar Kaganovich launched a major programme for the Reconstruction of Moscow. For Kaganovich, however, this project was always as much sociological as it was architectural. Thus, the transformation of the capital was to provide 'a laboratory to which people from all over the Union will flock to study its experience'.[3] The Reconstruction of Moscow was thus presented as a metonymic symbol for the transformation of the entire nation.

Significantly, the urban practice of *fizkultura* was to play a major role within the Reconstruction of Moscow programme. The building of numerous sports centres and stadia constituted an integral feature of the plan whilst the green areas on the periphery of the city were transformed from leafy suburbs into formalized parks of culture and rest, replete with sports facilities. In one sense, the demographic reformulation of the Moscow population had much significance for this expansion. During the 1930s two million peasants left the countryside for the bright lights of Moscow. Not surprisingly, this migration was strongest amongst the younger generation, many of whom left to seek work in the new factories built as part of the First Five-Year Plan. As the reconstruction programme itself got under way, this youthful migration was further accelerated, so that by mid-1933 just under a million of a total population of less than four million were aged between 20 and 30 years of age.[4] Whilst new living conditions and labour regimes were perceived to contribute significantly to the cultural transformation of this age cohort, the promotion of *fizkultura* as an appropriately healthy, communally spirited and publicly practised leisure activity clearly served a major role. Representations of idealized youthful sportsmen and sportswomen proliferated throughout the

city, appearing in city squares, parks and stadia. *Fizkultura*, however, was perhaps to play its most important role in one of the major projects within the Reconstruction of Moscow plan: the planning, building and decorating of a new metro system. This chapter will focus on the Moscow metro as one of the major sociological and cultural enterprises of the 1930s. In particular it will investigate the ways in which visual culture, deployed within the context of the metro project, frequently conflated the civic duty of labour with the leisurely practice of sport.

The appalling abuse of prison labour during the industrialization period of the inter-war years has been well documented. In particular, grand-scale projects such as the Moscow–Volga canal were heavily dependent upon what can only be described as slave labour, the great achievements of the Soviet state all too frequently being built upon a foundation of the bones of millions of ill-treated and unnamed workers. This coercive labour, however, was mostly exploited in the northern and Siberian timber camps in the Urals and Kuzbass, sites hundreds of kilometres from the capital and where the brutality and inhumanity of prison labour could largely be hidden from public scrutiny. Marching groups of starving prisoners up and down the Tverskaya Ulitsa or through Red Square was obviously a less than favourable option for the Soviet authorities. Accordingly, despite the huge labour demands of the Moscow metro project, relatively little prison labour was exploited here, the state depending instead upon a mixture of paid and voluntary workers.[5] With this need for volunteers, labour was often conflated with *fizkultura* to suggest that participation in these great projects was heroic and generated health, fitness, fun and social fulfilment. The building of the Moscow metro thus provides a particularly useful case study for this conflation of *fizkultura* and labour.

The Moscow metro is acknowledged as one of the finest achievements of the 1930s Reconstruction of Moscow project. Indeed, the recent programme of renovations introduced by the Moscow mayor, Yurii Luzhkov, attests to its continuing significance as a cultural landmark in the post-Soviet era. Between 1932 and 1938 two sections of the metro system were completed in record time, comprising more than twenty stations, and as many kilometres of track. Whilst each of these stations was given individual and elaborate attention, four were earmarked for special treatment: Ploshchad Revolyutsii, Mayakovskaya, Dinamo and Ploshchad Sverdlova. These stations were given extensive coverage in both the popular and specialist press.[6] Significantly, the decorative schemes devised for each station emphasized the centrality of Soviet youth to the new regime. As the new Soviet state itself approached and passed its twentieth anniversary,

the metaphor of the state as coming of age was, perhaps, inevitable. But it was not just Soviet youth per se that was celebrated. More specifically, the decorative schemes deployed in these stations made explicit claims about the transformation of Soviet youth under the new regime. Indeed, the physically fit, yet elegant bodies represented within the metro system can be interpreted as both the agents and the product of the transformation of the new Socialist state. Their willing participation in contemporary *fizkultura* programmes was an integral aspect of their representation.

The History of the Moscow Metro

As early as 1902 the American banking firm of Werner and Co. had approached the Tsarist authorities with the idea of building a metro in Moscow.[7] Their proposal, however, was rejected, probably due to the difficult geological nature of the Moscow subsoil as well as the subsequent expense of the project.[8] In 1925 a second foreign firm, Siemens-Bau-Union, put forward another plan to build a metro, but this also was rejected. It was not until the June Plenum of 1931, launching the Reconstruction of Moscow programme, that the idea of building a metro system was again seriously discussed. At this time Kaganovich identified transportation as one of the crucial needs of the city. His proposal to start construction of a metro system as soon as possible gained resounding support from the Central Committee of the Communist Party and, despite the involvement of a considerable number of foreign experts, the project was launched as a Soviet enterprise. In September 1931 the state established an official Building Trust, Metrostroi, and by the following January plans had been drawn up and preliminary shafts were already being dug in the city.[9] With the project under way progress accelerated in line with the gradual increase of the workforce. During 1934, 85 per cent of the excavation and 90 per cent of the concrete-laying work was carried out, and by 1935 a total of 70,000 workers had directly contributed to the completion of the first two lines of the metro system.[10] On 4 February 1935, at precisely 8.15 p.m., the first experimental train set off from Sokolniki station to run along the entire stretch as far as Krymskaya Ploshchad.[11] Three months later, on 14 May 1935, both Stalin and Kaganovich joined 2,000 shock workers in attending a celebration in the prestigious Hall of Columns at the House of the Trade Unions to mark the opening of the Moscow metro. Throughout the spring and summer of 1935 metro fever gripped the capital. Posters promoting the metro were disseminated throughout the city; official hymns in praise of the

metro were written and published in the press; and, for days after its inauguration, Muscovites walking through the city were likely to encounter large-scale marches in honour of the metro.[12] Kaganovich was even reported to have been mobbed by a grateful public when he rode on the metro a few days after its opening.[13] With the metro less than one month into operation, shafts were already being dug for stage two, and plans were officially released in October 1935. Progress on stage two was as rapid as on the original section, assisted now by the newly emergent Stakhanovite labour movement, so that by the early autumn of 1938 two more lines had been opened.

The building of the Moscow metro was a huge-scale construction project that demanded vast labour resources. The project thus expressed the aspirations of the Soviet leadership towards competing with the major industrial and engineering advancements of the West. Despite its obvious geographical specificity, the Moscow metro was ostensibly planned as a project for the entire Soviet Union. The work-force had been drawn from many different regions, including miners from the Ukrainian and Siberian coalfields and construction workers from the iron and steel mills of Magnitogorsk, the Dniepr hydroelectric power station and the Turkestan-Siberian Railway. Further, materials used in the construction of the metro included iron from Siberian Kuznetsk, timber from northern Russia, cement from the Volga region and the northern Caucasus, bitumen from Baku, and marble and granite from quarries in Karelia, the Crimea, the Caucasus, the Urals and the Soviet Far East.[14] In 1937 E. D. Simon, a British visitor to the Soviet Union, summed up the All-Union aims of the Soviet authorities by documenting the response of one Georgian peasant to the far-flung Moscow metro: 'I was told by an English-woman that a peasant in Tiflis [Tblisi] had asked her whether she had seen "our" metro? She said that she thought the only metro was in Moscow. "Yes" said the peasant, "our Moscow metro".'[15]

Planning the Moscow Metro

The original plan for the Moscow metro had ostensibly been drawn up with the aim of relieving the transportation problems of a significant number of urban workers. At the Plenum of June 1931 of the Central Committee of the Communist Party Kaganovich highlighted the waste of time and energy expended by many workers in commuting:

At present workers living in the Dongaverovsky suburb and in other outly-ing sections of the city are obliged to waste a considerable amount of time in travelling to the centre or to districts in opposite parts of the city. They

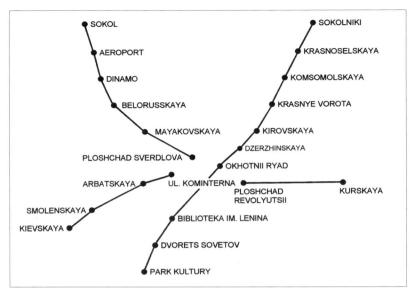

30 Map of the Moscow Metro in 1938.

spend as much as one and a half to two hours daily travelling. The building of new factories in the Proletarian, the Stalin and other districts, and the settling of large numbers of new inhabitants in these districts make it essential that we take immediate measures to provide them with adequate means of transport.[16]

With this in mind the two sections of the metro built in the 1930s were specifically planned to link with the main-line railway stations leading out of the city (illus. 30). Stage one connected the centre of Moscow with the Kazan and Yaroslavl stations leading to the east and north respectively, whilst stage two connected with the Kiev station heading south-west, and the Belorus station heading both north and west. In reality, however, these connections did little to relieve the problems of transportation for the vast majority of Moscow workers. The greatest industrial expansion of the city was concentrated in the east and south-east of the city, in the Proletarian and Stalin regions specifically highlighted by Kaganovich. Here, the populations increased by almost 50 per cent between 1933 and 1936, yet no significant transportation link connected these districts to the centre of Moscow.[17] The metro system was, in actuality, confined to the centre of the city, where the population had effectively remained static. Therefore it is important to consider which areas of the city the first two sections specifically served.

The first line of the metro, opened in May 1935, effectively cut a diagonal line through the centre of Moscow, terminating in the

south-west at Krymskaya Ploshchad, near the entrance to Gorkii Park of Culture and Rest, and in the north-east at Sokolniki Park of Culture and Rest. A branch line ran eastwards towards the Moskva River. The second section of the metro also ran from the central area of Ploshchad Sverdlova, this time heading north-west and passing by the Dinamo sports stadium and the smaller Tomskii stadium, before continuing on towards the airport. Another line running eastwards was planned to link the city to Izmailovskii Park, terminating at the site of the proposed, but never realized, Stalin stadium.[18] Thus, far from enabling distant workers to gain access to the city of Moscow, the metro lines built during the 1930s operated far more as a link between the centre of the city and its leisure facilities, most notably the newly built sports stadia and parks of culture and rest that formed an integral part of the Reconstruction of Moscow project: in other words, the primary arenas of *fizkultura*.

Building the Moscow Metro

In addition to being planned to serve these specific arenas, the Moscow metro also promoted *fizkultura* as a central aspect of its building programme. The physically demanding nature of digging tunnels and removing huge quantities of underground earth meant that most of the workforce consisted of young adults, many of whom were peasant migrants travelling to the city to find employment. In March 1932 the Komsomol (Communist Youth League) was called upon to supplement this workforce by supplying volunteers for the project. Originally 610 volunteers joined, although all but 30 were considered insufficiently qualified to work underground.[19] By July, however, Kaganovich had visited the various sites and was informed unanimously of the value of this youth labour.[20] From this point onwards, Komsomol involvement increased dramatically so that eventually 10,000 young workers, both male and female, were called upon to contribute their labour to the first section of the metro project. Moreover, participation in the building process was publicly presented as an educative experience with stories published in the national and international press giving examples of the socialist transformation of specific individuals. To take one such example, a story published in the *Moscow Daily News* told of a worker who arrived on the metro building site as an uneducated ruffian. At night he would return to his barracks and sleep in his muddy boots, unconcerned about the mess it made of his bed. Gradually he began to recognize the kind efforts and tolerance of the other workers, removed his boots at night, and eventu-

ally even started to use the bathhouse. The story concludes with the worker marrying and bringing his parents to live in Moscow. He had been transformed, the story claimed, into 'a Muscovite, a Metrostroi shock worker, an enthusiast in his difficult and noble work'.[21]

Much emphasis was also placed upon the cultural facilities available to metro workers. Metrostroi managed thirteen social clubs, and maintained its own symphony orchestra, Slavic string ensemble and Russian and Tartar choirs.[22] Fifty thousand theatre tickets were reserved solely for distribution to metro workers and famous singers from the Bolshoi were even reported as giving special performances in the tunnels 40 metres below Sverdlov Square.[23] Sport was inevitably identified as a major contribution to this cultural programme. In fact, the metro workers had their very own sports society, Strelsa (Arrow), complete with its own stadium and tennis courts. In the summer of 1933 more than 400 metro workers participated in the Annual Fizkultura Parade in Moscow. The following year this had extended to include more than 2,500 sportspersons marching under the Metrostroi banner.[24]

Decorating the Moscow Metro

The first section of the metro, opened in May 1935, was praised both for its architectural designs and its interior decoration. Diverse styles were employed for the station pavilions, ranging from the classical temple style of Arbatskaya Ploshchad to the modernist concentric arches of Krasnye Vorota. Below ground level vast quantities of grey granite and red marble lined the walls and pillars of the station platforms. Most effort and expense, however, was lavished on one particular station, Komsomolskaya, which was named in honour of the Communist Youth League and built as a tribute to the voluntary labour of Soviet youth. To celebrate this status it incorporated one of the largest and most impressive interiors, including a mural representing youthful metro workers. The artist commissioned, Yevgenii Lansere, originally designed eight separate panels, each illustrating various aspects of the life of the Komsomol. These, notably, included the *Komsomol at the Kolkhoz*, the *Komsomol in Defence of the Socialist Motherland* and the *Komsomol and Sport*.[25] In the end, however, this proposal proved too ambitious and Lansere settled on a simpler design, consisting of two panels installed on a semicircular concave wall and framing an entrance to a connecting passenger tunnel. Whilst this work focuses predominantly upon labour practices, Lansere did notably dress one female worker in a sports jersey, thus making at least an

oblique reference to *fizkultura*. At other stations on the first section of the metro the references to *fizkultura* were much more direct. For example, at Sokolniki station the sculptor Pyotr Mitkovitser produced a pair of statues representing sportspersons, a *Male Discus Thrower* and a *Female Figure with a Ball*.[26] Mitkovitser's *Discus Thrower*, in line with numerous sculptural representations of this subject produced at the time, made an obvious reference to Myron's classical precedent, the *Discobolus*, adopting the same preparatory twisting pose.[27] To ensure that his figure be specifically identified as a contemporary Soviet *fizkulturnik*, however, Mitkovitser added a touch of modernity, not to mention modesty, by dressing it in an athletics costume of vest, shorts and shoes.

Further down the line, towards the centre of the city, representations of *fizkultura* made further appearances. At Ploshchad Dzerzhinskovo, for example, a series of eight bas-relief panels were included above the main entrance to the station. Evidently planned to suggest an ideologically approved cross-section of Soviet youth, the series included a labourer, an agricultural worker, a dancer and a male tennis player. Once again, *Pravda* proudly included a photograph of four of these workers, including the tennis player, to illustrate a progress report on the completion of the metro project.[28] Even at the very heart of the city sculptural representations of *fizkultura* dominated the station exteriors. The façade of the huge, four-storey building at Okhotnyi Ryad station, which stands between the Bolshoi Theatre and the House of Unions, was built with six niches, each designed to hold an over-life-sized statue. Here, a *Discus Thrower* and a *Figure with a Ball* were chosen to decorate these niches. Like Mitkovitser's Sokolniki statues, these works simultaneously suggested the grand classical past and the contemporary Soviet state, both sportsmen once again clad in modern shorts.[29] All in all, the theme of *fizkultura* played a significant role in the decoration of the first stage of the Moscow metro. Yet most of these works were essentially free-standing, individual pieces placed within the metro setting, rather than integral features of the stations themselves.

The cement had scarcely dried in the new metro stations when construction began on the second stage of the project. Building on the successes of the earlier stations, new and grander plans were laid, resulting in some of the most spectacular designs for a metro system ever built. In the spring of 1938, several months before stations on this section of the metro were due to open, *Iskusstvo* published the first of two articles by I. Sosfenov entitled 'The Problem of Synthesis on the Metro'.[30] Not surprisingly, Sosfenov opened his article with a

paean to achievements thus far: 'The architecture of the first section of the Moscow metro is rightly considered one of the remarkable achievements in the artistic life of the nation during the last decade.'[31] Sosfenov also highlighted an area where he considered there was room for improvement. In particular, he claimed that there was a danger of simple ornamentation, the works not sufficiently contributing to an overall unity of conception or meaning.[32] In his view, both architecture and art needed to combine to produce a consistent and unified whole. This, Sosfenov claimed, was what made the monumental statues of ancient Egypt, the acropolis of ancient Greece and Michelangelo's Sistine Chapel so successful. Sosfenov believed that such a synthesis had been achieved in the Soviet Pavilion at the International Exhibition of 1937 in Paris. He was less convinced by the schemes for the first section of the metro. In the process of designing many of the stations for the second section, however, a new and more integrated approach was undertaken. In his two articles, Sosfenov proposed that the best new stations were those that had successfully addressed this problem, namely the four stations highlighted earlier: Ploshchad Revolyutsii, Mayakovskaya, Dinamo and Ploshchad Sverdlova. Here it will be worth looking in greater detail at each of these stations and exploring the underlying message that might be construed as offering an ideological unity first to each station, and second to the metro project as a whole.

Ploshchad Revolyutsii

One of the most important of these stations was Ploshchad Revolyutsii (Revolution Square). Situated just north of Red Square and adjacent to the Lenin Museum, the Historical Museum and the newly built Hotel Moskva, Ploshchad Revolyutsii stood at the geographical heart of the city. Furthermore, in being named in honour of the Revolution itself, the station took on the mantle of being symbolically representative of the principal event in Soviet history. Accordingly, it was highlighted for special attention. Designed by the architect Aleksei Dushkin, the interior of Ploshchad Revolyutsii contrasted with most other stations built for the first section of the metro, where huge underground vestibules, with both platforms and the central access area in one continuous space, were a common feature. Since the site for the station was particularly deep and directly below the old city walls, geological and technological factors restricted the repetition of these huge spaces. Dushkin therefore designed the interior of Ploshchad Revolyutsii as three interconnected tunnels, two for the

platforms and one as a central space. To reduce the resulting longitudinal impact of this space, he accentuated a number of transverse bays across the width of the main axis. Simultaneously these bays were arched, thus giving the impression of tunnels crossing tunnels and making a specific feature of a necessity. In contrast to the openness and light of the earlier stations, Dushkin further emphasized the tunnel effect by using dark colours, deep red and grey marble, in the decorative scheme. He also incorporated a large number of bronze statues as an integral aspect of the interior space. As Dushkin's early sketches reveal, these statues were to stand in the arched bays, which thus served as decorative niches, each bay containing a pair of over-life-sized bronze statues.[33] Since each platform had ten bays, replicated on either side of the central access area, a total of 80 sculptures was required to fill the space, a colossal commission by any standards. The artist chosen for this project was Matvei Manizer, professor of sculpture at the Leningrad Academy of Arts. Assisted by several of his students, Manizer produced 20 individual sculptures, divided into ten pairs, which were then reproduced four times over to fill the 80 spaces originally planned.[34]

Manizer's sculptures at Ploshchad Revolyutsii are relatively well known and make frequent appearance in major surveys of official Soviet culture. Usually, however, they are examined as individual pieces and not as a whole ensemble, and are thus divorced from their specific setting and relationship not only to the particular metro station but also to the entire metro project. By not considering the series as a whole, one of the decorative scheme's main messages can be overlooked: namely, the construction, or reconstruction, of a historical narrative that makes crucial distinctions between the pre-revolutionary past, the revolutionary era and the present day.[35] Manizer's series charts an evolution from the early days of the Revolution through the Civil War, reconstruction and the mass industrial and agricultural projects of the Five-Year Plan period, and culminates in a representation of the bright future for the communist state. It achieves this by reference to a number of stock characters: labourers and old soldiers for the revolutionary era; students, sportsmen and sportswomen and young parents for the present generation; babies and schoolchildren for the future population of the state. Yet, within Manizer's scheme a physical transformation also takes place. The figures representative of the revolutionary era are notably presented with grizzled and care-worn physiognomies, signifying the harshness and injustice they suffered at the hands of their Tsarist oppressors. As the narrative progresses, a new breed of citizen begins to appear, smoother in physiognomic

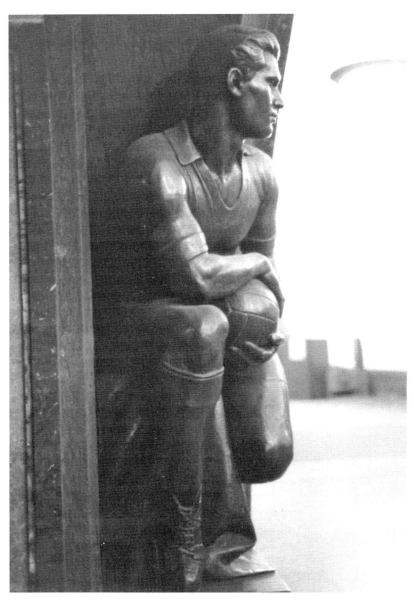

31 Matvei Manizer, Figure at Ploshchad Revolyutsii metro station, 1938, bronze.

features and with more elegant, classically proportioned physiques. It is as if a new physical type is emerging in response to new social and historical conditions. Notably, four of these latter figures emphasize sport and *fizkultura*, suggesting that the leisure afforded by the changed social circumstances, when combined with the civic duty of practising *fizkultura*, is a major factor in this historical development (illus. 31). By the end of the series, the next generation is represented planning the future expansion of the socialist state across the globe.

When examined as individual works, Manizer's bronze figures are often regarded as crassly defined examples of idealized Soviet types. Certainly these works make problematic claims, implying that social conditions in the Soviet Union have unquestionably improved and, in line with Stalin's famous dictum, that life had indeed become more joyous. Thus such crucial policy areas as agriculture, industry, defence and education were all given prominent billing. Considered as a series, and specifically within the contextual setting of Ploshchad Revolyutsii metro station, the works carry more complex, though equally problematic, associations. In decorating an interior that intrinsically drew its symbolic significance as a monument to the moment of the Revolution itself, the very notion of history, and a specifically Soviet history, informed every step in the development of this series. Manizer, following the dictates of Socialist Realism, deployed an unfolding narrative both to represent that history and to project it forward to an imagined, and even more glorious, future. Whether intending the form of representation to be metaphorical or actual, the underlying claim of Manizer's series is that the very physical make-up of the new Soviet generation had in fact evolved into a new and idealized form. In this context, the older revolutionaries, the generation of Lenin, look outmoded, displaced by a new generation more reminiscent of Hollywood matinée idols.

The fact that these works were positioned in a metro station 40 metres below ground level adds a further dimension to this analysis. In the deep and darkened tunnels of Ploshchad Revolyutsii station, Manizer's figures appear as if excavated from the earth itself, like one huge and neatly defined evolutionary rock record. At a time when Darwin's theories fascinated Soviet scientists and historians alike, Manizer's allusion to archaeological excavation could easily lend a quasi-scientific authority to what remains essentially an ideologically constructed notion of historical development.

Mayakovskaya

Whilst Ploshchad Revolyutsii carried an important historical message bridging the gap from the pre-revolutionary era, through the present day and into the bright future of the Soviet Union, Mayakovskaya station emphasized much more the here and now. At the time of its opening, Mayakovskaya station was generally accredited as being the most spectacular of all the new stations. Sosfenov, unabashed in his praise, declared in *Iskusstvo*:

Mayakovskaya station thus stands as the most outstanding example of architectural achievements on the Gorkii branch of the Moscow metropolitan. The boldness of its design, rich in content, its skillful, harmonious execution and meaningful conception merit enormous praise. Thanks to its creation, the second section of the Moscow metropolitan emerges as a new and wonderful stage in the history of Soviet architecture, in the history of the entire artistic culture of the Soviet Union.[36]

Mayakovskaya station, like Ploshchad Revolyutsii, served an important geographical point in the city. Situated half way up Gorkii Street, Ploshchad Mayakovskaya crossed the Sadovaya Ulitsa, the inner of Moscow's two main ring roads, and thus formed an important transportation junction within the new reconstruction plans. Moreover, this area had gained a considerable reputation as Moscow's second theatre district and was now home to four important venues, including the recently rebuilt Meyerkhold Theatre. Theatricality certainly played a crucial role in the overall design for Mayakovskaya metro station, which created one of the most dramatic baroque illusions of any of the new stations.

In contrast to his design for Ploshchad Revolyutsii, Dushkin here attempted to counter any potential feeling of claustrophobia, any sense of being in a tunnel below ground level. Unhindered by geological restrictions, he was able to build a huge open internal space, yet still subdivided the two flanking platforms from a wider and higher central vestibule. Along the longitudinal axis Dushkin placed a number of regularly spaced columns, thus creating separate bays, each of which he crowned with a miniature cupola (illus. 32). The overall impression on entering the station is one of procession, the richly decorated columns, lined with traditional red marble and modern stainless steel, marking off separate stages of an architectural promenade. The origins of Dushkin's design, for Sosfenov, lay in the Gothic cathedral, though the design's more rounded arches suggest the Romanesque.[37] Whilst Dushkin could easily suggest the sense of a cathedral space through the use of floor plan, columns and cupolas, the biggest challenge was

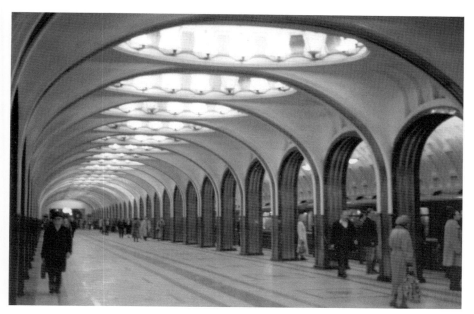

32 Mayakovskaya metro station.

how to give the impression of light and airiness in what remained essentially a windowless tunnel. This was where the artist and designer Aleksandr Deineka came in. Above each of the 35 central bays, Dushkin allowed for the inclusion of an elliptical decorative panel.[38] Produced in bright-coloured mosaic and illuminated by specially designed lights, these panels were thus planned to glow and give the impression of light flooding in from above.

During the winter of 1938 Deineka published two articles, one in *Iskusstvo*, the other in *Tvorchestvo*, expressing his views on the Mayakovskaya metro commission.[39] Evidently he was less than thrilled with some of the restrictions that the project placed upon him. To start with, Deineka received the commission very late in the day, in the winter of 1937, thus giving him just five months to complete the designs for the 35 panels required. Further, Deineka recognized that the particular positioning of these panels, directly above the viewers' heads, would cause enormous design problems. In particular, he bemoaned the extreme foreshortening demanded by this viewpoint.[40] Nonetheless, Deineka's approach to the commission made a major contribution to the overall impact of Mayakovskaya station. Like Manizer's project at Ploshchad Revolyutsii, Deineka undertook to produce a series representing an all-encompassing, positive vision of life in the Soviet Union. Unlike Manizer, however, Deineka avoided a

chronological history, taking as his subject one day in the life of the nation. Since the ceiling panels were to be installed high up, requiring a low viewpoint, Deineka framed each of his panels against a background of open sky, thus contributing to the viewers' sense of light coming in naturally from above. At each end of the central vestibule the scenes represent morning. As the series moves towards the centre, the time of day progresses. Thus in the seventh panel the hands of the clock on the Spasskii Tower of the Kremlin read midday. As the series progresses further, afternoon gradually turns to evening, the sky darkens and finally, at the centre of the whole cycle, the night sky once again frames the Spasskii Tower, the clock this time reading midnight. Deineka's reference to naturally changing light works here on many different levels. First, it suggests a high degree of activity throughout the Soviet Union, action taking place both day and night. Second, by simultaneously representing different times of the day the artist alludes to the wide geographical scope of a nation that incorporates nine different time zones. And third, the representation of the natural cycle of the day alters significantly the impact of the necessarily monotonous lighting of an underground tunnel, thus lessening the potential claustrophobic atmosphere of a metro station.

To express the diversity of life in the Soviet Union, Deineka undertook to represent a wide range of themes, including nature, agriculture, industry, militarism, aviation and sport. Yet what unites the series is an emphasis on the boundless abilities of Soviet youth. This idea is most interestingly explored in three key images of *fizkultura*, representing a pole-vaulter, a ski jumper and a pair of high divers. The first of these represents a pole-vaulter at the very apex of his jump (illus. 33). Flying through the air, having just released his pole, this athlete has cleared the high bar by some considerable margin. Since the bar itself is at the very top of the upright, the implication is of a remarkable, potentially record-breaking, leap. Dressed in an athletics costume this figure appears as a specialist whose sporting prowess simultaneously results from, and symbolizes, the new Soviet era. Like the pole-vaulter, the representation of a ski jumper also emphasizes sports specialization (illus. 52). Notably, this figure is also depicted flying through the air above the viewers' heads. Leaning forward into his jump, the skier maintains a perfect posture, legs close together, skis parallel, arms stretched out ahead. His leap is evidently considerable, as he flies over the uppermost branches of a tree, and both the ski-suit and number emblazoned across his chest suggest that he is actually participating in a competition. Towering above the viewer, this sportsman evidently signifies, once more, the potential for huge achievements, thus justify-

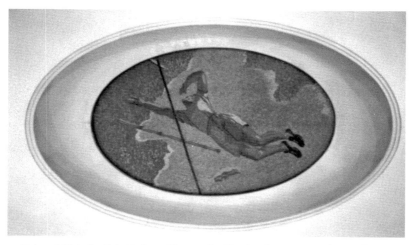

33 Aleksandr Deineka, *Pole-Vaulter*, ceiling panel at Mayakovskaya metro station, 1938, mosaic.

ing his status as number one. In the last of these three panels, Deineka depicted two high divers (illus. 53). The upper, female figure raises her head and stretches her arms out horizontally, like an aeroplane in flight, whilst the lower, male figure arches his back more dramatically, physically replicating the elliptical frame of the panel. The horizontal disposition of these figures contributes towards an overall sense of gravity defied. Rather than diving downwards they seem to glide slowly and gracefully through the air, their movements appearing more as if they are actually passing through water rather than air. The male diver, in particular, looks as if he has just reached the lowest point in his dive and is turning upwards to surface. By simultaneously implying movement through air and water, Deineka alluded once again to the versatilities and capabilities of Soviet youth.

In all three of these panels, Deineka made careful use of the low viewpoint to express both aspiration and attainment as crucial components within Soviet *fizkultura*. By representing the diversity of *fizkultura* practices, taking place in warm and cold climates in both summer and winter, Deineka signified the centrality of youthful fitness to the entire nation. Yet, in line with the necessary emphasis on the sky above, he further represented his sportsmen and sportswomen as if they themselves were flying aircraft, technological products of a new Soviet era.[41] These *fizkulturniki*, symbolizing the new generation of Soviet youth, are depicted having broken the very bounds of human limitation, leaping ever onwards and ever upwards to new heights. Within the context of the whole cycle of panels at Mayakovskaya station, their aspirations and achievements parallel developments in

industry, agriculture and defence. For Deineka, the *fizkulturnik* came to be the ultimate symbol of the fitness, skill and dedication of the new youth generation, which, he believed, would inevitably lead the Soviet Union forward to a brighter future.

Dinamo

Of the four metro station designs highlighted by Sosfenov for special attention, Dinamo was unquestionably the one most directly related to the *fizkultura* theme.[42] Named in honour of the sports society set up by the security chief Feliks Dzerzhinskii in 1923, the station served the adjacent Dinamo stadium, at that time the nation's largest sports arena. Built in 1928 for the First Workers' Spartakiad, and expanded in 1935, the Dinamo stadium had proved an enormously popular arena for sports spectatorship. Yet it soon became evident that the city's transportation infrastructure was drastically incapable of coping with the huge number of sports fans regularly making their way from the city centre to the stadium on big match days. Whilst the new metro link between city centre and stadium certainly alleviated some of the major match-day congestion problems, this was probably not the prime motivation for building the station. In fact, the Dinamo site was more broadly recognized as an important arena for *fizkultura* practices rather than spectatorship. In addition to the stadium itself, a number of other centres of *fizkultura*, such as the Young Pioneers' Sports Complex built in 1932, were situated nearby.[43] Indeed, the entire region around Dinamo station was specifically associated with *fizkultura* practices, and the opening of the station provided a major impetus to young Soviet men and women to make full use of the *fizkultura* amenities supplied by the state.

With such emphatic links to both sports practice and spectatorship, it was hardly surprising that the *fizkultura* theme dominated the designs for Dinamo metro station. Two separate architectural projects were here undertaken: the first consisting of two identical over-ground pavilions forming the entrance to and exit from the station; the second, the underground central vestibule and platforms. Decorative sculpture formed an integral element within both designs. Above ground, in the two pavilions designed by Dmitrii Chechulin, the emphasis was very much on the classical heritage with a direct reference made to the Parthenon in Athens (illus. 34). Built from light-coloured stone and surrounded by classical columns, these pavilions carry a sculptural frieze running around the upper walls. Simultaneously, this proto-classical reference carries overtly modern elements. The capitals of

34 Dmitrii Chechulin, Pavilion at Dinamo metro station, 1938.

the columns, for example, far from conforming to the classical orders, are alternately decorated with Soviet star and hammer-and-sickle motifs, whilst the subject of the frieze itself is not the battles of ancient Greece but the sporting activities of modern Soviet citizens, participating in boxing, weight-lifting, swimming, athletics and tennis. Several of these figures, designed by the sculptor Yelena Yanson-Manizer, wear the distinctive vest of the Dinamo Sports Society, thus symbolizing the popular activities of the region. Below ground, Yakov Likhtenberg and Yurii Revkovskii adopted a different architectural approach with more ambiguous historical allusions. The principal feature here was the inclusion of a large number of bas-relief roundels, 90 cm in diameter and executed in fine porcelain, which were positioned between the pillars on the walls of both the central vestibule and each of the two platforms. These roundels, once again depicting the theme of *fizkultura*, were also the work of Yanson-Manizer. Sixteen separate designs were reproduced four times making 64 roundels in total, each of which represented a single figure performing a specific sports activity (illus. 35 and 36). The original designs incorporated a diverse range of sports activities, divided equally between male and female participants, and were categorized by Yanson-Manizer under the headings of throwing, running, games, exercises, heavy athletics and winter sports.[44] Shortly after their installation, Yanson-Manizer's roundels were given much press coverage, and both *Iskusstvo* and *Tvorchestvo* published articles on the Dinamo project.[45] Despite general

35 Yelena Yanson-Manizer, *Hurdler*, roundel at Dinamo metro station, 1938, porcelain.

36 Yelena Yanson-Manizer, *Footballer*, roundel at Dinamo metro station, 1938, porcelain.

praise and approval, however, Sosfenov was somewhat critical of the roundels themselves:

All [Yanson-Manizer's] characters are mannered, dry and lifeless. In the work 'Runner', for example, the energetic final burst of a healthy, well-trained body has been reduced to an artistically 'beautiful' pose, in which a finely groomed young woman appears motionless and stiff. If we also examine other of her female forms such as 'Figure-Skater', 'Girl with a Skipping Rope', etc., they all carry the imprint of a feigned prettiness, are utterly devoid of strength and life and, most of all, lack a naturalness, which thus prevents our belief in the creation of an artistic form.

In the male figures, Yanson-Manizer deviates a little from this pattern, but here her forms do not become free of academic coldness. Clearly the

sculptor does not manage to convey movement. Football, skiing and boxing are lively sports activities, full of physical exertion and dynamism, but in this interpretation they become frozen and lifeless.[46]

The examples chosen by Sosfenov might seem to justify his claims. The figure *Runner*, for example, certainly adopts a highly affected pose, balanced tiptoe, head dramatically thrown back. The broken ribbon, carefully composed to curl decoratively across the figure's chest, adds a further dimension of artificiality to the work. And this careful contrivance, condemned by Sosfenov, is certainly typical of the whole series, perhaps seen at its most extreme in the two images of figure skaters, the shot putter and tennis player. Yet, by attacking Yanson-Manizer's works as essentially posed, and lacking in dynamism, Sosfenov perhaps missed the point. Yanson-Manizer declared in *Iskusstvo*: 'I set myself the task to represent . . . the *most characteristic movement* inherent in each of the given sports' (my italics).[47] Here, the 'most characteristic movement' did not necessarily require an accurate rendition of a sportsperson in action. Rather, the series was conceived more as an attempt at a static, decorative solution, determined by the restrictions of the roundel format, that best conveyed the nature of the sport depicted. Indeed, this posed quality had characterized Yanson-Manizer's work throughout her career, a fact of which Metrostroi would doubtless have been aware when selecting the sculptor for this commission.

By 1938 Yanson-Manizer had already established a reputation within the representation of *fizkultura*. Yet her interests in this field also extended to dance. In 1935 she produced the first of many works depicting the famous Soviet ballerina Galina Ulyanova, and throughout her career Yanson-Manizer's name was strongly associated with the ballet.[48] For Yanson-Manizer, both dance and *fizkultura* were closely interrelated themes, both allowing the opportunity to focus on the grace, harmony and beauty of the body in motion. Between 1935 and 1937 three major bronzes by Yanson-Manizer were selected for public display in Gorkii Park. All three of these works represented young female figures. Significantly, two focused on *fizkultura* (*Female Discus Thrower* and *Girl on a Beam*), whilst the third, entitled *Dancer*, emphasized ballet.[49] In contrast to many public monuments produced at this time, Yanson-Manizer's three bronzes are frank in their nudity. Yet despite an obvious erotic frisson – few sportswomen either threw the discus or performed exercises on the beam naked – Yanson-Manizer's primary interest here seems to be the search for the perfectly choreographed frozen moment, an attempt to capture the essence of

particular physical activities. In all three works the body is tensed, stretched and strained into unnatural postures, yet essentially appears perfectly balanced and harmonious, as if in a pose that might be held comfortably for some time.

In the roundels executed at the Dinamo metro station, Yanson-Manizer effectively fused her two primary interests, dance and *fizkultura*. Here, the figures strike exaggerated, dramatic poses inspired by the grace, posture and physical control of dance. At the same time, Yanson-Manizer used this device in an attempt to convey the enthusiasm, energy and excitement of popular, modern-day sports. Once again, the grace, elegance and beauty of Soviet youth were presented as a sign of the new age.

Ploshchad Sverdlova

Significantly, Ploshchad Sverdlova also used porcelain as a decorative material. Moreover, the close relationship between the themes of dance and *fizkultura* linked this project to Dinamo station. Ploshchad Sverdlova station, designed by the architect Ivan Fomin, lies at the heart of Moscow.[50] Adjacent to Ploshchad Revolyutsii station, it serves Teatralnaya Square, then named Sverdlov Square, the home of the Bolshoi and Malyi theatres. With this theatrical connection in mind, the theme adopted for Ploshchad Sverdlova was the art and culture of the peoples of the Soviet Union. Here Natalya Danko produced a series of fourteen different figures, cast in white-glazed porcelain and decorated with gold, to be incorporated into the highly decorated ceiling of the underground central vestibule. As at Dinamo station, each of these figures was reproduced four times, making a total of 56 figures, each representing the music and dance of the various regions of the Soviet Union. The series included seven male and seven female figures representing Armenia, Belorussia, Georgia, Kazakhstan, Russia, the Ukraine and Uzbekistan.[51] Dressed in national costumes and presented either performing a local dance or playing an ethnic musical instrument, the series glorified the diverse, multinational status of the Soviet state. By presenting a number of different societies at leisure, all involved in the practice of music and dance, the series also attempted to prioritize cohesion over division. In an article published in *Iskusstvo* in winter 1938, Danko pointed out that the commission to produce works on this theme originated in 1936. Yet, interestingly enough, Fomin at this time produced a full-colour sketch indicating the planned appearance of the central vestibule at Ploshchad Sverdlova. Here, the architectural layout is very much as was later

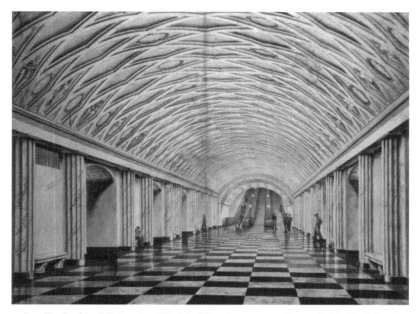

37 Ivan Fomin, *Sketch for Interior of Ploshchad Sverdlova metro station*, 1936–8, indian ink and watercolour on paper.

38 Detail of the ceiling of Ploshchad Sverdlova metro station.

built, incorporating a black and white chequer-board floor with benches and marble columns supporting an arched ceiling highly decorated with diamond motifs. Directly above the columns, on each side of the central vestibule, the diamond spaces incorporate white and gold wreaths alternating with representations of small-scale figures. Yet here, the figures are not the multi-national dancers and musicians of Danko's final project. Instead, Fomin included sportsmen and sportswomen, boxers, athletes and tennis players (illus. 37, 38). It is unclear when exactly the decision was taken to alter the proposed theme at Ploshchad Sverdlova from *fizkultura* to music and dance. Certainly, both the artists and architects responsible for the station would have been aware of Yanson-Manizer's plans for Dinamo station not least of all because the porcelain roundels for the latter were being produced in the same factory as the figures for Ploshchad Sverdlova. In the end it doubtless made more sense to highlight *fizkultura* at Dinamo station, and theatricality at Ploshchad Sverdlova. Yet Fomin's original sketch shows once more just how central the theme of *fizkultura* was when undertaking the design and decoration of the principal stations on the Moscow metro.

By the end of 1938 the Soviet state was rightly proud of its achievements in having built one of the most outstanding metropolitan transportation systems in the world. Countless articles and texts appeared extolling the virtues of the new metro, and scarcely a single journal failed to praise the splendour of the project. With the Reconstruction of Moscow programme continuing to develop new areas and produce grand-scale buildings throughout the city, the metro system was seen as the essential nexus of the entire scheme, enabling Muscovites to move with relative ease around the new city, to witness first hand the advances being made and to contribute more directly to a notionally transformed public life. The huge practical and sociological impact of the new metro system was also combined with huge successes in both the technological and cultural spheres, suggesting not only the great scientific capabilities of the new state, but also its commitment to cultural development and public art.

The aforementioned E. D. Simon, visiting Moscow in the late 1930s, offered an interesting analogy between past and present practices:

In medieval days, the whole people of a town joined together to build a cathedral. So in Moscow the people joined to build the metro; and regard it today as a thing of beauty, their common achievement, their common possession. It is constantly referred to as 'the most beautiful underground in the world'.[52]

Whilst Simon's comments are perhaps overly simplistic, as dependent upon a romanticized vision of medieval utopias as they are upon modern ones, they still merit some attention. It was certainly the case that vast numbers of Soviet citizens had contributed their labour to the building of the metro, and a significant proportion of these labourers offered their services free of charge. Also, through their overt references to 'palaces', 'temples' and 'cathedrals', the metro stations provided a form of proto-religious arena in an officially atheist state; spaces in which to honour, to pay homage to, an abstract concept, here the symbolic notion of the Soviet state itself. Yet in contrast to the more dominant cultural orthodoxy, the metro did not overtly emphasize the role of the political leadership. Rather, at the centre of the whole metro project lay the image of the Soviet New Person, or *novyi chelovek*, the strong, fit, dedicated citizen, physically and mentally transformed by the emergence of this new Soviet state. Ultimately, the metro project honoured the fit, youthful worker, but not uniquely through his or her labour. Increased labour productivity notionally generated increased leisure time, which in its turn was utilized to develop further the potential for labour productivity. In this context the image of the *fizkulturnik* came to symbolize the very conflation of labour and leisure activities. With the conflation of labour and leisure activities into one sphere, the notion that participation in the grand labour schemes of the 1930s could be presented as fun as well as ideologically honourable was publicly reinforced. Whether or not such a view gained much credence with a broad public is highly debatable. But what does remain is the indisputable centrality of the image of the sportsperson as the archetypal image of new Soviet heroism.

5 The Last Line of Defence

In 1938 Aleksandr Deineka produced one of his most famous paint-ing: a work entitled *Future Pilots* (illus. 39). Set in the warm, south-ern region of the Crimea, this is often regarded as the culmination of Deineka's series of works representing the Black Sea coast. Since the late 1920s Deineka had made several trips south, initially as a result of commissions to produce illustrations for Soviet periodicals such as *Krasnaya Niva*, *Bezbozhnik i stanka* and *Prozhektor*.[1] In the summer of 1934 he made his first visit to Sevastopol, which subsequently became a kind of spiritual home to the artist. Here Deineka produced dozens of works representing life both in the Don basin and on the Crimean peninsula, focusing in particular on Soviet youths at leisure, bathing in the sun and the sea. In *Future Pilots* he presents three young boys seated on the shore and watching hydroplanes fly over-head or land in the warm waters of the Black Sea. Deineka's emphasis upon the exposed, tanned bodies and sun-bleached hair of the boys signifies the warmth of the region and conveys the message that regu-lar exposure to sunshine and fresh air contributes to the development of the fit and healthy body. At first glance, the work thus appears be an idyllic scene of children enjoying a leisurely, timeless summer, thus presenting a kind of modern-day Arcadianism, typical of many of Deineka's Crimean works. Yet, it might be noted, even in Arcadia the threat of danger exists and, on closer inspection, *Future Pilots* can be seen to engage with one of the principal anxieties of the era: the vulnerability of the Soviet borderlands to invasion by a foreign enemy.

The three boys represented are all of differing ages, ascending from the youngest on the left to the eldest on the right. As they advance in age their modesty also appears to alter, the youngest sitting naked, the middle child wearing the briefest of swimming costumes, the eldest more fully covered. There is also a notable distinction in the actions of the three boys. The eldest makes a gesture with his right hand, seem-ingly describing the path of the aircraft being watched, whilst the younger two listen. Accordingly, this scene carries an educational

39 Aleksandr Deineka, *Future Pilots*, 1938, oil on canvas.

context, the eldest, and most developed, boy giving the youngsters the benefit of his knowledge. This educational context is further emphasized by the actions of the aircraft. These are hydroplanes, aircraft with the capacity to take off and land on water. Three craft can be seen: the nearest, on the left, appears to be descending, possibly about to land; a second at the centre, seen in profile, has just landed, leaving a trail of white water behind it; whilst a third, seen above the youngest boy's head, appears to be rising from the water in the process of taking off. The specific title of Deineka's work, *Future Pilots*, clearly forges a direct correlation between these aircraft and the foreground figures. Here the three boys watch specific aircraft manoeuvres, their spectatorship thus presented as a form of training, contributing to the youngsters' future role as aviators themselves.

By setting this scene on the shores of the Black Sea, the Soviet Union's principal naval base situated at the very south-western margins of its territory, Deineka draws the viewer's attention specifically to the spaces beyond the borders of the Soviet Union. These boys are gazing out into the unknown, into the very region from which foreign invasion, were it to happen, would come. The waters

over which they look are, in fact, not as tranquil as the setting might first suggest. Waves break far from shore and crash against the rock promontory depicted on the right of the painting. It is also unclear precisely what role these unmarked aircraft are fulfilling. They might be read as leisure craft, reflecting the idyllic nature of the Black Sea coast. At the same time, they could be patrol vessels, guarding the coastal waters for the benefit of the defence of the nation. The precise positioning of the three young spectators also plays a crucial role in the interpretation of the image. Whilst looking out over the open waters, these youngsters are notably situated behind a barrier, a concrete breakwater that curves protectively around on the left edge. Although the boys are positioned some distance behind this structure, Deineka has carefully aligned the upper edge of the wall at eye level so that the boys' heads appear as if they are peeping above a parapet. In the context of 1938, such a militarily defensive outlook would have held very specific resonances.

From the mid-1930s onwards the Soviet military leadership identified the south-western frontier of the Ukraine as the likely area of strategic invasion. To counter this threat, the military authorities began work on fortifications that came to be known as the Stalin Line: a series of concrete bunkers, hidden ditches and anti-tank traps that ran from Pskov in the north-west, following a southern line down through Kiev and on to the Black Sea coast.[2] In *Future Pilots*, Deineka's inclusion of a concrete breakwater clearly alludes to these military defences, whilst the youngsters who gaze out from behind this fortification are identified as the future defenders of the Soviet borderlands and, indeed, faith. Despite his self-avowed belief in the developing fitness and strength of the Soviet people, however, Deineka's *Future Pilots*, in highlighting the current frailty of Soviet youth, proved to be all too prophetic.

During the later 1930s, as the shadow of war in Europe loomed ever larger, fears of military invasion increasingly dominated the thoughts of the Soviet leadership. Both the practice and the representation of *fizkultura* were transformed by these circumstances. Where, previously, the introduction of widespread *fizkultura* programmes had been strongly associated with developing labour potential, now it became increasingly affiliated with military strength and the defence of the Soviet borders. This link between *fizkultura* and military defence had established historical roots. Throughout the nineteenth century many European nations had introduced campaigns to promote fitness and health amongst the general population. The primary objective here was usually the desire to develop the nation's capacity

to wage war. In Britain, for example, sport played a major role in the military academies, deployed as a means of improving physical fitness and developing discipline, team spirit and loyalty. During the First World War sport and militarism were inextricably linked. In 1916, for example, even after news of the horrific carnage of modern warfare had filtered back home, the popular press continued to present war as a gentlemanly sport, reporting on soldiers such as Lieutenant-Colonel Edgar Mobbs, a former international rugby player, who led an attack by hoofing a rugby ball out of the trenches and calling on his men to 'follow up'.[3] In France, too, *fin-de-siècle* fears of national degeneration had inspired a growing cult of physical fitness and exercise, a factor that contributed significantly to Baron Pierre de Coubertin's mission to revive the ancient Greek Olympic Games in 1896.[4] Throughout Europe, organizations such as the German Turnen society and the Czech Sokol movement promoted physical fitness as a broad-scale expression of national military strength.[5] Unsurprisingly, similar nationalistic fears contributed to the various historical developments of sports societies and programmes in the Russian Empire. Defeat in the Crimean War in 1855 had highlighted the problems of maintaining poorly trained and undernourished armed forces. Further military involvement with the declining Ottoman Empire, most notably the Russo-Turkish Wars of the late 1870s, plus the regular spectre of regional famine, resulted in widespread concern for the state of the nation's health during the second half of the nineteenth century. During these years the relationship between sport and militarism was strongly forged, not least through the activities of Pyotr Lesgaft. Originally a teacher of anatomy, Lesgaft sought to promote physical education amongst a broad population and turned to military institutions to inform his work. In 1875, sponsored by the Russian War Ministry, Lesgaft set off on a fact-finding mission to Europe to study the physical education systems of many major institutions. Amongst those that most appealed to him were the Central Army Gymnastics School at Aldershot and the Royal Military Academy at Woolwich.[6] By 1905 Russia's shock defeat by Japan in the Russo-Japanese War once again drew attention to the poor state of health of much of the population. The stereotypical European image of the Russian as a lumbering bear came to be seen as an affront to national pride, and campaigns to improve the nation's health were launched in many periodicals. In 1912 the Tsarist authorities responded by creating the post of Chief Supervisor of the Physical Development of the Population of the Russian Empire. Perhaps unsurprisingly, this post was filled by a military figure, one General Voyeikov, whose power, by the

time war broke out two years later, was extended to political control over all sports clubs in Russia.[7]

Following the Bolshevik seizure of power in 1917, and the subsequent period of civil strife and foreign intervention, sport and *fizkultura* were placed on a more militaristic footing than ever before. With its urgent brief to supply the newly formed Red Army with suitably fit recruits and conscripts, Vsevobuch immediately took control of all existing sports clubs and organizations, and instigated a crash programme of fitness training for all men aged between 16 and 40. Despite its obvious powers of compulsion, Vsevobuch early recognized a value in promoting sport as an attractive enticement to physical fitness. In 1919, to celebrate its first anniversary, Vsevobuch organized a sports parade to cement the already established links between sport and militarism.

Whilst victory in the Civil War clearly increased the power and the reputation of the new Red Army, the end of the conflict did result in a decreased need for military personnel. In this climate of relative peace Vsevobuch was disbanded and the responsibility for developing the Soviet *fizkultura* programme fell more into the hands of the trade union and labour movements. Throughout this period, however, the military institutions never fully relinquished their strong connections with *fizkultura* and continued to support their own sports clubs and societies. By the early 1930s they even began to re-establish their authority over *fizkultura*. In March 1931, inspired by the growing demand for quantifiable results, a consequence of the implementation of the First Five-Year Plan, the All-Union Physical Culture Council launched a new stage in the development of *fizkultura*. The Ready for Labour and Defence campaign, popularly known by the acronym GTO, introduced an accreditation system for physical culturists, setting levels of competence for which badges were awarded. On 1 January 1933 the existing GTO awards system was further refined by the introduction of a second and higher level of achievement. Theoretically, as its name implies, the GTO system was designed to take account of the dual demands of developing industrial productivity and military might. This dual objective was notably emphasized within the design of the badges awarded by the state, which featured an athlete, mounted on a red star, the latter inscribed upon an industrial cog (illus. 40). This symbol soon became widely familiar and was adopted as part of the Annual Fizkultura Parades, as can be seen in a photograph by Rodchenko from 1936 (illus. 41). In practice, however, the GTO programme focused predominantly upon militaristic objectives. General fitness activities such as running, jumping and swimming formed a

40 GTO Badge, 1930s.

regular part of the GTO programme. Participants, however, were also required to train in grenade throwing and rifle shooting, and to pass tests in first aid and military affairs.[8] The centrality of the military dimension of this system is perhaps best exemplified by the fact that the first recipients of this new award had all been trained at the Frunze Military Academy in Moscow.[9] Other fitness activities encouraged by the state included parachute jumping, gliding, mountaineering and motorcycling. The increasingly militaristic GTO *fizkultura* programme focused on two primary objectives: first, to improve the overall standard of military competence of those already involved in *fizkultura*; and second, to establish a broader base of popular participation. To encourage these objectives, the GTO launched a wide publicity campaign promoting *fizkultura* as both a leisure activity and a civic

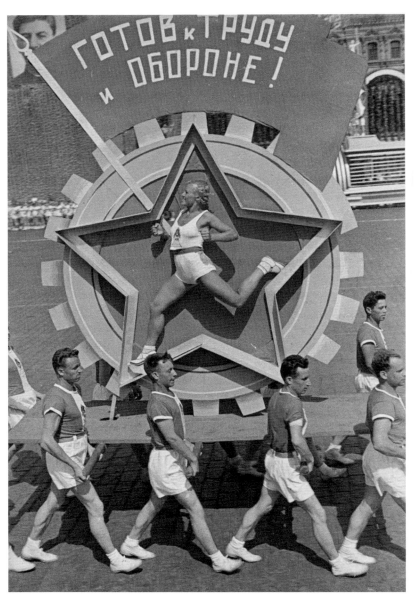

41 Aleksandr Rodchenko, *The GTO Badge*, a 'living sculpture' display at the Annual Fizkultura Parade of 1936.

42 Darya Preobrazenskaya, *Water Sports*, late 1920s, flannel.

43 Dmitri Zhilinskii, *Gymnasts of the USSR*, 1965, tempera on panel.

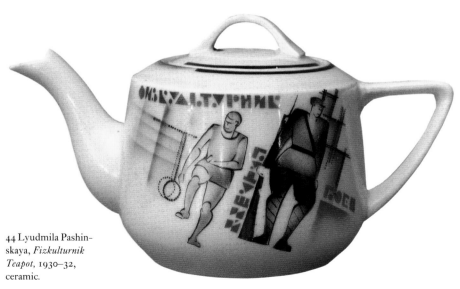

44 Lyudmila Pashin-skaya, *Fizkulturnik Teapot*, 1930–32, ceramic.

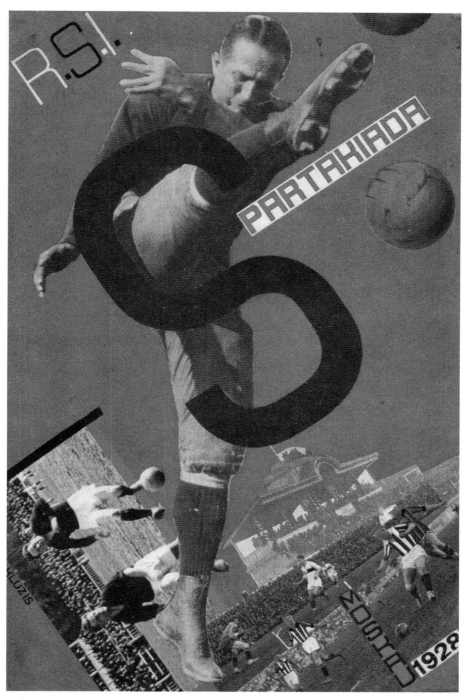

45 Gustav Klutsis, *Postcard for the First Workers' Spartakiad*, 1928, lithograph.

46 Aleksandr Samokhvalov,
Girl with a Shot Put, 1933,
oil and tempera on canvas.

47 Poster advertising the Annual Fizkultura Parade of 1937.

48 Aleksandr Samokhvalov, *At the Stadium*, 1935, oil on canvas.

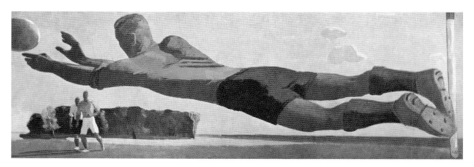

49 Aleksandr Deineka, *Goalkeeper*, 1934, oil on canvas.

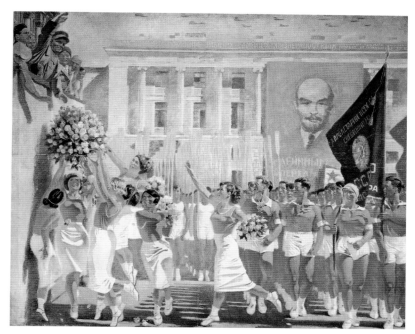

50 Aleksandr Samokhvalov, *Kirov at the Fizkultura Parade*, 1935, oil on canvas.

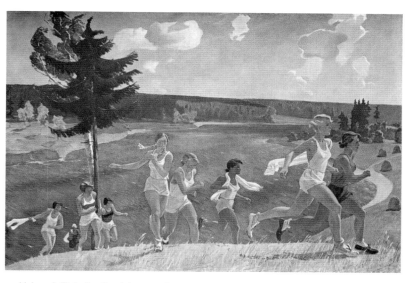

51 Aleksandr Deineka, *Razdol*, 1944, oil on canvas.

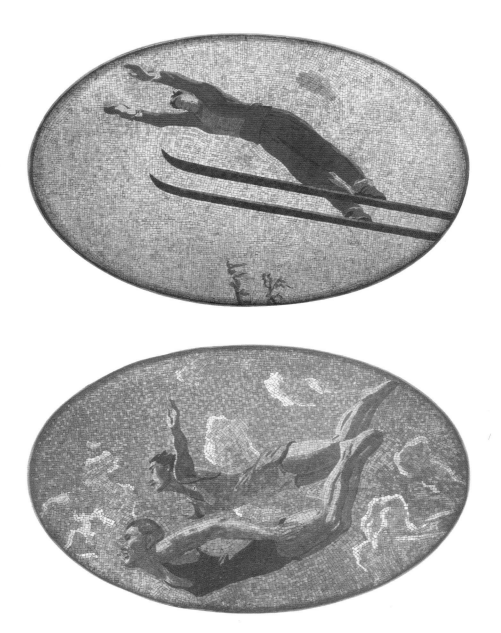

52 Aleksandr Deineka, *Ski Jumper*, ceiling panel at Mayakovskaya metro station, 1938, mosaic.

53 Aleksandr Deineka, *Divers*, ceiling panel at Mayakovskaya metro station, 1938, mosaic.

Работать, строить
и не ныть!
Нам к новой жизни
путь указан.
Атлетом можешь
ты не быть,
Но физкультурником—
обязан.

54 Aleksandr Deineka, *Fizkulturnitsa*, 1933, chromolithographic poster.

duty. Posters were commissioned, produced and disseminated through-out the nation. The best known of these posters, entitled *Fizkulturnitsa*, was produced in 1933 by Deineka (illus. 54).

As one of the major proponents of the *fizkultura* theme, Deineka was perhaps an obvious choice of artist for the GTO commissioners. Moreover, the success of his painting *The Defence of Petrograd* at the *Tenth Anniversary of the Red Army* exhibition of 1928 had strength-ened his credibility in military circles. By this time, Deineka had also come to occupy a crucial position at the forefront of the revival of the political poster. By the early 1930s the political poster had come to be regarded as one of the major cultural achievements of the early post-revolutionary era. The rise of NEP, however, had shifted the attention of many poster producers away from ideology and towards consumer-ism, a factor that generated much criticism from as early as 1922.[10] In the heady atmosphere of the first decade of Soviet power, posters promoting beer, galoshes, babies' dummies or Douglas Fairbanks movies were unlikely to capture the political imagination in the same way as the work of the great War Communism poster artists such as Viktor Deni, Ivan Malyutin and Dmitrii Moor. The introduction of the First Five-Year Plan created a new environment in which the political poster could once again flourish. Hundreds of posters were now produced to promote increased industrial activity and, in July 1932, the Tretyakov Gallery even staged an exhibition specifically focusing upon *Posters in the Service of the Five-Year Plan*.[11] At this time Deineka produced a number of widely disseminated political posters, including *Let's Mechanize the Donbass* and *China on the Journey from Imperialism to Liberation*.

Deineka's *Fizkulturnitsa* was produced within the context of this revitalization of the political poster. Adopting the simply drawn forms and large flat areas of colour that typified his earlier journalistic work, Deineka here attempted to recapture something of the excitement, commitment and urgency of the early years of Soviet poster art. At the same time he adapted his message to the new demands made by the GTO programme, namely, that *fizkultura* was a civic duty. In the tradition of War Communism posters a legend is emblazoned across the lower left of the composition, which reads:

> To work, to build and not to shirk!
> Shows us the way to a new life.
> You might not all be athletes,
> But to be a *fizkulturnik* is your duty.

Whilst this legend certainly implies the importance of labour, the

emphasis in the poster is essentially upon militarism. The central message here is that sporting activity and military preparedness go hand in hand. The principal figure represented is a young Soviet sportswoman dressed in a modern athletics vest and shorts. Her participation in discus throwing, however, simultaneously recalls the traditional ancient Greek origins of the sport. Contrary to many representations of discus throwers, this figure is not depicted in the passive moment of preparation but rather at a moment of explosive action. The body is tensed and contorted, the arms and hair unwinding in full flight in the split second before the release of the discus. Indeed, Deineka's composition suggests that this figure has almost spun out beyond the margins of the frame, the head, left arm and foot all sharply cropped. Here, strength, vigour and determination are celebrated as qualities required of Soviet youth entering the GTO programme. At the same time, a more direct reference to military training is made. In a space behind the central figure a young male sharpshooter lies on the ground, aiming and about to fire his rifle. By this juxtaposition Deineka suggests how the explosive release of a discus thrower parallels the firing of a gun, thus conflating the two actions and endowing the discus thrower with obviously militaristic associations. Moreover, Deineka repeats this conflation of sport and militarism in the background of the image. Here a group of six male runners are represented directly below a group of motorcyclists, once again linking human fitness and endurance with the need to learn to use the tools of warfare. In case the obvious militaristic dimension be lost to any viewer, Deineka used a range of colours – predominantly green, brown and khaki – more reminiscent of camouflage than of sports costumes.

The Keeper at the Gate

Athletes, however, were not the only sportspersons who could be used to convey the importance of military defence. From the mid–1920s onwards the figure of the goalkeeper (*vratar*) gradually emerged and took on the mantle as the primary symbolic defender of the Soviet state. At a time when representations of border guards increasingly dominated both literary and visual culture, this emphasis on a sporting hero served to reinforce the notion that defending the borders was not the sole responsibility of soldiers. Regarded as the last line of defence, the goalkeeper was widely promoted as the archetypal *fizkultura* hero whose sporting prowess, focused upon defending a clearly defined border from the onslaught of the opposing team, provided a

straightforward and easily comprehensible metaphor for military defence. The concept of the goalkeeper as defender of the nation can be traced back, once again, to Yurii Olesha's novel of 1927 entitled *Envy*. Here, Olesha used the setting of a soccer match to draw a contrast between the Soviet New Person and his Western counterpart. One episode, in particular, describes a match between a German team, with its star player Getzke, and a local Moscow team symbolized, significantly, by their young goalkeeper Volodya Makarov.[12] Getzke, here representing outmoded Western values, is described as an individual 'who was only concerned about showing his personal mastery . . . who cared little about his team's reputation'.[13] Makarov, on the other hand, is a team player 'interested in the general course of the game, victory and outcome'.[14] Olesha openly acknowledged the superiority of German soccer and accordingly placed most of the action in the Soviet goalmouth. It is Makarov, however, constantly preventing the Germans from scoring, who turns out to be the hero:

The ball was constantly flying towards the Soviet goal . . . Volodya would catch the ball at angles that seemed mathematically impossible . . . [He] did not seize hold of the ball, he plucked it from its line of flight, and by violating the laws of physics, subjected himself to the stunning effect of the enraged forces. He soared upwards with the ball, spinning round just like he were screwing himself onto it: he clutched the ball with his whole body – knees, stomach and chin, throwing his weight onto the speeding ball, like one would throw rags onto a fire to put it out. The speed of the ball he caught sometimes threw him two metres sideways and he would drop like a brightly coloured paper bomb. The German forwards would rush at him but in the end the ball would go flying high over the fray.[15]

Olesha's language notably employs the vocabulary of military battle more than friendly sports competition. Makarov, despite his status as the underdog, performs beyond the realms of human possibility, flying through the air, throwing himself at the opposition, denying the superior might of the German assault. Here *fizkultura* and the defence of the nation are conflated in a powerful narrative simultaneously highlighting leisure activities and civic duty.

Olesha's literary text seems to have had a direct impact upon the visual arts and can clearly be traced as a major inspirational source for two crucial works: Deineka's large-scale painting of 1934 entitled *The Goalkeeper*, and Semen Timoshenko's popular movie of the same title of 1936. In Deineka's work, the monumental figure of a more-than-life-size goalkeeper fills the entire frame, whilst the long horizontal format emphasizes his athletic dive (illus. 49). Seemingly defying gravity, this figure stretches out his arms to grasp at a ball in the top

left-hand corner of the painting. The background is noticeably devoid of any spectators: the only characters included in addition to the monumental goalkeeper are two diminutive and distanced players dwarfed by the central figure. Here, the sheer physical presence of the young goalkeeper is matched with his grace and agility as he commits himself fully to the task at hand. As in *Future Pilots*, the spectator is not placed facing this defender, but behind him, ensuring that his defensive actions thus protect, rather than confront.[16]

Two years later, in 1936, the goalkeeper was to make an even more significant appearance as the eponymous hero of Timoshenko's popular movie. *The Goalkeeper* is, to all intents and purposes, a product of the mid-1930s craze for light entertainment films in the Hollywood mode. Essentially a musical comedy, *The Goalkeeper* offers the spectator the conventional journey from obscurity to celebrity in the figure of the young goalkeeper Anton Kandidov. At the start of the movie Kandidov is an unknown agricultural worker in the countryside who dreams of fame and fortune in the big city. His opportunity comes when his agility in catching melons is recognized by a group of Moscow footballers on a tour of the provinces. Kandidov is instantly invited to come to the capital and become a goalkeeper for a factory team. Grabbing this opportunity with both hands, Kandidov soon becomes a famous sportsman. Unfortunately, his rural naivety results in his inability to handle his fame as well as he handles a football, and he soon neglects his work and his colleagues. Such pride inevitably comes before a fall, and Kandidov's disloyalty to his team-mates results in his being disgraced on the football pitch. It is the final scene of the movie, however, in which Kandidov is given the opportunity to redeem himself and truly become a Soviet New Person that is of particular interest. His chance comes when he is selected to keep goal for the Soviet national side against an international team named the Black Buffalos, here clearly symbolizing Fascism. Dressed from head to foot in black, these foreign players engage in foul play, deliberately attempting to injure Kandidov. Following Olesha's literary precedent, most of the action takes place in the Soviet team's goalmouth and it is only the heroic acrobatics of Kandidov that prevents the foreign opposition from scoring. In the final minute of the game, with the score still 0–0, the Black Buffalos are awarded a penalty. Kandidov, naturally, saves this penalty with consummate ease. Not content with this heroic act, however, he proceeds to throw the ball up the field, chase it himself, run past all opposition and score the winning goal past an opposition goalkeeper, whose indecisiveness and panic serve only to highlight Kandidov's confidence and cool-headedness. Thus

the principle of defence is turned into attack and Kandidov becomes the ultimate hero and victor. Yet, it is not just the narrative that is of interest here. The manner in which the match is filmed also reinforces the conflation of heroic goalkeeper, border guard and everyman. The camera is noticeably brought down amongst the action and moves freely amongst the players to give the spectator the impression of participation. It might be noted here that such a filmic device had earlier been used in the sports scenes for Vertov's *Man with the Movie Camera* of 1929. Inevitably, the camera focuses predominantly upon Kandidov, showing him jumping in the air, diving both left and right and generally hurling himself into the breach with total disregard for his own safety. Several shots deploy a low angle behind the goal, thus allowing the spectator to see the onslaught faced by Kandidov, and yet to be reassured by his ability in preventing the enemy from penetrating the territory beyond his goal line. Lest this most explicit reference to the goalkeeper as a metaphorical military border guard be lost on the public, and it seems inconceivable that it could have been, the movie was also regularly punctuated with the principal musical theme, a song entitled 'The Sportsman's March'. In line with countless popular songs of the 1930s, 'The Sportsman's March' makes explicit references to the links between *fizkultura* and the defence of the nation in its lyrics as well as its title:

> Fizkult-hurrah!
> Fizkult-hurrah-hurrah-hurrah!
> Be ready!
> When the time comes to beat the enemy,
> Beat them back from every border!
> Left flank! Right flank! Look sharp!
>
> Hey you, goalie, prepare for battle!
> You're a watchman by the gate!
> Just imagine that behind you
> The borderline must be kept safe.[17]

Both Deineka and Timoshenko would probably have been aware of Olesha's text, and especially of the passage outlined earlier. In the context of the mid-1930s, however, this image of Soviet youth defending itself heroically against a foreign onslaught could not but carry a more explicit military significance.

Finally, the goalkeeper-border-guard metaphor can be traced in one other major work of the later 1930s, Iosif Chaikov's previously mentioned *Football Players*. Chaikov's plaster maquette, first exhibited in 1929, had been largely forgotten by the mid-1930s. It re-emerged,

however, when Chaikov was invited to submit a work for inclusion in the Soviet Pavilion at the New York World's Fair of 1939. Chaikov's earlier success at the Paris International Exhibition of 1937, where he had produced a frieze including sportsmen and sportswomen, may well have contributed to his being selected to represent contemporary Soviet sculpture at the New York show. There is, however, little further evidence to suggest precisely why Chaikov now returned to the *Football Players*, and redesigned the work to be cast over life-size and in bronze (illus. 55).[18] One explanation may be that the technical demands of casting the work, so dependent upon two slender points of contact, may have inspired both Chaikov and, indeed, the Soviet authorities to highlight their technological, as well as artistic, abilities. Certainly, the Soviet Union's best casting expert, Vladimir Lukyanov, was called upon to oversee production of the final work.[19] Whatever the motivations, the bronze casting of Chaikov's *Football Players* served to transform the work, which now acquired a number of additional potential meanings. Scale, for example, changed its designated audience. The original version had, like its Renaissance bronze predecessors, been suitable for private, domestic exhibition. Now, at more than 3 metres in height, the *Football Players* took on a new, literally larger-than-life, appearance, thus becoming a monumental public statement on a grand scale. But it was not just scale that distinguished the bronze version from its earlier plaster incarnation. As previously mentioned, the plaster model of 1928 is sketchily defined with little attention paid to surface detail. The final bronze, however, is much more highly finished and greater attention has been paid to expression and costuming. Even the football itself has been given a detailed surface texture absent in the earlier version. Whilst on the one hand this development satisfied the increasing concern for veracity of detail apparent in Socialist Realist culture, it also altered the notional moment represented. In the original sketch version it is difficult to distinguish between the roles played by the two competitors, who appear, ostensibly, to be outfield players tackling for possession of the ball. The increased detailing on the bronze, however, now specifically defined the lower of these two figures as a goalkeeper, distinguished from his opponent by his distinctive woollen jersey and gloves. This additional information adds a new dimension to the work. Here the ubiquitous goalkeeper is again throwing himself into the thick of the action, diving at the feet of the opposition in a valiant attempt to defend his territory. By representing skill, grace and balance deployed within the context of disciplined teamwork in that most working-class of sports activities, soccer, Chaikov's now-monumental *Football Players* usefully

55 Iosif Chaikov, *The Football Players*, 1938, bronze.

signified the vigour, determination and invincibility of the still youthful Soviet state.

Chaikov's *Football Players* proved highly popular when displayed at the New York World's Fair. It was on its return home to Moscow, however, that it found true fame. Afforded pride of place in the gardens in front of the Treyakov Gallery, the *Football Players* now

became one of the most familiar and popular sculptural works on display in the capital. A miniature copy of the work was even cast to crown the trophy for the Soviet soccer championship.[20] The success of Chaikov's *Football Players* ultimately resides in its ability to signify a wide range of issues and ideas to its audience. Stylistically, its emphasis on geometry, movement and space retains significant vestiges of the experimentalism of the earlier avant-garde, practices in which Chaikov himself had been highly active, yet it simultaneously alludes to the detailed veracity beloved by many Soviet cultural critics, and indeed audiences, in the later 1930s. Its subject matter, on the one hand, invited associations with the pleasurable aspects of leisure. Its simultaneous allusion, however, to the responsibilities of military combat and defence addressed more serious issues, and not least of all the principal anxieties so prevalent in Soviet society as the inevitable battle against German Fascism rapidly approached.

Ultimately, the goalkeeper became a ubiquitous cult hero in the years leading up to the German invasion. Whether presented in literary form, in the lyrics of popular songs or in any one of a variety of visual media, the goalkeeper expressed the notion that Soviet citizens were both willing and able to stand tall against potential aggressors whatever was thrown at them.

Fizkultura *at War*

On 22 June 1941 Hitler's armies launched Operation Barbarossa, the mass invasion of Soviet territory that had long been predicted and no more than suspended by the Nazi-Soviet Non-Aggression Pact of 1939. In cities throughout the Soviet Union *fizkulturniki* traded their sports costumes for military uniforms and marched, often straight from the parade ground, to the front. Notably, the two major *fizkultura* institutions, the Lesgaft Institute in Leningrad and the Stalin Institute in Moscow, were immediately called upon to play a major role in the conflict both through the supply of volunteers and by further developing military training programmes. The Soviet authorities were in little doubt as to the vital role that *fizkultura* had played in preparing citizens for the hardships and physical demands of the conflict. The next few years would provide the ultimate test of the merits of this strategy.

In the context of one of the bloodiest and costliest conflicts in history, an excessive emphasis on sport might seem more than a little anomalous. Throughout the conflict, however, the significance of *fizkultura*, both as a practice and as a theme for cultural production,

56 Aleksandr Deineka, *The Defence of Sevastopol*, 1942, oil on canvas.

hardly diminished. Indeed, the influence of *fizkultura* can be traced even in the most explicitly militaristic of images. For example, in 1942 Deineka set to work upon his best-known image of the conflict, *The Defence of Sevastopol* (illus. 56). During a period in which the armed forces of the Third Reich were marching ever deeper into Soviet territory, the resistance of the Sevastopol garrison stood out as one of the nation's few military successes. By December 1941 the port town had been completely encircled by German troops. Against huge odds local divisions, supported by reinforcements from the Black Sea fleet, managed to hold the town until July 1942, when the Germans eventually bombarded them into submission. By December of that year the Soviet authorities had instigated a medal in honour of the Defence of Sevastopol, awarded, posthumously in many cases, to 45,000 people. Deineka did not actually witness events in the Crimean conflict. Although he had visited the front lines as an official war artist earlier that year, he was now based in Tashkent with countless other evacuated artists. Having seen a number of photographs of the destroyed landscape of his beloved Black Sea coast, however, he recognized the opportunity to replicate his success of 1928 with the *Defence of Petrograd*, and to produce a monumental battle painting reminiscent of the works of the nineteenth-century artist Vasilii Surikov.[21] Deineka also used this event to represent his own particular vision of battle, a vision far from factual in its account and indicative of how sport and *fizkultura* continued to dominate his work.

Deineka's *Defence of Sevastopol* is once again set on the Black Sea coast. Unlike *Future Pilots*, however, the waters are now much darker,

reflecting a blood-red and smoke-blackened sky. In the background several buildings, destroyed by aerial bombardment, continue to burn. This threatening landscape acts as a backdrop for the principal foreground action. Here, Soviet troops and their German opponents meet in a hand-to-hand conflict more reminiscent of Agincourt than of the actual events of 1942. The sailors of the Black Sea Fleet, having just come ashore from the military vessel in the bay, dominate this image. In the left foreground two young sailors hurl grenades at the enemy whilst, in the middle distance, more armed riflemen charge forward in unison. The Germans crumple beneath this onslaught, their plight epitomized by the dead trooper lying in the foreground, blood gushing from a head wound. Here the impression is very much one of a Soviet attack rather than a defensive action. More significantly, Deineka here adopted poses based specifically upon sports action. The main figure in the left foreground, for example, is depicted standing legs astride and swinging his arms in a pose simultaneously reminiscent of an athlete throwing a hammer, or a baseball player about to strike a home run. Indeed, Deineka had earlier produced a similar view of a baseball player whilst on his trip to the United States in 1935.[22] Here, Deineka was clearly signifying the strength and invincibility of this Soviet fighter. The figure stares to the right, focusing on the enemy he is about to attack. Notably, his gaze falls upon three disembodied rifles, armed with bayonets and pointing in his direction. In this way, the physical bulk of the Soviet sailor is pitched against seemingly insurmountable odds, facing both lead and cold steel. His prominent position and purposeful posture, however, leads the spectator not to doubt that he will succeed in releasing his grenades and destroying the enemy, even if it should cost his own life.[23] Deineka has also included a second level of notional invincibility. Here the fighter's gaze also lines up with the German bomber diving over the city in the background. By compressing foreground and background it is as if a gargantuan Soviet sailor single-handedly faces a German aircraft that he will beat off with a powerful swing of his arms.

The representation of the second grenade thrower, positioned to the left of the main figure, also alludes to *fizkultura*. This sailor has stripped off his shirt ready for action, allowing the artist to focus on the fall of light on his muscular torso. He winds up, about to hurl his grenade with great care and precision, using a technique more reminiscent of discus throwing and recalling Deineka's earlier *Fizkultur-nitsa* poster. Between these two figures a third marine jogs up the embankment, the contented smile on his face contributing to a sense of bloody military conflict as little more than a joyous occasion of

spirited competition, whilst even the charging riflemen in the middle distance appear as if they have just leaped off the starting blocks. In the *Defence of Sevastopol* Deineka utilized a sub-text of sport and *fizkultura* to operate as a metaphor for the conflict rather than presenting any details of the actual circumstances of the battle of 1942. Here, courageous, fit young Soviet fighters are contrasted with the disorganized and nervous-looking German opposition, the energetic dynamism of the former overpowering the static inertia of the latter. For Deineka, as for the Soviet military institutions in the pre-war period, participation in *fizkultura* provided the essential training for the defence of the nation. When the skills acquired by such training were put to the test, it perhaps seemed only appropriate to Deineka to reveal their eventual uses.

Deineka's continued emphasis on *fizkultura* during the war was far from simply an aberration on the part of the artist. Rather, to a significant extent, it accurately reflected contemporary circumstances. Indeed, the practice of *fizkultura* was hardly to diminish throughout the entire conflict. Even in the besieged city of Leningrad soccer matches continued to take place despite the desperately meagre food rations and constant bombardment. On one notable occasion, 6 May 1942, a match between the Leningrad Dinamo side and a local garrison team attracted a large spectator crowd, and a radio commentary was broadcast throughout the nation in an attempt to boost morale.[24] But without doubt the most famous sporting incident of the conflict took place in occupied Kiev in the summer of 1942. Here, a local team, consisting of some former members of the pre-war Dinamo Kiev squad, were pitched against a German team, some of whom were reportedly members of the Luftwaffe. The local Kiev team had been formed earlier that year and proved itself invincible against all opposition. This success increasingly drew the attention and support of the local population and soon became a vehicle for coded expressions of resistance. The Germans, too, identified the power of sport to rally such support and sought to diminish the authority of the local team by defeating them, literally, at their own game. This policy, however, backfired because the Ukrainian team twice defeated the Germans on the football pitch. The arrest of many of the Ukrainian footballers shortly after these defeats, though probably not directly linked to this event, curtailed any possibility for the occupying forces to suffer further sporting humiliation.[25]

The most powerful manifestation of *fizkultura* during wartime, however, was the widespread staging of mass cross-country runs. In 1942 five and a half million participants were reported as taking part

in a nationwide cross-country event. The following year, the number swelled to nine million.[26] By 1944 these events took on a new significance as cross-country runs were staged in the lands earlier occupied by German forces. In March of that year more than half a million young men and women competed in a cross-country run in the Ukraine.[27] Similar, if smaller-scale, events took place in other liberated areas. For example, in 1944 a race was staged at Tula, the eastward limit of the German advance. A total of 7,000 participants took part to celebrate the liberation of the city the previous summer.[28] These events might be read as the final conflation of the competitive and theatrical elements of *fizkultura*. Here the mass participation usually associated with the *fizkultura* parade dominated, though did not exclude, spectatorship. The excitement of competition was maintained and the whole event was given a huge nationalist boost by its association with youth, fitness and, most importantly, the reoccupation of the Soviet landscape.

In the summer of 1944 Deineka produced a large-scale painting in honour of the nation's newly regained freedom from occupation and imminent victory (illus. 51). The work was entitled *Razdol*, meaning 'Freedom', or 'Free as the Air'. Once again, Deineka chose *fizkultura* as the central theme; the work represents a group of female athletes running through an expansive landscape overlooking a broad, winding river. It must be stated from the outset that Deineka's work clearly carries somewhat problematic gender associations. First, he adopts a somewhat crude and conventional conflation of the landscape with the feminine. Similarly, this subject provided the artist with a scarcely veiled outlet for the voyeuristic gaze at the sparsely clad female body. The work, however, can also be read as carrying other important symbolic references. For example, his focus upon Soviet sportswomen could signify a recognition of the heroic role played by many women during the conflict, both at home and on the front lines. With a male population hugely reduced through wartime attrition, Deineka could also be highlighting an important and positive role for women in the rebuilding of the Soviet Union. Whatever the artist's motives may have been, his clear focus on *fizkultura* as making a major contribution to the victory of the nation in the Great Fatherland War lies at the heart of this image. And Deineka was far from alone in this idea. As one military leader, writing to the sports journal *Fizkultura i Sport* in the early months of the war, pointed out:

We owe it primarily to the sports organizations that Soviet people were trained and had imparted to them such qualities as courage, persistence, willpower, endurance and patriotism. The soldier needs such qualities in the

war we are fighting. The same qualities will be very much needed in peace-time too.[29]

And it is through participation in *fizkultura*, Deineka further claimed, that the nation would now be rebuilt.

6 Aiming for World Supremacy

By May 1945 Soviet troops had marched into Berlin and secured a victory that established a new world order. In just over a quarter of a century, the Soviet Union had advanced from being an industrially backward nation to one of the world's two super-powers. Having suffered enormous casualties, the Soviet regime was loath to relinquish any of the so-called liberated lands of Eastern Europe, preferring to spread the influence of communism westward and retain a vital buffer against any possible future invasion. Yet, in the newly emerging Cold War, the battle would be much more for hearts and minds than strictly for territory. The forging of wartime alliances had also served to bring the Soviet Union into much greater prominence in the international community. In this context sport and physical culture came to play a more vital role than ever as a crucial component of foreign policy. Cultural representations of *fizkultura* were similarly to play their part in the forefront of a national and international propaganda campaign in the post-war era.

The demographic shift brought about by a war in which practically an entire generation of Soviet youth was killed or injured, combined with the sheer exhaustion of a nation that had endured every kind of privation imaginable, hardly made for a propitious environment in which to re-launch extensive sports and physical fitness programmes. Nonetheless, the re-establishment and expansion of such programmes were widely promoted as part of a return to normality. Soccer matches, athletics meetings and a reduced *fizkultura* parade had been reintroduced as early as 1943 in the midst of the conflict. The following year the Moscow city soccer championships were held, despite the inevitable absence of many players still serving at the front. In the post-war era, however, Soviet sport was to launch itself into a new arena. Previously, international sporting events had largely been confined to competitions between worker-teams affiliated with left-wing, pro-Soviet political organizations. Now the Soviet authorities relinquished this strategy and began to forge links with major international sporting institutions

regardless of political leaning. In the autumn of 1945, for example, the Dinamo Moscow soccer team accepted an invitation to tour Sweden, Norway and Great Britain. In England they played matches against Arsenal and Chelsea, in Scotland against Glasgow Rangers, and in Wales against Cardiff City, remaining unbeaten in all four games.[1] The Soviet Union also joined several of the major international sporting federations, including FIFA (Federation Internationale de Football Association) and the IAAF (International Association of Athletics Federations) in 1946 and the IOC (International Olympic Committee) in 1951. In 1952 a Soviet team was sent to compete in the Olympic Games for the first time, although Russian teams had competed in the pre-revolutionary era. The objectives here were clearly defined in a Central Committee Resolution of 1948 that stated the need to 'raise the level of skill, so that Soviet sportsmen might win world supremacy in the major sports in the immediate future'.[2] In a mood of unadulterated triumphalism the Soviet state, having secured military victory on the battlefields of Europe, now sought to claim further victory on the sports fields of the entire world. Such sporting victories, it was claimed, would prove the innate superiority of Soviet political, economic and cultural policies over those of the capitalist West:

Each new victory is a victory for the Soviet form of society and the socialist sports system; it provides irrefutable proof of the superiority of socialist culture over the decaying culture of the capitalist states.[3]

This new strategy, however, was not without its problems. First, several of the international federations to which the Soviet Union had now signed up adopted a strictly amateur code. This, theoretically, excluded the Soviet Union's top athletes, many of whom had been awarded huge cash prizes for victories or for record-breaking achievements. Thus in 1947 a new decree was issued outlawing such rewards.[4] Second, an increased focus on competition, especially in the international arena, would inevitably exacerbate the tensions between mass participation and specialization in sport that had so characterized the 1930s. In practice, only sports specialization was likely to raise the standard of individual sportsmen and sportswomen and thus allow them to compete and succeed against the best athletes in the world. In the new Cold War climate potential international victory in the sporting arena gradually came to dominate all other concerns. In this respect, the history of sport and *fizkultura* in the second half of the twentieth century is increasingly one of growing 'professionalism', despite the claims to the contrary made by the Soviet regime throughout the remainder of its existence.

57 Aleksandr Deineka, *Relay Race on the B Ring Road*, 1947, oil on canvas.

During the early post-war period the *fizkultura* theme retained its popularity in visual culture and images of sport continued to play a significant role in both official exhibitions and in the art press. One of the first post-war re-evaluations of *fizkultura*, however, came in the medium of film. In 1946 Sergei Yutkevich released a documentary entitled *The Youth of the Country*. One of the first colour films to be released in the Soviet Union, *The Youth of the Country* conforms largely to the triumphalism of late wartime and early post-war culture, interspersing scenes of a *fizkultura* parade with romantic, long shots of the Soviet landscape. Here Yutkevich, seemingly taking his lead at least in part from Deineka's *Razdol*, equates the fitness and strength of Soviet youth with military victory and the liberation of the nation. In the urban centres, however, where most infra-structural damage was evident, triumphalist celebrations of liberation soon necessarily turned to pragmatic considerations of reconstruction. Such a shift is clearly discernible in Deineka's *Relay Race on the B Ring Road*, one of the first major paintings addressing the *fizkultura* theme produced in the post-war era (illus. 57). This work is, in many respects, a direct response to the artist's earlier *Razdol*. Almost identical in scale, *Relay Race* notably takes the cross-country run out of its rural setting and places it firmly in Moscow, at the heart of the Soviet Union. Deineka later claimed that his inspiration for the painting came from witnessing a race that

took place on 1 May 1947 around Moscow's Sadovaya Ulitsa, also popularly known as the B Ring Road. Such races had been staged since the 1930s and were revived after the war. During this time Deineka was living nearby and made several sketches of the event, deciding only later to use these to produce the large-scale canvas.[5] The end result, however, is far from a casual glimpse of a popular event. Rather, *Relay Race* evokes a significant sociological shift in attitudes towards sport in the post-war era. In contrast to *Razdol*, *Relay Race* prioritizes strict competition over collective participation. Whereas the former work specifically extols the virtue of mass participation as symbolic of the strength of the Soviet Union, the latter is perhaps most striking for the relative paucity of athletes, reduced to three pairs of male and female runners. The clear view into the empty boulevard behind confirms that these athletes are the only competitors, whilst the emphasis on sports costumes and flags reinforces the notion that these are specialist performers, the best representatives of their individual teams. The sense of competition is also emphasized by the actual moment depicted. The scene is centred upon the white line defining the start and finish of the race with three pairs of athletes shown having passed, about to pass and approaching this significant boundary. One of the crucial developments from *Razdol*, however, is the inclusion of male athletes. Whilst female athletes still play a major role, thus emphasizing the official policy encouraging women into participation in sport and physical culture, their presence here is clearly subordinate to that of the sportsmen. Indeed, here women are shown literally passing the baton to their male counterparts, who now take charge of the race. In the immediate post-war context, when returning male soldiers were reclaiming both jobs and social roles dominated by women during the conflict, the inclusion of such an explicitly symbolic gesture can scarcely have been unconsciously generated or, indeed, read. A glimpse of the spectators in the right foreground might also serve to reinforce this sense of a shift in the balance towards an increasingly male hegemony. Of the six figures identifiable in this crowd, three are women, two men and one a young boy. In contrast to Deineka's pre-war emphasis on the participant-spectator, two of the women, at least, are spectators pure, dressed in notably fashionable clothes. Here, the stylish shoes of the young women contrast starkly with the functional, specialist footwear of the performing athletes. The male figure on the far right, in contrast, is constructed as a participant-spectator, his tracksuit defining him as a *fizkulturnik*. Moreover, since he has the letters CCCP (USSR) emblazoned across his chest he is not just any athlete, but presumably one of some considerable national or interna-

58 Photograph
of Aleksandr
Deineka taken
in the 1930s.

tional standing. Of the two remaining spectators, the young boy
stands nearest the athletes and is keen to participate. The male figure
furthest from the picture plane is perhaps the most ambiguous of this
group. In fact, Deineka has here included a self-portrait, the raised
head and strong profile clearly deriving from a photograph of the
artist taken during the 1930s (illus. 58). From his earliest days, Deineka
had been keen to promote his self-image as a participant in *fizkultura*.
By 1947, however, he was already in his late forties and conscious of
his increasing physical limitations. It is perhaps no coincidence that
the following year Deineka produced a near-life-sized self-portrait as
a *fizkulturnik* in which he superimposed his head onto the fit and
healthy body of an obviously much younger model (illus. 59). Thus
Deineka's decision to include himself in *Relay Race* can also be read in

155

59 Aleksandr Deineka, *Self-portrait*, 1948, oil on canvas.

terms of the metaphorical handing over of the baton, this time from the older to the younger generation.

By representing a relay race taking place in Moscow, Deineka also reinforced a conflation between *fizkultura* and reconstruction in the post-war era. Indeed, he was later at pains to point out the significance of the setting, stating: 'During this time, Moscow was changing so much! Tall buildings and new houses were appearing everywhere. Thus my work [Relay Race] can, to a certain degree, be read as a historical document.'[6]

The inclusion of architectural detail in *Relay Race*, however, does much more than simply document the reconstruction programme. Here, three tall buildings dominate the scene and serve to frame the

composition. More importantly, these buildings are explicitly aligned with the three male athletes, the height of building also equating directly with the stage of progress in the race. Sporting success and architectural achievement are thus neatly conflated.

Relay Race on the B Ring Road certainly helped to re-establish Deineka's reputation as the central proponent of the *fizkultura* theme in the post-war era. In distinction to many of his pre-war works, however, this work is much more highly finished. Here the artist is at pains to include such minor details as the cracks in the foreground asphalt, a tram parked on the side of the road in the left background and, perhaps most prominently of all, the flags and motifs of the Dinamo sports society, represented here by the easily recognizable 'D'. The sketchy finish, earlier potentially signifying the ongoing transformation of the *novyi chelovek*, has here seemingly given way to the finished article. Indeed, victory in the Great Fatherland War led many to believe that the transformation of the *novyi chelovek* was now complete. Nonetheless, in the increasingly tense cultural atmosphere of late Stalinism, even this level of detail was insufficient to protect Deineka from accusations of stylistic cosmopolitanism. For in the visual arts, as in sport, a new attitude of international competitiveness and triumphalism came to dominate the cultural agenda.

The end of the war was greeted by many as potentially heralding a new era of liberalism and tolerance in cultural matters. As early as 1946 the art critic Nikolai Punin, erstwhile member of the Soviet avant-garde and early supporter of Vladimir Tatlin, delivered a lecture to the Leningrad Artists' Union in which he explicitly identified French nineteenth-century masters, including Manet, Monet and, most notably, Cézanne, as ideal models for contemporary Soviet artists.[7] Punin's promotion of French modernists clearly reflected the interests of many Soviet artists at the time, including Boris Ioganson, Aleksandr Gerasimov, Sergei Gerasimov and Igor Grabar, all of whom continued to hold influential posts in the Soviet art bureaucracy. As Cold War tensions gradually emerged, however, the Soviet authorities increasingly adopted an overtly nationalistic and xenophobic attitude. The first signs of this shift are usually attributed to the infamous victory banquet held at the Kremlin in May 1945 at which Stalin specifically highlighted Russia as 'the most outstanding of all the nations that make up the Soviet Union'.[8] Accordingly, Russia was now to take centre stage over and above the other Soviet nationalities whilst all things foreign, and especially Western, were to be condemned as politically harmful. In this climate, Punin's voice was soon drowned out by the virulent cries of Andrei Zhdanov, the mouthpiece, if not

the actual author, of a range of official cultural decrees issued between 1946 and 1948. During this brief period, the so-called *zhdanovshchina*, artists who had previously been associated, however loosely, with international modern art found themselves increasingly sidelined. The establishment of the USSR Academy of Arts in the summer of 1947 also signalled a state-approved shift towards a more highly finished, academic style of painting. Increasingly, Russian nineteenth-century academicians and realists such as Karl Bryullov, Aleksandr Ivanov, Ilya Repin and Vasilii Surikov were highlighted as the classic exemplars for young art students, their works regularly illustrated in the art journals and new art historical publications, or shown in major exhibitions. Huge-scale collective works, most frequently representing scenes from Soviet history or the genre of the leader – Stalin or Lenin – dominated commissions and exhibitions. This policy inevitably had a detrimental effect upon those artists, like Deineka, whose reputation had been founded upon the deployment of a looser finish and sketchy quality. In 1948, for example, despite his long-acknowledged reputation as one of the most influential and highly respected of Soviet artists, Deineka was forced to resign from his position as director of the Moscow Institute of Industrial and Decorative Arts. From then, until after the death of Stalin in 1953, Deineka remained an artist largely out of favour with the Soviet authorities.

The demise of Deineka did not, however, mean the demise of the *fizkultura* theme in official Soviet art. On the contrary, a younger generation of artists, including Sergei Grigorev, Anatolii Nikich and Tatyana Yablonskaya, soon took up the mantle. Whilst each of these artists benefited from the popularity of sport in the wider community, their works also addressed important issues arising in society during the first decade after the war. These, as shall be seen, included regeneration in the aftermath of war, the rise of competitive sport and changing attitudes towards mass participation and specialist performance, and the emergence of national identity for the non-Russian republics.

In 1950 Grigorev was awarded the Stalin prize for a work produced the previous year entitled *The Goalkeeper*, a factor signifying the official approval of sporting subjects (illus. 60).[9] Grigorev's *Goalkeeper* largely conforms to the emphasis on everyday genre scenes, or *bytovoi zhanr*, that increasingly characterized post-war Socialist Realism, and presents a seemingly everyday scene of children playing soccer. The moment depicted is one of tension and drama as a young goalkeeper faces a shot on goal, presumably from a penalty kick. He crouches, appearing anxious but resolute, to face the onslaught of an unidentified opponent, situated beyond the frame of the image. His bandaged

60 Sergei Grigorev, *The Goalkeeper*, 1949, oil on canvas.

right knee, presumably grazed from diving on such a rough playing surface, highlights a dedication to the cause that surpasses concern for personal safety. Clearly, Grigorev was here redeploying the metaphorical association of the goalkeeper as the last line of defence, so central to pre-war cultural conventions. However, the particular setting and larger cast of characters suggests a possible further significance to the work. Grigorev's scene is notably situated on a piece of scrubland on the margins of an unspecified town or city. In one sense, setting the last line of defence beyond, yet in such close proximity to, the city carried clear connotations for the proximity of the front lines to both Moscow and Leningrad during the Great Fatherland War. The distant view, however, simultaneously emphasizes the process of reconstruction, so central to Deineka's *Relay Race* of two years earlier, thus situating the scene temporally in the later 1940s. Scaffolding can clearly be seen on at least two of the buildings depicted whilst an area of excavation is discernible in the far right background. Even the spectators included within the scene itself are seated on wooden planks, suggesting that the space inhabited is itself a construction site, an odd setting for this episode. These spectators, predominantly children, also focus their gazes on the opponent beyond the frame as the artist attempts to eke out every last bit of drama within the composition. The ambiguous presence of one sole adult amidst this group serves notably to destabilize the sense of straightforward play. After all, it is less than clear precisely who this man is? Is he a parent? a teacher? a stranger who happens to be present? And what role does he

play within the context of the moment depicted? The posture of this figure is striking. Seated on the far right he thrusts his left leg forward, in the direction of the unseen opponent, with his hand resting on his knee. This gesture notably echoes that of the young goalkeeper and, indeed, is replicated by the young child to the immediate left of the seated man, thus linking all three. The other children are not playing but watching in an organized fashion. Several of the children are dressed in tracksuits, the most notable of these being the boy on the far left who stands behind the goalkeeper, as if assessing the situation. The adult's costume also adds to the ambiguity of the scene. Dressed in civilian clothing he does not appear to be an official trainer or coach. Moreover, the file and documents held in his right hand seem to have little bearing on the moment depicted, rather implying an alternative role for this character as a worker of some description. His left lapel, however, is notably decorated with ribbons, thus identifying him as a veteran and, most likely, a hero of the recent conflict. Here, it would seem that the older figure is potentially instructing the children, passing on the knowledge of the older generation. This educational context is reinforced by the inclusion of schoolbags, here used as goal-posts. This lesson, however, seems more spontaneous than planned, the ex-soldier, the hero of the 1930s generation, generously passing on his knowledge and skills, specifically in defence, to post-war Soviet youth.

The artist has also included at least two girls in his group of chil-dren. Whilst this once more alludes to the official policy encouraging women into participation in sport and physical culture, there can be little doubt that their presence, like the female athletes in Deineka's *Relay Race*, is here made subordinate to that of the young boys. One of the girls, despite wearing similar sports trousers to her male colleagues, is represented cradling a doll, thus highlighting her role as a future mother more than as a *fizkulturnitsa*, whilst the second female is marginalized towards the back of this group. Grigorev's *Goalkeeper* emphasizes the continuing importance of *fizkultura* in the post-war era, equating this practice directly to the demands for the reconstruc-tion and regeneration of the nation. However, greater stress is placed upon the role of the older generation, whose knowledge and experi-ence are now highlighted as vital to the transformation of Soviet youth into the new defenders of the nation.

Whilst both Deineka and Grigorev prioritized the male athlete over the female, events in the real sporting world did not always follow this pattern. Here the sport of speed skating provides a useful exam-ple. In a nation in which snow and ice frequently remain present for over half the year, winter sports have inevitably played a significant

role in Russia and the Soviet Union. Speed skating was a popular sport in the pre-revolutionary era, and in 1896 the city of St Petersburg staged one of the earliest World Championships in the sport. The Russian Empire continued to send competitors to this event right up to the outbreak of the First World War. After 1917, however, the new Soviet state refused to participate in what it now designated a bourgeois event. This was all to change in 1946. As part of the new policy of competing in international sports events, a team of skaters was sent to the Men's World Championship held that year in Oslo. The outcome was extremely disappointing for the Soviets. None of the skaters managed to win any of the events and the second and third places secured were clearly regarded as scant consolation. When the championship was held the following year, again in Oslo, the Soviet authorities decided not to send a team to compete. In 1948 improved standards amongst the male skaters reignited confidence and the Soviets competed once again, this time in Helsinki. The victory of Konstantin Kudryavtsev in the 500-metre race was cause for some celebration, but the poor performance of the other team members meant that no other medals were won. The Soviet Union did not send a team abroad to the Men's World Championship again until 1953. This circumstance was in notable contrast to the activities of the women speedskaters during the same period. In 1948 the Women's World Championship was held in Turku in Finland. A team of four skaters was sent to compete and came back triumphant. Three of the four finished in the overall top three, the acknowledged star of the competition being the newly crowned World Champion Mariya Grigorevna Isakova.[10] The following year, whilst the male skaters remained at home, the female team headed off to Kongsberg in Norway, where they repeated their success of the previous year.[11] Once again Soviet skaters dominated the competition, taking the top three overall rankings, with Isakova retaining her status as World Champion. Now dominant in the international arena, the Soviet authorities managed to secure the World Championship of 1950, which was duly held at the Dinamo stadium in Moscow. For a third time the Soviet team annihilated the opposition, taking all three top positions. Isakova was crowned World Champion for the third time. The decision to compete internationally in the World Speed Skating Championships for women, but not for men, reflects a clear strategy on the part of the Soviet authorities. Here, likelihood of victory was a major determining factor and, if success was unlikely, the safest course of action was not to compete at all.

61 Anatolii Nikich, *The Awards of World Champion M. Isakova*, 1951, oil on canvas.

Isakova's domination of international speed skating inevitably made her a national hero. Stories were told in the press of how, as a youngster, she was given a pair of skates by her elder brother when he went to serve in the Red Army.[12] Since these were several sizes too big, the young Mariya Grigorevna was forced to wear several pairs of socks to make the skates fit. Isakova's photograph, usually presented in the conventional 'smiling youth' mode, appeared in both the sporting and the national press, and in 1951 she even became the principal subject for a painting by a young graduate of the Surikov School of Art in Moscow, Anatolii Nikich. The work, entitled *The Awards of World Champion M. Isakova*, offers another interesting insight into Soviet attitudes towards sport and sporting victory in the late Stalin era and highlights the diverse ways in which the *fizkultura* theme was articulated in the cultural arena (illus. 61). Nikich's particular specialization was still-life painting and in *The Awards of M. Isakova* he deployed many of the conventions of the still-life genre. The end result, however, is in essence a portrait without a sitter, an evocation of specific characteristics of an individual as symbolized through significant objects associated with her.[13] Nikich's work presents an array of objects orga-

nized, seemingly haphazardly, on a table before a window. Amongst the objects represented are medals, sashes, pennants, letters, diplomas, certificates, books, a presentation box, a variety of vessels ranging from cut-glass bowls and decanters to pewter goblets, and a huge bouquet of flowers. These objects clearly constitute awards for sporting success, a factor reinforced by the dominant presence of a trophy in the form of a statuette representing a speedskater that hovers in an ill-articulated space above the cornucopia set before the viewer. The scene through the background window is framed by lace curtains and shows a winter cityscape, clearly defined as Moscow by the presence of one of the numerous spire-topped skyscrapers erected throughout the city at this time. On one level, these objects operate as straightforward prizes, thus signifying material rewards for specific victories. Hence, medals, cups, flags, ribbons, certificates and bouquets, the trophy paraphernalia of sporting triumph, dominate the still-life arrangement. Yet, such trophies also signify a wider issue here. For these decorative objects – carefully crafted glass and metalwork, rich fabrics, gold and silver – clearly recall the trinkets of the pre-revolutionary bourgeoisie. The medals, significantly arranged overflowing the box in the left fore-ground, appear like an assortment of jewellery on a lady's dressing table. Even the abundant and diverse array of blooms, particularly incongruous when set against the winter landscape beyond the confines of this interior space, bespeak an excess of luxury at a time of continu-ing post-war shortages. The apartment setting further emphasizes this sense of luxury. The high viewpoint over the surrounding city implies that this scene is set in a brand new apartment, possibly in one of the newly erected high-rise buildings.[14] Here, Nikich's work operates like a modern version of a seventeenth-century Dutch still-life painting, emphasizing luxury and abundance whilst simultaneously revealing his own technical skills in representing a variety of textures and materials. The presence of flowers in such an unseasonable context can also be read symbolically, emphasizing the bloom of a youthful spring emerg-ing from the bleakness of a winter landscape. Perhaps unlike Dutch flower painting, however, none of these blooms is overblown and they show no sign of decay. On the contrary, several of the flowers push themselves beyond the natural confines of the bouquet. The *vanitas* theme, so popularly deployed by Dutch still-life painters to emphasize the transience of life, here has no role to play in the coming communist utopia. In the final analysis, however, it is the peculiar and ghostly pres-ence of Isakova herself that makes Nikich's still-life such a troubling work, albeit one that amply articulates the ambiguities and contradic-tions of Soviet attitudes towards sport and *fizkultura* at this time. For

62 Yelena Yanson–Manizer, *Speedskater*, 1949, coloured plaster.

here, the individual persona of Isakova has effectively been frozen out of the image, her presence reduced to a petrified model, eternally trapped in a skating posture whose dynamic forward thrust acts almost as a clichéd quotation of Vera Mukhina's *Worker and Collective Farm Woman*, then, as now, the most famous sculptural monument produced in the Soviet Union.[15] The white tonality of the skater trophy, recognizable as a plaster maquette by Yelena Yanson–Manizer, here seems to contrast strikingly with the colourful, almost gaudy, display arranged for the viewer's delectation and forms a bridge between the interior and exterior world, much as the white lace curtain links the frozen cityscape beyond to the interior scene (illus. 62).[16] Here the surrogate representation of Isakova the skater is conflated with the exterior world whilst simultaneously focused upon the prizes for her endeavours. It seems less than clear whether Nikich's work extols the virtues of material reward for sporting endeavour or highlights such a motivation as problematic. The hypocrisy implicit within the 'amateurism' of Soviet sport at this time seems particularly redolent here. Either way, in Nikich's work the representation of a sporting figure now adopts an entirely new identification. The participant has been reduced to a cipher for victory, the sportsperson and the prize effectively becoming one and the same thing.

63 Yelena
Yanson-Manizer,
Skater, roundel
at Dinamo metro
station, 1938,
porcelain.

The Soviet Union's increasing international success in winter
sports inevitably generated a whole host of popular images represent-
ing skiers and skaters in the early post-war era, many of which
notably prioritized female athletes. These included Grigorev's *Young
Skier* (1948), Aleksandr Burak's *The Young Skier* (1953) and Mikhail
Devyatov's *Athletes* (1953).[17] It was also in 1953 that Yanson-Manizer
extended her series of decorative roundels, originally installed at
Dinamo metro station in 1938, by adding eight new designs (illus. 63).[18]
The inclusion of a female speedskater, clearly a paeon to the success
of Isakova and her colleagues, was here hardly surprising. However,
the fact that half of these new designs addressed winter sports –
mountaineering, ice hockey and downhill skiing accompanied speed
skating – clearly reflects the importance ascribed to such activities in
the wake of international sporting successes. Several of these winter
sports notably demand incredible physical and mental endurance.
The ability to perform at the highest level in the most inhospitable of
sporting climates was thus recorded as an extension of the stoical
endurance of the Soviet population during the war and presented as
an indication to the rest of the world that such a capacity for endurance
was a fundamental national characteristic.

The inaugural participation of the Soviet Union at the Olympic Games in Helsinki in 1952 transformed attitudes to sport both at home and in the international community. The first post-war Games had been held in London four years earlier. Officially, the IOC did not invite the Soviet Union to participate, possibly still anxious about the dubious amateur status of most Soviet sportsmen and sportswomen. However, as the drama and political significance of the Olympic Games grew in the minds of the mass audiences for such events, ever-increasing with the development and expansion of television, non-participation by one of the two super-powers threatened the validity of the Games as a global spectacle.[19] In any case, it is unlikely that the Soviet authorities would have accepted an invitation for the London Games. In 1948 Nikolai Romanov, the head of the All-Union Committee for Physical Culture and Sport, could not assure the Soviet leadership of overall victory and Stalin himself is reputed to have insisted upon a delay until such a victory could be guaranteed. The performance of Soviet athletes in Helsinki appears to have justified this decision and certainly gained the propaganda coup demanded by the leadership. A total of 71 medals were won, including 22 golds. More importantly, the Soviet Union tied with the United States for overall victory. At its very first attempt the Soviet Union had succeeded in gaining the world supremacy in sport it had so recently set out to achieve.

The successes of the Olympic team in 1952 launched a new era in Soviet sport and, from this point onwards, the authorities placed ever-greater emphasis on securing such victories in the international sporting arena. At the same time, however, it was the final nail in the coffin for many of the utopian aspirations of the early Soviet *fizkultura* programmes. The notion that mass participation was one of the primary objectives of *fizkultura* policy was retained in principle, and more and more people were encouraged to participate in sporting activities. Yet despite this claimed objective, state efforts and funds were increasingly directed towards the fine-tuning of highly skilled specialist athletes. Even the *fizkultura* day celebrations, such a crucial aspect of 1930s Soviet culture, were diminished in scale and redirected towards competitive, rather than theatrical, activity. For example, in 1947 the Annual Fizkultura Parade was removed from Red Square and now took place in the more specialist arena of the Dinamo stadium. By 1951 it had taken on a new, and far more disparate identity, reduced to a series of events, many competitive, spread throughout

the city.[20] Sports spectatorship was also increasingly encouraged as a suitable activity in its own right and not as a contingent means to encourage participation. Attendance at soccer matches in particular grew dramatically during the first decade after the war. In recognition of this fact, a significant proportion of the funds dedicated to the development of the sports programme were notably directed towards the building of hundreds of new sports stadia, many capable of holding huge crowds of spectators. Most notable amongst these was the massive Lenin stadium built in Moscow in 1956 and capable of holding in excess of 103,000 spectators.

This new emphasis on spectatorship pure was articulated in Yevgenii Tikhanovich's *Football Fans* of 1952, a work that shows a crowd of spectators enjoying a soccer match despite the poor weather conditions (illus. 64). Tikhanovich's emphasis on joyful, though notably passive, spectatorship in many ways epitomizes the shift brought about by the Soviet Union's change in policy towards gaining world supremacy. The crowd, orderly, enthusiastic and collectively inspired, are no longer presented as potential participants. Rather they are now defined as the supportive infrastructure behind the specialist performers beyond the frame of the work. Their behaviour is, of course, exemplary, encouraged no doubt by the presence of several figures of authority within the crowd itself. For millions of Soviet citizens, watching and supporting the specialist performances of Soviet athletes now increasingly dominated any sense of mass participation.

The End of an Era

Within a year of its inaugural Olympic success the Soviet Union was plunged into a new era of uncertainty. On 1 March 1953 Stalin collapsed at his dacha at Kuntsevo. Four days later he was dead. Countless millions of citizens mourned the loss of their leader and genuinely wondered how the Soviet state would survive without Stalin at the helm. Whilst Stalin's corpse lay at rest inside the Kremlin walls the battle for political succession immediately commenced. Over the coming months Nikita Khrushchev gradually secured his position of authority and a notable wind of change swept across the Soviet landscape. Thousands of prisoners were released from the gulags as some of the worst excesses of Stalinism began to be dismantled. By 1954 the publication of Ilya Ehrenburg's novel *The Thaw* seemed to many to herald a new era of liberalism. The real shock was to come in 1956, however, with Khrushchev's famous denunciation of Stalin and Stalinism delivered at the Twentieth Congress of the Communist

64 Yevgenii Tikhanovich, *Football Fans*, 1952, oil on canvas.

Party of the Soviet Union. Stalin's official reputation had shifted from that of a demi-god to a tyrant in the space of less than three years.

In the immediate aftermath of the death of Stalin, however, the last vestiges of the tension between the specialist performer and the mass participant could still just about be detected in some examples of visual culture. A work by the Ukrainian painter Tatyana Yablonskaya entitled *Morning*, produced in 1954, here offers an interesting case study (illus. 65). In the early 1950s Yablonskaya had gained a significant reputation when two of her works, *Corn* (1951) and *Spring* (1952), were awarded Stalin prizes. She had also recently produced several paintings on the *fizkultura* theme, including *Before the Start* (1947) and *On the Dneiper* (1952). Both these works highlight mass participation in *fizkultura* programmes, the latter, in particular, emphasizing the participant-spectator in a clear homage to the work of Deineka. Her first major work of the post-Stalin era, however, reveals a departure from this convention. *Morning* focuses upon a subject familiar to many ordinary Soviet citizens at this time, namely participation in a morning routine of physical exercises. Each day Soviet radio would broadcast a programme encouraging the whole nation to leap out of bed and conduct a series of physical stretches and jerks. Yablonskaya's work clearly references such a social practice. The young girl represented has just risen from the unmade bed that lies to the left. Her day clothes are neatly folded on a chair by the open doorway whilst she, dressed in a

simple vest and shorts, stretches her arms upwards and prepares to balance on her left leg. The scene ostensibly presents the viewer with an everyday, private moment. However, both the backlighting that carefully frames the action, and the high spectatorial viewpoint adopted, contribute notably towards an overall sense of performance, rather than unobserved practice. This is further emphasized by the very precise pose of the young athlete. Indeed, she is not executing routine stretches but rather adopts a sophisticated posture that would not look out of place in a ballet school or a gymnastics academy. And herein lies one of the crucial significances of this work. At the Helsinki Olympics of 1952, the greatest success for Soviet sportsmen and sportswomen proved to be in the gymnastics arena. Here, 20 medals, including 8 golds, were evenly distributed between male and female competitors. Gymnastic training had long been a crucial component within military training and had formed part of the curriculum in specialist *fizkultura* training institutes since before the war. In the immediate post-war era, however, the training of young gymnasts, particularly young girls, rapidly expanded throughout the Soviet Union both in schools and in specialist sports training centres for children.[21] This policy, which was later to foster the talents of such famous female gymnasts as Larisa Latynina, Olga Korbut, Lyudmila Turishcheva and Nelli Kim, clearly contributed towards the goal of gaining sporting victories in the international arena. In this context, Yablonskaya's young gymnast signifies less a sense of the importance of mass participation in *fizkultura* practices than the potential of youthful specialists to bring glory and honour to the Soviet nation through sporting prowess. It is also highly significant that Yablonskaya's young gymnast is identified ethnically as Ukrainian rather than Russian, a factor specifically articulated by the inclusion of ethnic artefacts within the room, the bright sunlight and warm climate of the Soviet south evident beyond the balcony, and the headdress and braided hair of the young girl.[22] Yablonskaya's decision to depict a Ukrainian, rather than a Russian, athlete might easily be explained as a consequence of her own personal national identity. Doubtless, Yablonskaya would also have been aware of the fact that the most successful Soviet gymnasts at the Olympic Games of 1952 – Viktor Chukarin, Dmitrii Leonkin, Mariya Gorokhovskaya and Nina Bocharova – were all from Ukraine. But clearly there is more at stake here than regional sporting pride. As indicated earlier, the Soviet state's official attitude towards the non-Russian republics during the last years of Stalin's rule was largely antagonistic. To a significant degree this strategy reflected anxieties held by the Soviet leadership with regard to the separatist agendas developed by numerous nationalist groups,

65 Tatyana Yablonskaya, *Morning*, 1954, oil on canvas.

not least of all those within the lands that had been occupied by the Germans during the conflict. Ukraine, in particular, was viewed with great suspicion. Following the occupation of Ukraine, a number of insurgent guerrilla groups fought openly for the liberation of Ukraine from Soviet rule. Indeed, the last of the Ukrainian nationalists were not fully routed until the mid-1950s.[23] In this climate, excessive expressions of Ukrainian national identity inevitably risked being identified from the centre as potentially seditious. The final demise of Stalin brought about renewed hopes that a more equitable relationship between Russia and the non-Russian Soviet republics might be reintroduced. Thus, Yablonskaya's emphasis on the distinctive Ukrainian identity of her youthful gymnast can be read as engaging with this unique historical moment. Here, Ukrainian national identity is reconciled with the broader aims and objectives of the modern, multi-national Soviet state by reference to the practice of *fizkultura*. It might also be worth noting here that within a year of Yablonskaya, completing *Morning*, the Soviet authorities officially recognized the need to bring together Soviet sportsmen and sportswomen from all the nationalities within its borders, thus countering the Russian chauvinism that had dominated the last years of Stalin's rule. In January 1955 plans were put in place to stage the first ever Spartakiad dedicated to the Peoples of the Soviet Union, an event that concluded in the newly built Lenin stadium in Moscow the following summer. Yablonskaya's *Morning* thus operates as a critical work engaging with the dramatically changing atmosphere of the early Thaw era. Here the artist significantly foregrounds a shift from sleep to consciousness, from darkness to light and from disorder (the unmade bed) to a new order, balance and harmony, the young gymnast thus standing metaphorically for the hopes and aspirations generated in the wake of the death of Stalin. In this way, the representation of *fizkultura* practices once more provided a useful prism through which complex sociological and political concerns could be articulated effectively.

The First Signs of Dissent

In the decade or so following the death of Stalin, Soviet sporting success on the international stage went from strength to strength. In 1956, 1960 and 1964 Soviet teams dominated the Olympic Games, defeating their nearest opponents, the United States, by some considerable margin. In other sports too, including soccer, ice hockey and basketball, the Soviet Union was to gain significant international victories. Domestically, sports competitions expanded, drawing ever

increasing audiences to the newly built sports stadia and, from the mid-1950s, sports programmes began to be broadcast on television. Yet, whilst sport had perhaps never been so popular, its very meaning for the Soviet population had now dramatically shifted. The 1960s saw an increase in the standard of living for many Soviet citizens. At the same time, a reduction in working hours allowed more time for leisure pursuits. Yet, the previous ideological emphasis on optimism, mass participation and the potential of *fizkultura* to transform the Soviet citizen rapidly declined. In its place sport increasingly became a crucial component within a newly burgeoning consumer industry. In this context, from the mid-1950s onwards, fewer artists, writers or film-makers regarded *fizkultura* as a crucial theme through which to explore major social, political and ideological issues.

Despite this dramatic shift, one artist continued to produce heroic images of *fizkultura*. In 1957 Deineka, briefly out of favour during the last years of Stalin's rule, was effectively rehabilitated, not least of all by the staging of a major retrospective exhibition of his work at the USSR Academy of Arts in Moscow. Here, around 200 works were exhibited, including many dealing with the *fizkultura* theme produced over the last four decades. In 1959 the publication of two major monographs on the artist, by Ivan Matsa and Andrei Chegodaev, served further to establish Deineka's post-Stalinist reputation as the grand old master of Socialist Realism.[24] In 1964 he was even awarded the prestigious Lenin prize for a lifetime's achievement. Spurred on by this revival of his reputation, Deineka continued to produce works on the *fizkultura* theme and to experiment with a variety of media. Thus his late works include sculptures (*Shot Putter*, 1957), mosaics (*Ice Hockey Players*, 1959–60), paintings (*Youth*, 1961–2) and stained glass (*Basketball*, 1964). In these works Deineka once again deployed bright, glowing colours to emphasize the energy, enthusiasm and boundless achievement of anonymous Soviet youth. Nonetheless, his shift in focus towards competitive sports – athletics, ice hockey and basketball – might well be read as an inevitable response to the world supremacy objectives of the post-war Soviet regime.

Throughout the 1950s and '60s Deineka's rehabilitation impacted upon a generation of younger Soviet artists. In particular, his fusion of a looser, modernist-inspired stylization with specifically Soviet subject matter appealed broadly to those who now wished to challenge the more draconian strictures of Socialist Realism yet not simply follow in the wake of Western avant-garde developments. The unadulterated utopianism implicit within Deineka's images of sportsmen and sportswomen, however, was largely out of step with current attitudes.

This factor is perhaps made most evident in one of the few large-scale official images produced during the post-Stalinist era that directly addressed the sports theme: Dmitrii Zhilinskii's *Gymnasts of the USSR* of 1965 (illus. 43). Zhilinskii first emerged as an important figure during the late 1950s with works such as *In the Metro* (1957) and *Bridge Builders* (1959). These conformed largely to the growing emphasis on a looser, more formalistic style combined with an austere, down-to-earth subject matter that later came to be referred to as the Severe Style.[25] In the wake of Khrushchev's de-Stalinization policy Soviet society increasingly sought a return to the Leninist principles that had characterized the first period of Soviet rule. In cultural terms, this meant a renewed interest in the more experimental works of the early 1920s and particularly those artists, like Deineka, who had attempted to develop a modern figurative style derived in part from the formalist experiments of the early Soviet avant-garde. In *Gymnasts of the USSR* Zhilinskii certainly attempted to revive this formula. At the same time, he was notably far more critical of the role that sport might play in the life of the Soviet Union in the mid-1960s.

Perhaps the most striking feature of Zhilinskii's work is its lack of overall cohesion. The large work is crowded with more than twenty figures arranged in a shallow, tilted and compressed space. The scene is set in a gymnasium with a large red mat forming a backdrop to the frieze of male gymnasts who dominate the foreground space. Perspectival lines and scale differentiation are here deployed to suggest spatial depth. The overall effect, however, is one of flatness and compression, the lack of tonal modulation in the background adding to the claustrophobic feel of the work. This effect is further enhanced by the treatment of the individual figures. Each of the male gymnasts is identically dressed in white, rendering them almost as silhouettes. Two figures, dressed respectively in red and blue tracksuits, add a note of colour to the foreground group and can be identified as coaches rather than participants. The inclusion of three instructors amidst the sportsmen and sportswomen is here worthy of note. With the implementation of the world supremacy strategy, coaches increasingly played a major role within officially approved sport. By 1956 the Soviet authorities even introduced a new sporting title, Merited Trainer of the USSR, to be awarded to those coaches who had trained the most successful athletes. Zhilinskii's inclusion of coaches, however, also contributes to the overall mood of the work. Here the instructors effectively act as the state's eyes, watching over the gymnasts like foremen at a factory or prison guards during daily exercises. This sense of surveillance is further articulated by the high

viewpoint, enabling the viewer to overlook the entire space of the gymnasium. The inclusion of the confrontational gaze of the gymnast in the lower right foreground also serves to destabilize any sense of the viewer's presence as legitimate, not least of all because very little athletic activity seems to be taking place. And this is perhaps the most curious aspect of Zhilinskii's work. For most of the gymnasts included in this painting are not engaged in any activity at all. Most stand around seemingly awaiting instruction or contemplating their own thoughts. There is no interaction between the figures represented, despite the close proximity generated by the compressed space, and each adopts a static posture that seems to belie the energy and exuberance most frequently associated with gymnastic performances. On the contrary, Zhilinskii's sportsmen seem to emphasize torpor and paralysis, each gymnast appearing as little more than an anonymous cog in the Soviet sports machine. The potential for collective endeavour has here been replaced by a sense of alienation, between the gymnasts themselves, the gymnasts and the coaches, and the gymnasts and the spectator. Thus Zhilinskii articulates a bleak vision of *fizkultura* in notable contrast to the joyousness of Stalinist works on this theme. Whereas artists and film-makers throughout the 1930s celebrated *fizkultura*, Zhilinskii here seems to emphasize the dull, monotonous and mechanical aspects of a practice whose primary objective now is simply to generate medals for the state.

In stylistic terms *Gymnasts of the USSR* is rich and diverse in its cultural references. Early in his career Zhilinskii established a reputation for his extensive knowledge and analysis of traditional painting techniques, especially those derived from early Renaissance masters such as Jan van Eyck, Lucas Cranach the Elder and Paolo Uccello. He also studied closely the icons of Andrei Rublev. This is specifically revealed in *Gymnasts of the USSR* through his use of tempera on panel and his emphasis on dramatic scale discrepancy between the foreground and background figures. Here the female gymnasts, reduced to minute peripheral figures, recall similar devices deployed in icon painting. At the same time, however, Zhilinskii's use of traditional techniques to represent a contemporary subject matter makes reference to the similar strategies used by artists such as Petrov-Vodkin and Samokhvalov during the 1920s and '30s, not least of all representations of *fizkultura*. However *Gymnasts of the USSR* also alludes strongly to the Soviet avant-garde at a time when critics and historians were beginning to mention once more the names of artists such as Kazimir Malevich, Vladimir Tatlin, Lyubov Popova and Varvara Stepanova, so long out of favour in the Soviet Union.

Here, for example, it could be argued that the strictly geometrical forms that constitute the background to this work make reference to both Suprematism and Constructivism. The red mat, for example, floats in an ambiguously defined space, whilst the dashed red line in the foreground could be read as a quotation from Constructivist canvases such as Popova's *Spatial Construction* (1920). In 1980 the Soviet critic Platon Pavlov even argued that the principal formal structure of the foreground group of gymnasts echoes a spiral, starting with the coach dressed in red in the centre of the image and running anti-clockwise through more than 360 degrees to the figure standing by the parallel bars.[26] There can be little doubt that Zhilinskii's composition deliberately emphasizes simple geometrical forms. Most of the figures included are shown either face on or in stark profile, whilst the athletes' bodies form verticals, with only one of the figures, in the right foreground, adopting a more conventional *contrapposto*. Arms and legs are arranged to form rigid triangles and all the gymnastic equipment is organized strictly parallel to the picture plane. In this way, Zhilinskii's *Gymnasts of the USSR* is very much a product of 1960s Socialist Realism. On the one hand it adopts a conventional figurative style to depict a contemporary theme officially sanctioned by the state. On the other it alludes to the stylistic diversity that characterized cultural production in the Leninist, rather than the Stalinist era. Perhaps most importantly, Zhilinskii's work abandons the excessive utopianism associated with the Stalinist era and adopts a more critical stance towards the subject matter. In contrast to the heroism evident in the works of artists such as Deineka, Samokhvalov and Chaikov, Zhilinskii portrays *fizkultura* as a somewhat ambiguous practice. Whilst this is undeniably a representation of heroes of the Soviet Union, the role of these figures seems confused and uncertain, characterized more by paralysis and stagnation than by exuberant energy. By the mid-1960s the utopian idealism of *fizkultura* as the archetypal means to the development of a new generation had all but been abandoned. Sport was now a simple and straightforward tool of international diplomacy, and sportsmen and sportswomen the products deployed to fulfil the state's plan for world supremacy. Victory in sport had now become a substitute for, rather than a means towards, achieving the goal of world communism.

7 Towards the Bitter End

Zhilinskii's *Gymnasts of the USSR* effectively constituted the first anti-heroic engagement with the *fizkultura* theme in official Soviet culture. Indeed, it is difficult to interpret the work as anything other than a critique of the nostalgic utopianism so central to Deineka's late works. Like many Soviet artists working during the early 1960s, however, Zhilinskii set out neither to reject Soviet values nor to abandon official Soviet culture. Rather, his work attempted to introduce a more critical engagement with the traditions and conventions of Socialist Realism and thus strove to modify, or even reform, official cultural practices. Nonetheless, *Gymnasts of the USSR* marked a watershed in official representations of *fizkultura* and, in many respects, can be regarded as the last major intervention in this genre. From the mid-1960s until the final collapse of the Soviet Union, with the exception of a brief revival of interest at the time of the Moscow Olympic Games of 1980, the *fizkultura* theme all but disappeared from the work of official artists. Yet the decline of the *fizkultura* theme in official culture did not necessarily mean that all artists rejected it. For this was the era of the rise and consolidation of dissident movements within literature and the visual arts, movements that increasingly strengthened as the power and authority of the state itself declined. Thus, on the rare occasions when *fizkultura* did make an appearance it was often in an ironical or critical, rather than a heroic or idealized, context. In this final chapter it will be worth briefly analysing the ways in which the *fizkultura* theme was deployed within unofficial culture during the last two decades of Soviet rule. Here representations of sportsmen and sportswomen increasingly took on a negative identification, signifying political and ideological conformity in a growing era of dissidence.

The roots of the Soviet dissident movement can be traced back to the last years of Stalin's power. For example, as early as 1949 the satirical journal *Krokodil* had reported on what it perceived to be a disturbing sociological phenomenon: namely, the emergence of a disaffected youth sub-culture.[1] A new term was even coined for these

dissident youths, *stilyagi*, deployed ironically as a derivative from the Russian word for style. The notional miscreants were identifiable by certain traits. They let their hair grow long, wore loud clothes and were extremely materialistic in their love of all things Western. Their most damning feature, however, was their idleness (*bezdelnichestvo*). The growth of this sub-culture was predicated, to some degree, on the appalling legacy of the war years. The extensive suffering of children and teenagers during the conflict, both mentally and physically, effectively scarred a whole generation. A significant proportion of Soviet youths had marched straight from the classroom to the front line, whilst many of those too young to serve had been forced to take the place of factory workers. Here conditions were frequently so bad that constant ill health and even retardation of physical development were alarmingly common. Others still, deprived of family and domestic care, were forced into vagabondage and crime just to survive on a daily basis. Whilst readjustment to post-war circumstances inevitably impacted upon the entire population, the effects upon a youthful generation who now knew little or nothing other than constant deprivation were particularly acute. This factor was identified by the Soviet authorities early on. Indeed, the new school curriculum introduced after the war immediately highlighted the importance of physical education specifically to counter the poor health of the younger generation.[2]

Events following the death of Stalin further exacerbated the potential disillusionment of Soviet youth. In the wake of Khrushchev's denunciation of Stalin in 1956 an increasing sense of a generation gap contributed towards the fragmentation of Soviet society. Radicals amongst Soviet youth declared not only Stalin, but also the whole generation that came of age under Stalin, as responsible for the crimes and atrocities perpetrated in his name. This phenomenon, frequently described as the 'fathers and children' debate, contributed significantly towards a new self-confidence amongst Soviet youth, many of whom increasingly rejected the authority of the older generation and, indeed, the Soviet state itself.[3] In this climate, activities specifically promoted by the state and identified as part of the culture of the Stalinist era were widely rejected. Participation in *fizkultura* increasingly came to represent ideological conformity in contrast to more dissident leisure pursuits condemned by the Soviet regime. These, most prominently, included a love of jazz, rock 'n' roll and modern art. This division between conforming and dissident youth was notably articulated in official culture by reference to such notions as health and sickness. Throughout the later 1950s the officially endorsed image of Soviet youth remained broadly similar to that of the Stalin era.

Enthusiastic, dedicated and attractive young men and women, usually of a robust healthiness that belied post-war conditions, adorned the pages of countless novels, appeared on screen in films and formed the subject matter of paintings at the major art exhibitions. The launch of Khrushchev's Virgin Lands project certainly contributed to this presentation of idealized Soviet youth. During the mid-1950s Khrushchev placed a great deal of emphasis on improving agricultural output throughout the Soviet Union. To achieve this objective, vast tracts of Central Asia, western Siberia and the Urals were opened up to agricultural development. Much as youth had been called upon to move to the city during the 1930s to help with the rebuilding of Moscow, now volunteers were asked to abandon the city in favour of forging a new life in the sparsely populated and far-flung regions of the Soviet Union. Leisure, and sport in particular, played almost no role in the public image of the Virgin Land pioneer. Physical fitness and a robust constitution, however, were intrinsically linked to high labour productivity and support for the state. Dissident youth, on the other hand, was most conspicuous by its relative absence within cultural representation. Nonetheless, the *stilyagi* generation was to make a frequent appearance in the caricatures of the popular journals of the day. Here they provided easy targets for officialdom and became the butt of numerous jokes. In particular, the new youth rebels were commonly illustrated as emaciated, anaemic and of sickly pallor. To take just one of countless examples, in 1958 the caricaturist A. Kanevskii produced a satirical image of parents attending their *stilyaga* son (illus. 66). Here rebellious youth is identified not by its energy but its torpor. This youth is not only incapable of supporting his own weight, but can barely lift his head whilst his mother lights his cigarette for him.[4] Such images were explicitly conceived to contrast with the notional vibrant, healthy physiques of Komsomol youth.

By 1957 the Soviet authorities were only too aware of the gulf between the officially approved image of Soviet youth and the reality of growing youth dissidence. In a clear attempt to paper over cracks that were rapidly turning into large fissures and win back popular support amongst the younger generation, the state set about organizing an official public celebration of Soviet youth. The Sixth World Festival of Youth and Students for World Peace, held in Moscow during the summer of 1957 as part of the celebrations for the fortieth anniversary of the October Revolution, was a huge-scale cultural event that attracted both national and international attention. It was also, in many respects, to provide one of the major turning points in post-war Soviet history. From the outset, the Soviet authorities high-

66 Cartoon
published in
Krokodil, 20
December 1958.

lighted sport as a crucial component of the festival and an activity
around which Soviet youth could unite. Thus, the festival began with
a march through the centre of Moscow to the newly built Lenin sports
stadium where the opening ceremony was to take place.[5] Sporting
competitions between individuals and national teams were held
throughout the festival with many of the press responses emphasizing
the friendliness and communal spirit displayed amongst the partici-
pants. Here sport was highlighted as the ultimate expression of officially
sanctioned Soviet values. In terms of popularity, however, far more
interest was focused on the other cultural events that constituted a
part of the overall programme. The most popular and controversial of
these, without doubt, was the major international art exhibition held
at Sokolniki Park. Here, most of the 4,500 works displayed were by
relatively little-known international artists.[6] Nonetheless, the fact
that many of the works on display engaged explicitly with Western
modernist styles certainly added to the caché of the event amongst the
more dissident visitors. Indeed, the staging of the first major Picasso
exhibition in both Moscow and Leningrad the previous year had
already provided a rallying point for dissident youth.[7] The international
art exhibition at the Sixth World Youth Festival served to reinforce
interest in Western modernist culture amongst Soviet youth. Many
artists who subsequently forged their reputations as non–conformists

during the later Soviet period highlight the centrality of this exhibition as one of the major turning points in their careers.[8] Thus, whilst the staging of the Sixth World Youth Festival had aspired to celebrate the unity of Soviet youth, even to bring the dissidents back into the fold, the result was largely to reinforce the division between official and unofficial cultural practices. Sport and *fizkultura* increasingly signified an uncritical, collective conformity. Engagements with so-called modern art practices, on the other hand, became associated with individualism and a rejection of official Soviet values.

Throughout the late 1950s and '60s many unofficial artists, increasingly aware of developments within Western modernism, experimented with Abstraction, Surrealism and other individualistically inspired styles. In this climate it is hardly surprising that the *fizkultura* theme was to play little part. By the early 1970s, however, as a new generation of unofficial artists began critically to re-explore the legacy of Socialist Realism, the *fizkultura* theme raised its head once more. The catalyst for this revival was undoubtedly the emergence of Sots Art, a movement instigated by Vitalii Komar and Aleksandr Melamid, two young graduates of the Stroganov Art Institute in Moscow. Komar and Melamid were broadly familiar with developments in modern Western culture, not least of all the emergence of Pop Art and Conceptualism in the United States and Europe. Rather than follow these practices slavishly, however, the two artists specifically highlighted the distinctions between Soviet and Western ideological positions, focusing their attention much more towards local contexts and experiences. In particular, they identified a parallel between the ubiquity of consumerism in Western capitalism and the abundance of ideological signs and slogans within Soviet socialism. Whereas Western Pop Art deployed imitation, irony and parody to critique this obsession with consumerism, Sots Art used similar strategies to question and undermine official Soviet ideology. In their early collaborative works, such as *Our Goal is Communism* (1972) and *Double Self-portrait* (1972), Komar and Melamid embraced both the verbal and the visual language of Socialist Realism, working explicitly, as Yevgenii Barabanov has claimed, 'with the fetishes of Soviet mass consciousness'.[9] One of the earliest of these works, *Portrait of Melamid's Wife* (1972), reveals the ways in which *fizkultura* could now be deployed to address notions of political and ideological conformity (illus. 67).[10] *Portrait of Melamid's Wife* is designed to parody the utopianism of contemporary official culture and, in particular, ideological posters. Far from being a portrait in the conventional sense of the term, the work presents a simplified, and somewhat clichéd, scene constructed from four distinct signs

67 Vitalii Komar and Aleksandr Melamid, *Portrait of Melamid's Wife* (from *Sots Art* series) 1972, oil on canvas.

stacked, like a series of theatrical backdrops, before a sketchy, utopian blue sky that would grace many a contemporary Socialist Realist canvas. In the background is a silhouette of the Kremlin walls coloured in a uniformly flat red and outlined boldly in white. To the left of this stands the unmistakable profile of the Ostankino television tower, first erected in the north of Moscow in 1967, and then, as now, the tallest structure in the city. Next in sequence is a stylized sail-like form identifiable as the profile of the 100-metre-tall titanium Space Obelisk erected in Moscow in 1964 as a monument to Soviet achievements in space.[11] Here three architectural forms, all strongly associated with the power and authority of the Soviet state, are removed from their geographically disparate settings within the city of Moscow and brought together to form a backdrop to the principal 'sitter' of the portrait, a female athlete who marches before the viewer, performing a movement typical of a choreographed mass gymnastics routine. In one sense, Komar and Melamid are here simply equating the Soviet sportswoman with other recognizable symbols of Soviet monumentalism. The figure is effectively depersonalized, presented as little more than a uniform, anonymous component within the grand machine of the Soviet state, a cipher for Soviet conformity. Other aspects of the

work, however, destabilize this otherwise straightforward reading. First, the sportswoman is presented in isolation from any other performers and notably marches alone. Indeed, her gesture and marching posture look somewhat incongruous as an individual act. Furthermore, the title of the work, *Portrait of Melamid's Wife*, reinforces the sense that we are presented with an individual rather than a type. Here the title should not be taken at face value, and clearly we are not presented with a likeness of Melamid's wife. The lack of facial features or any other identifiable characteristics reinforces this point. Rather, the title draws our attention to the artists' deployment of irony to emphasize the coexistence of, and tensions between, on the one hand, the public and the monumental and, on the other, the private and the personal. Both these modes collide within Komar and Melamid's work much as they collided within Soviet society and culture during the early 1970s. As the dissident movement itself grew, the officially approved emphasis on the collective type was increasingly tempered by the demands for freedom of individual expression and identity. Thus Komar and Melamid here embrace, rather than reject, the signs and symbols of Soviet officialdom, but do so specifically to destabilize the meanings conventionally associated with them. Ultimately, no attempt is made to resolve the tensions here articulated. Rather, it is the incompatibility of these competing aspects that gives the work such a forceful and destabilizing impact.

The satirical representation of the sportsperson as an icon of official Soviet culture can also be detected in the work of another graduate of the Stroganov Art Institute and contributor to the Sots Art movement, Boris Orlov. In 1975 Orlov notably included an ice hockey player in his *Avenue of Heroes*, a mixed-media composition in which the artist presents fourteen illustrations of figures reminiscent of ancient Roman portrait busts (illus. 68). These illustrations are altered by the addition of a uniform to suggest a series of Soviet archetypes including the soldier, the sailor, the worker, the young pioneer and the sportsman. Each figure proudly displays a medal on his or her significantly enlarged chest to reinforce their identity as national heroes. All the faces, however, derive from just two models, thus insisting that their personalities are as uniform as the costumes they wear. Three years later Orlov developed further his series representing Soviet sports figures, as can be seen in *Dinamovka* of 1978 (illus. 69). Here, he again emphasized the imperial bust format, this time, using rough-hewn pieces of wood crudely assembled and painted in bright, garish colours. Orlov's specific emphasis on the imperial Roman bust was clearly intended as an ironic comment on the imperialism of Soviet

culture during the Brezhnev era and, not least of all, the obsession with medals and rewards. Yet, at the same time this stylistic reference makes an allusion to political decline, the fall of the Roman Empire thus providing a historical analogy to the, then merely hoped for, disintegration of the Soviet Union. Orlov's specific use of materials can also be read as a reference to pre-Soviet traditional Russian folk art and particularly the production of carved and painted wooden toys. The mass production of such artefacts for the tourist market, however, especially during the 1970s, certainly diminished the more romantic associations of these objects. Thus Orlov's work refers more broadly to the frequently shoddy manufacture of consumer goods in the Soviet Union at this time, an issue also taken up in the work of other Sots Artists including Aleksandr Kosolapov and Leonid Sokov. For Orlov, the body of the sportswoman is deliberately contrasted with the idealistic model of high Stalinism. Instead, we are presented with a grotesque, carnivalistic version of the Soviet sportswoman, an anti-hero who simultaneously signifies, and challenges, the conventional image of the Stalinist sporting hero.

The emphasis placed upon sport and *fizkultura* by Komar, Melamid and Orlov had a certain topicality in the context of the early 1970s. During this period Soviet sport had continued to dominate the international stage, gaining success after success in major competitions. Nonetheless, the authorities recognized that too few young citizens were now being attracted to sport, not least of all as a consequence of the alternative leisure pursuits popular within the youth dissident movement. In March 1972 the All-Union Committee for Physical Culture and Sport tacitly acknowledged the failures of recent years by introducing a new programme for the GTO training system. This programme encouraged children to participate in sport from a younger age and, more pertinently, tightened up the qualification standards for the award of badges. As Riordan has pointed out, it was popular knowledge at this time that sports honours had frequently been awarded without the requisite level of achievement having been attained. In some cases, badges and awards had even been sold on the black market, a mockery of the awards system that seems to inform Orlov's work.[12] Another crucial motivation, however, for this tightening up of official sports practices was the decision by the Soviet Olympic Committee to put in a bid to host the Olympic Games in Moscow and the need, therefore, to ensure that the next generation of Soviet athletes was capable of performing at the very highest level. The Soviet Union's first proposal to stage the Olympics had come as early as 1969, but at

68 Boris Orlov,
Dinamovka, 1978,
wood, mixed media.

69 Boris Orlov, *Avenue of Heroes*, 1975, mixed media.

this stage they failed to win enough votes to stage the Games due to be held in 1976. In 1974 their second bid was successful and the IOC announced that the Olympic Games of 1980 would take place in Moscow. Throughout the run-up to this event sport was once more widely promoted throughout the Soviet Union. The building of many new sports facilities in the capital provided a clear focus for the further development of sporting interests and for the adoption of sporting themes as part of the architectural decoration. The Games also generated a vast array of specialist sports books and journals, which certainly generated considerable interest. By the late 1970s the *fizkultura* theme thus crept back, albeit briefly, onto the official cultural agenda. In 1979, for example, works such as Z. Dzhakhadze's *Olympic Flame* were exhibited at the Exhibition of Young Artists from the Academy of Arts and attracted the attention of much of the art press, whilst a major All-

Union Art Exhibition in Moscow was dedicated to *Fizkultura and Sport*.[13] Without doubt the most significant work on the *fizkultura* theme produced at this time was B. Talberg's monumental three-panel triptych entitled *Sport* (1979), subsequently purchased for the permanent collection of the Tretyakov Gallery.[14] As the Olympic year dawned, more and more attention was focused upon the relationship between sport and visual culture. A major publication, entitled *Sport and Soviet Art*, was issued by the Soviet publishing house Sovetskii Khudozhnik, whilst countless articles in the official art journal *Iskusstvo* addressed the *fizkultura* theme.[15] Much of this coverage, however, notably emphasized the so-called past masters rather than contemporary practitioners. Both Deineka and Chaikov gained the lion's share of attention in the art press, despite the fact that both artists were already deceased, further reinforcing the sense that the *fizkultura* theme was essentially a nostalgic hangover from an earlier era.

In April 1980, with the Games less than three months away, the Soviet Union suffered a substantial blow to its prestige when the United States, along with 55 other nations, withdrew from the Moscow Games in protest over the Soviet invasion of Afghanistan. In one fell swoop the Soviet Union's crowning moment of sporting glory was reduced to a sideshow. The Soviet press fought on valiantly, referring hardly at all to the absence of the United States and insisting, at all times, that the Games were a huge international success. However, the Soviet team's inevitable victory in the Games rang somewhat hollow without the challenge of its main sporting rivals. The political fiasco generated by the withdrawal of the United States from the Moscow Olympics served, on the one hand, to show that sport was still a highly potent weapon within the ideological and political struggle of the Cold War. But it also revealed how easily a long and carefully planned propaganda coup could be overturned. When the Soviet Union retaliated four years later by withdrawing from the Los Angeles Olympics it was already evident that the significance of the Olympic Games as a Cold War battle-ground and, indeed, the glory days of Soviet sporting hegemony were by now coming to an end.

In the wake of the Moscow Olympics the sports theme continued to make sporadic appearances in the work of unofficial artists, as can be seen in Orlov's ironical caricature entitled *Archaic Values (A Russian Thinks of Himself First)* (illus. 70). Here Orlov placed a diminutive figure before the victory rostrum conventionally used for the medal ceremony at sports events. The victorious athletes are excluded, however, replaced by three huge-scale bottles of vodka, port and beer.

Orlov's biting satire contrasts the officially approved image of clean-cut, healthy living, as epitomized in sport, with the more down-to-earth reality of alcohol abuse, an endemic problem in Soviet society by the early 1980s. Rather than celebrate public victory for the good of the nation, this Soviet citizen fantasizes only about his next journey into private oblivion.

The sports figure also appears as one of a cast of Soviet archetypes in the work of Grisha Bruskin. A contemporary of Komar, Melamid and Orlov, Bruskin first attracted widespread attention in 1983 when his first major exhibition, held in Vilnius, was closed down by the Lithuanian Communist Party. His work, at this time, is reminiscent of the Belgian Surrealist painters René Magritte and Paul Delvaux, not least of all in its emphasis upon highly finished mannequin-like figures, as can be seen in *Monuments* and *Monuments 2* of 1983 (illus. 71). In both these works Bruskin presents a group of incongruous figures, each floating enigmatically above a series of pedestals situated in an eerily empty landscape setting. Each represents a type rather than an individual, and sports figures feature prominently. Drained of all colour, these figures also recall the numerous cheap plaster monuments erected in public spaces throughout the Soviet Union. Indeed, Bruskin was later to highlight the significance of these public monuments to the development of his work:

At that time, the entire country was filled with such sculptures, bad sculptures made from plaster and painted in oil and representing Soviet archetypes . . . Such sculpture was in every city and town square, on buildings, in the subways . . . I remember that opposite my home there was a big statue of Stalin in a garden. And around him were sculptures of sportsmen and sportswomen. Stalin was made of bronze and the others of plaster and painted with oil . . . The statues were terrible, just terrible.[16]

Bruskin's *Monuments* series was to provide the impetus for many of the artist's later works, including his *Fundamental Lexicon* begun in the mid-1980s. These works marked a turning point in his art (illus. 72). Now working in a tiny Moscow studio, Bruskin produced a series of small-scale canvases, each representing a stock character from the pantheon of Soviet archetypes. Each figure is generalized and finished in a neutral white tonality to emphasize a lack of individuality. It is only costume and the inclusion of an attribute, finished in full colour, that ultimately distinguishes one figure from the next. These works were then combined with other, similar images to form one larger work. In this way the final work resembles a traditional Russian iconostasis. Sequence is deliberately random, however, with no individual figure carrying any more significance than another. Thus the work

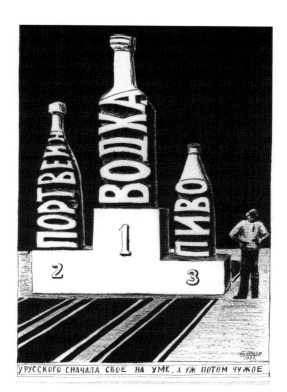

70 Boris Orlov, *Archaic Values (A Russian Thinks of Himself First)*, 1982, pen and ink on paper.

У РУССКОГО СНАЧАЛА СВОЕ НА УМЕ, А УЖ ПОТОМ ЧУЖОЕ

effectively has no centre, no beginning and no end, and, since Bruskin has subsequently produced several works within this format in which the same figures reappear arranged in a different order, the relative positioning is defined as essentially meaningless. Whilst developing his *Fundamental Lexicon* series, Bruskin also experimented with other materials, producing three-dimensional versions of his characters in copper and plaster. The subsequent series of works, presented collectively as *The Birth of the Hero*, once again highlights the absurdity of the Soviet hero as articulated in late Soviet culture, with the sportsman and sportswoman playing a crucial role (illus. 73). More recently, in his series entitled *Archaeologist's Collection*, Bruskin has represented the Soviet sportsman as a fragmented relic, an abandoned monument from a long-forgotten era (illus. 74). Bruskin's collections of Soviet archetypes bear all the hallmarks of high kitsch. Unlike the consumerist kitsch of Western culture, however, these artefacts signify the growing redundancy of official Soviet culture. Like the cheap plaster statues that initially inspired Bruskin, these works cannot but fail to inspire, to communicate the authority associated with the Stalinist era. They are empty shells devoid of ultimate meaning or significance. As Bruskin

71 Grisha Bruskin, *Monuments*, 1983, oil on canvas.

himself has claimed, any 'attempt to identify with such a "hero" means a renunciation of self, of one's individuality'.[17]

For the unofficial artists Komar and Melamid, Orlov and Bruskin, the sportsman and sportswoman operated as little more than stock characters in an official Soviet mythology, and one that was showing signs of rapid decline. These figures were thus deployed critically to signify a lack of individual identity, slavish loyalty and unbending support for the status quo. By the mid-1980s the representation of *fizkultura*, once such a heroic genre within Soviet culture, had become little more than a parody of itself and of the Stalinist heritage, a signifier of all that was bad in Soviet ideology and culture.

When Mikhail Gorbachev came to power in 1985, the Soviet Union was already in deep economic crisis. Opposition to state authority was

72 Grisha Bruskin, *Fundamental Lexicon, Part III (fragment)*, 1986, oil on linen.

potentially at an all-time high as the conflict in Afghanistan continued unabated. The explosion at the Chernobyl nuclear power station in Ukraine the following year served further to destabilize the Soviet government. With more urgent matters to deal with, state support for sports programmes sunk into a significant decline during the perestroika era. Nonetheless, whilst funding was taken away with one hand, political and economic reforms offered a new and lucrative alternative to the major sports clubs and organizations of the Soviet Union. Now

professionalism, so long practised but publicly denied, was out in the open and joined by a more explicitly commercial approach to sport as a consumer product. In 1987, for example, Soviet national teams began to display logos on their sports kits, frequently advertising Western products. More importantly, the transfer of players between clubs took on a new dimension. Whilst this practice was scarcely a novelty – such transfers had taken place during the 1930s – it now entered the international market. Initially, these transfers were confined to players over the age of 28 years.[18] This stipulation was soon dropped, however, as the hard–currency value of such deals became more apparent. In 1988, for example, the Italian soccer team Juventus paid an estimated $5 million for the Dinamo Kiev striker Aleksandr Zavarov.[19] Similar international transfers followed for countless soccer, basketball and ice-hockey stars. These deals were welcomed by some and brought a degree of international prestige, as well as hard cash, to Soviet sport. The inevitable consequence, however, was a rapid decline in the quality of domestic team sports, and the crowds soon drifted away. The reforms of the perestroika era thus brought about what has popularly been referred to as the 'brawn drain', the mass exodus of the Soviet Union's top sportsmen and sportswomen in search of more lucrative financial contracts in the West, a practice that has continued well into the Post-Soviet era.

In 1988, in one final gasp of sporting effort, the Soviet Union secured victory in the Olympic Games at Seoul. By this time, however, the value of such a victory was minimal since few Soviet citizens any longer held the conviction that it could in any way signify the superiority of the communist over the capitalist system. After all, there was now little to distinguish the now openly professional athletes of the Soviet Union from their Western counterparts.[20] *Fizkultura*, such a crucial concept in the early Soviet era, was by now long deceased, its place taken by the global phenomenon of commercial sport. And this was of no more particular interest to Soviet artists, writers or film-makers than it was in any other nation.

Afterword

The dramatic events that unfolded in Moscow during August 1991, leading to the collapse of the Soviet Union, have inevitably facilitated and accelerated a reassessment of official Soviet history and culture. Yet conditions in the Post-Soviet era perhaps serve only to underline the continuing problem of addressing this history. Whilst contemporary theorists and practitioners debate the future direction of Russian

73 Grisha Bruskin, *Sports Figure*, from the series
The Birth of the Hero, 1985.

74 Grisha Bruskin, *Athlete*, from the series
Archaeologist's Collection, 2003, painted bronze.

culture one crucial question continues to cause controversy: what is to
be done with the cultural relics of the Soviet era? Here medium and
display environment have proven crucial. Thus artefacts regarded as
politically sensitive in the wake of the overthrow of the Soviet Union,
such as portraits of Stalin and Lenin and other now less-than-popular
political leaders, could be removed to basements and storage areas
away from the eyes of the public. Monuments erected in public arenas,
however, faced a less certain future as iconoclastic fervour swept
through the former Soviet state. The destruction and subsequent
resurrection of significant monuments, such as Yevgenii Vuchetich's
bronze statue of *Feliks Dzerzhinskii,* the Secret Police Chief, originally
placed in front of the Lubyanka in 1958 and removed by crowds in
August 1991, have been well documented.[21] Less well reported, how-
ever, has been the fate of other monuments less explicitly associated
with the Soviet political leadership. And here, Chaikov's *Football Play-
ers* of 1938 once more provides a useful case study. In 1982 the
Tretyakov Gallery in Moscow was temporarily closed for the renova-
tion and extension of the original building first completed in 1874. At
this time, many exhibits were removed for display at the Picture Gallery
of the USSR on Krymskii Val near the entrance to Gorkii Park. These
included many of the official works of the Stalinist years. The political

and economic upheavals of the late 1980s and early '90s inevitably had a detrimental effect upon the rebuilding programme and the gallery did not in fact fully reopen until 1992, a year after the final collapse of the Soviet Union. With much official Soviet culture, particularly that of the Stalin era, now out of favour, many works were not returned to the original building and remain, to this day, exhibited at the far less popularly attended Krymskii Val site. In the early 1980s, in line with the rebuilding programme, Chaikov's *Football Players* was removed from its former prestigious site in front of the old Tretyakov Gallery and also taken to Krymskii Val. Here it remained for many years, no longer on public display. In the wake of the collapse of the Soviet Union it was to be found neglected, caged off from close public scrutiny, in a darkened corner of the Gallery exterior (illus. 75). Casually mounted on three broken columns, the work was surrounded by other equally neglected works amongst a pile of broken light fittings.[22] One reason for this was that the work was in dire need of repair, the intense weight and pressure on the two pivotal points of football and lower left boot having survived the ravages of time less successfully than Lukyanov's casting first suggested. There was, however, probably more at stake here. As a prime example of a representation of *fizkultura* produced during the inter-war period, Chaikov's *Football Players* was certainly linked to Stalinism by association. Yet, simultaneously, its emphasis on sport seemed to distance its direct significance for the worst atrocities of the Stalinist era and, unlike other monuments to important political figures, it was not targeted for vandalism. Rather, Chaikov's *Football Players* stood uncleaned, unrepaired and seemingly unloved. In recent years however, the work has undergone restoration and has now been re-displayed within the New Tretyakov Gallery, as an enduring document exemplifying the youthful aspirations, as well as the misguided falsehoods, of Soviet society and cultural production during the decade or so before the Great Fatherland War. As one of the largest, best-known and most interesting representations of *fizkultura*, it certainly deserves this more sympathetic fate.

The *fizkultura* theme in Soviet culture has been much neglected by historians and cultural commentators. Too omnipresent to be entirely ignored, representations of *fizkultura* are commonly given a fleeting mention, yet relegated to minor interest in comparison with other themes such as the representation of workers, soldiers and political leaders. Yet, as I hope to have shown, representations of *fizkultura* marked a significant contribution to the ultimate development of official Soviet culture. Whilst the overriding aim of many of these works was unquestionably to serve the needs of the Soviet state, the ways in which those

75 Iosif Chaikov,
The Football Players,
1938, bronze.
Photograph taken
outside the State
Tretyakov Gallery in
Moscow, Spring 1996.

interests were to be served, and indeed what those interests specifi-
cally were, were not always predetermined or agreed upon. Hence a
degree of interpretation on the part of the cultural producer was
always required. By the end of the Soviet era sport and *fizkultura* had
even permeated attitudes developed within the work of unofficial
artists. As we reflect upon the passage of the twentieth century and
take stock of its major cultural achievements it is impossible to ignore
the significant role played by the Soviet Union. The emergence and
consolidation of Socialist Realism as the officially approved cultural
policy throughout much of the century contributed to the transforma-
tion of the cultural landscape, both through imitation and opposition,
and continues to be a contentious arena both for academic study and
public exhibition. Yet, to be fully comprehended, official Soviet culture
must be studied in detail, in its breadth and complexity, not in its
simplicity. Ultimately, it is to be ignored, underestimated or simplified
at our peril. As Joad Raymond has suggested, 'it is an act of historical
retouching to efface its profound and critical voice. In any other context
we would label this vandalism.'[23]

References

Introduction

1 *Sovetskii Sport* (6 August 1957), p. 8.
2 James Riordan, *Sport in Soviet Society* (Cambridge, 1977), p. 148.
3 Quoted in Mary Ann Wingfield, *Sport and the Artist: Ball Games* (Woodbridge, 1988), vol. I, p. 14.
4 Henry Morton, *Soviet Sport: Mirror of Soviet Society* (New York, 1963).
5 Robert Edelman, *Serious Fun: A History of Spectator Sports in the USSR* (Oxford, 1993), p. ix.
6 Louis Lozowick, *Modern Russian Art* (New York, 1925); Alfred H. Barr, *Cubism and Abstract Art*, exh. cat., Museum of Modern Art, New York (1936); Camilla Gray, *The Great Experiment: Russian Art, 1863–1922* (New York and London, 1962).
7 Jack Chen, *Soviet Art and Artists* (London, 1944); Cyril Bunt, *Russian Art: From Scyths to Soviets* (New York and London, 1946); George Loukomskii, *A History of Modern Russian Painting, 1840–1940* (London, 1945).
8 *Russian Painting*, exh. cat., Royal Academy of Arts, London (1959); *Exposition Lénine, 1870–1924*, exh. cat., Grand Palais, Paris (1970); *Russian and Soviet Painting*, exh. cat., Metropolitan Museum of Art, New York (1977).
9 See Peter Roberts, *George Costakis: A Russian Life in Art* (Ottawa, 1994).
10 Paul Wood, 'The Politics of the Avant-Garde', in *The Great Utopia: The Russian and Soviet Avant-Garde, 1915–32*, exh. cat., Guggenheim Museum, New York (1992), p. 6.
11 Brandon Taylor, *Art and Literature under the Bolsheviks, 1917–1932*, 2 vols (London, 1991–2).
12 Matthew Cullerne Bown, *Art under Stalin* (Oxford, 1991); Matthew Cullerne Bown, *Socialist Realist Painting* (New Haven, CT, 1998).
13 Matthew Cullerne Bown and Brandon Taylor, eds, *Art of the Soviets: Painting, Sculpture and Architecture in a One-Party State, 1917–1992* (Manchester, 1993).
14 A recent collection of essays has further contributed to this expansion. See Thomas Lahusen and Evgeny Dobrenko, eds, *Socialist Realism without Shores* (Durham, NC, and London, 1997). Whilst this collection focuses predominantly on literature, it also includes contributions on architecture, film and the visual arts.
15 Igor Golomstock, *Totalitarian Art in the Soviet Union, the Third Reich, Fascist Italy and the People's Republic of China* (London, 1990), and Boris Groys, *The Total Art of Stalinism: Avant-Garde, Aesthetic Dictatorship and Beyond*, trans. Charles Rougle (Princeton, NJ 1992).
16 Golomstock points out in his introduction that his text was first completed in 1985, before the period of perestroika. Similarly, Groys's text was first published in German in 1988 under the title *Gesamkunstwerk Stalin*.
17 The use of dissident voices from within the Soviet system to reinforce opposition from without was a common practice at the height of the Cold War. Here exiles, most notably such figures as Aleksandr Solzhenitsyn, played a crucial role in Western

attempts to undermine official Soviet culture. Paul Wood has referred to this tactic as 'the horse's mouth effect'. See Wood, 'The Politics of the Avant-Garde', p. 4.

18 *Agitation for Happiness: Soviet Art of the Stalin Epoch*, exh. cat., Dokumenta, Kassel, and State Russian Museum, St Petersburg (1993); *The Tyranny of Beauty: Architecture of the Stalin Era*, exh. cat., Oesterreichisches Museum, Vienna (1994); Irina Antonova and Jorn Merkert, *Berlin–Moscow, 1900–1950*, exh. cat., Pushkin State Museum of Fine Arts, Moscow (1996); and *Dream Factory Communism: The Visual Culture of the Stalin Era*, exh. cat., Schirn Kunsthalle, Frankfurt (2003).

19 *Art and Power: Europe under the Dictators, 1930–45*, exh. cat., Hayward Gallery, London (1995).

20 Amongst the many texts addressing these issues, see C. V. James, *Soviet Socialist Realism: Origins and Theory* (London, 1973).

21 Soccer did provide something of an exception to this rule. Having its origins in the factories, frequently run by British industrialists, local worker teams had been formed in the major cities by the early 1910s.

22 Quoted in James Riordan, *Sport, Politics and Communism* (Manchester, 1991), p. 4.

23 Riordan, *Sport, Politics and Communism*, p. 25.

24 Riordan, *Sport, Politics and Communism*, p. 25.

25 Other terms derived from this root, such as *fizkulturnik* and *fizkulturnitsa* (male and female physical culturists) and their associated plurals *fizkulturniki* and *fizkulturnitsy*, will also be used throughout this text.

26 'Fizicheskaya Kultura', *Great Soviet Encyclopaedia*, vol. LVII (Moscow, 1936), pp. 304–5.

1 *Visualizing* Fizkultura

1 N. G. Chernyshevsky, *What Is To Be Done?: Tales about New People*, trans. Benjamin R. Tucker (London, 1982). See also Katerina Clark, *The Soviet Novel: History as Ritual* (Chicago, 1981), p. 49.

2 The role of Rakhmetov in the formulation of the Soviet New Person is also discussed in Toby Clark, 'The "New Man's" Body: A Motif in Early Soviet Culture', in *Art of the Soviets: Painting, Sculpture and Architecture in a One-Party State, 1917–1992*, ed. Matthew Cullerne Bown and Brandon Taylor (Manchester, 1993), pp. 33–50.

3 James Riordan, *Sport in Soviet Society* (Cambridge, 1977), p. 43.

4 Quoted in Lewis Siegelbaum, *Stakhanovism and the Politics of Productivity in the USSR, 1935–41* (Cambridge, 1988), p. 225.

5 Christina Lodder, *Russian Constructivism* (New Haven and London, 1983), p. 187. See also Margarita Tupitsyn, *The Soviet Photograph, 1924–37* (New Haven, CT, 1996), p. 13.

6 K. Michael Hays, 'Photomontage and its Audience: El Lissitzky Meets Berlin Dada', in *The Avant-Garde Frontier: Russia Meets the West, 1910–1930*, ed. Gail Harrison Roman and Virginia Hagelstein Marquardt (Gainesville, FL, 1992), p. 185.

7 Hays, 'Photomontage and its Audience', p. 185.

8 Tatyana Strizenova et al., *Costume Revolution: Textiles, Clothing and Costume of the Soviet Union in the Twenties* (London, 1989), p. 173.

9 Nicoletta Misler, 'The Science of Dressing from the Industrial Workshop: The Russian Academy of Artistic Science and Costume – A Summary', in Strizenova et al., *Costume Revolution*, p. 47.

10 Amongst textile designs emphasizing the *fizkultura* theme are *Gymnasts* by Serpuchov, late 1920s; *Water Sports* by Raisa Matveeva; and *Water Sports* by Mariya Anufrieva. See Strizenova et al., *Costume Revolution*, pp. 130–60.

11 Margarita Tupitsyn, 'Back to Moscow', in her *El Lissitzky beyond the Abstract Cabinet: Photography, Design, Collaboration* (New Haven and London, 1999), pp. 33–4. *El Lissitzky: Architect, Painter, Photographer, Typographer, 1890–1941*, exh. cat., Abbemuseum, Eindhoven (1990).

12 The international Workers' Olympic movement was also founded during the inter-war period. This organization staged three Olympiads, beginning in Frankfurt-am-Main in 1925. Conflict between the two major Workers' Sports Movements, the European-based Lucerne Sport International (LSI) and the Soviet-based Red Sport International (RSI), resulted, however, in the Soviets not being invited to participate until the last Antwerp event in 1937. See Victor Peppard and James Riordan, *Playing Politics: Soviet Sport Diplomacy to 1992* (Greenwich, CT, and London, 1993), pp. 27–48.

13 *Izvestiya* (12 August 1928), p. 1.

14 The official capacity of the Dinamo stadium in 1928 was 35,000, although crowds up to 50,000 were not unusual. The largest sports arena in Moscow before the building of the Dinamo stadium was the Tomskii stadium with a capacity of 15,000. See Robert Edelman, *Serious Fun: A History of Spectator Sports in the USSR* (Oxford, 1993), pp. 39–47.

15 *Izvestiya* (12 August 1928), p. 1.

16 *Izvestiya* (23 May 1925).

17 Vera Vasilevna Yermonskaya, *Yanson-Manizer* (Moscow, 1961), p. 6, and Avgusta Ivanovna Komoliets, *Yanson-Manizer* (Moscow, 1970), p. 1.

18 Komoliets, *Yanson-Manizer*, p. 1. This exhibition was briefly mentioned in the specialist journal *Spartakiada*, 2 (1928), p. 13.

19 Chaikov had earlier stated the important relationship between form and space in sculptural work: 'In a composition of two or more figures, the most difficult thing is to exploit the hollow spaces between the figures so that we don't see "holes" in the sculpture . . . so that the inner space is as expressive as the figurative aspects.' Quoted in John E. Bowlt, 'Rodchenko and Chaikov', *Art and Artists* (October 1976), p. 32.

20 *Iskusstvo*, 3 (1933), p. 113. The article in which Romm posited the notion of 'constructive realism' entitled 'On the Creativity of Iosif Chaikov' specifically addressed the work of Chaikov, yet clearly sought to promote a wider acceptance of a formalist vocabulary in contemporary art. Romm's concept was never really taken up, and, after the Soviet Writers' Congress of 1934 and the declaration that Socialist Realism was to be the only acceptable method for Soviet artists, effectively disappeared.

21 An early twentieth-century sculpture of *Hercules and Antaeus* by Vasilii Kuznetsov (1911–12) is also in the collection of the Russian Museum in St Petersburg.

2 Sporting Icons

1 *Iskusstvo* appeared bi-monthly. In 1934 it was joined by a second journal, *Tvorchestvo*. This larger-format monthly was more an illustrated journal with considerably shorter and fewer articles.

2 Of the artists given monographic coverage in the first year of *Iskusstvo* only Fyodor Bogorodskii was a full member of AKhRR. Other artists, more usually associated with the left, included Pyotr Konchalovskii and Georgii Stenberg.

3 The Moscow leg of the exhibition opened on 27 June 1933. See *Iskusstvo*, 4 (1933). For a full list of contributors, see *Artists of the RSFSR during the Last Fifteen Years (1917–32)*, exh. cat., Historical Museum, Moscow (1933), and Valentina Grigorevna Azarkovich, *Exhibitions of Soviet Art*, 4 vols (Moscow, 1965–75), vol. II, p. 9.

4 Natan Strugatskii, 'Aleksandr Samokhvalov', *Iskusstvo*, 5 (1933), pp. 1–17. The article

was based on Strugatskii's monograph published later that year. See Natan Strugatskii, *Aleksandr Samokhvalov* (Leningrad, 1933).

5 A. Lebedev, *Soviet Painting in the Tretyakov Gallery* (Leningrad, 1976), p. 103. *Girl Wearing a Football Jersey* was awarded a Gold Medal at the Paris show. See Leonid Semenovich Zinger, *Aleksandr Samokhvalov* (Moscow, 1982), p. 15.

6 The work was later illustrated in *Iskusstvo*, 2 (1934), p. 28.

7 'In his compositions Samokhvalov deployed volumetric and planar principles, which originated in his discovery and appreciation of Russian frescoes and antique painting.' Strugatskii, *Aleksandr Samokhvalov*, p. 21.

8 John Milner, *A Dictionary of Soviet Art and Artists, 1420–1970* (Woodbridge, 1993), p. 369, and Wolfgang Holz, 'Allegory and Iconography in Socialist Realist Painting', in *Art of the Soviets: Painting, Sculpture and Architecture in a One-Party State, 1917–1992*, ed. Matthew Cullerne Bown and Brandon Taylor (Manchester, 1993), pp. 73–85. Matthew Cullerne Bown has also claimed that Samokhvalov incorporated into his work 'a revival of stylistic elements from old Russian religious paintings'. See Matthew Cullerne Bown, *Art under Stalin* (Oxford, 1991), p. 46.

9 Amongst other scholars publishing work on the icon in the late nineteenth century were N. Pokrovskii, D. Rovinskii, A. Vinogradov, V. Vostokov, I. Zabelin and V. Zverinskii.

10 Alison Hilton, *Russian Folk Art* (Bloomington, IN, 1995), pp. 266–7.

11 Hilton, *Russian Folk Art*, pp. 266–7.

12 See Aleksandr Samokhvalov, *My Creative Journey* (Leningrad, 1977), pp. 40–42. At the Academy of Arts he enrolled in the classes of Professor Kiplik, who taught the traditional techniques of painting in encaustic, fresco and tempera.

13 See Samokhvalov, *My Creative Journey*, p. 106. The murals have been discussed in V. N. Lazarev, *Old Russian Murals and Mosaics* (London, 1966), and V. N. Lazarev, *The Frescoes of Staraya Ladoga* (Moscow, 1960).

14 Samokhvalov specifically linked the painting of *The Man with a Scarf* with his experiences at Ladoga: 'The small work *The Man with a Scarf* dates from this period. It is a search, by simple means, for the image of man. Ancient Russian frescoes here showed me the way.' Samokhvalov, *My Creative Journey*, p. 120.

15 Strugatskii, *Aleksandr Samokhvalov*, p. 29.

16 Nina Tumarkin, *Lenin Lives! The Lenin Cult in Soviet Russia* (Cambridge, MA, 1983).

17 Ulf Abel, 'Icons and Soviet Art', in *Symbols of Power: The Esthetics of Political Legitimation in the Soviet Union and Eastern Europe*, ed. Claes Arvidsson and Lars Erik Blomqvist (Stockholm, 1987), pp. 141–62; Holz, 'Allegory and Iconography', pp. 73–85; Brandon Taylor, 'Photo–Power: Painting and Iconicity in the First Five Year Plan', in *Art and Power: Europe under the Dictators, 1930–45*, exh. cat., Hayward Gallery, London (1995), pp. 249–52; and A. Michelson, 'The Kinetic Icon in the Work of Mourning: Prolegomena to the Analysis of a Textual System', *October*, 52 (1990), pp. 16–51.

18 Abel, 'Icons and Soviet Art'.

19 Abel, 'Icons and Soviet Art', p. 145.

20 Taylor, 'Photo–Power', p. 250.

21 Leonid Ouspensky and Vladimir Lossky, *The Meaning of Icons* (New York, 1982), pp. 38–9.

22 Ouspensky and Lossky, *The Meaning of Icons*, p. 38.

23 Ouspensky and Lossky, *The Meaning of Icons*, p. 37.

24 Sergei Averintsev, '"Visions of the Invisible": The Dual Nature of the Icon', in *Gates of Mystery: The Art of Holy Russia*, ed. Roderick Grierson, exh. cat., Victoria and Albert Museum, London (Cambridge, 1993), p. 12.

25 In an earlier sketch version of *Girl Wearing a Football Jersey* Samokhvalov included a

tennis racket in the figure's right hand.

26 Melanie Ilič, ed., *Women in the Stalin Era* (Basingstoke, 2001), p. 4.

27 These phrases were commonly used in the both *Pravda* and *Izvestiya*. See Mary Buckley, *Women and Ideology in the Soviet Union* (New York, 1989), pp. 109–15.

28 Buckley, *Women and Ideology*, p. 103. For more on the formation of Zhenotdel, see Barbara Evans Clements, Barbara Alpern Engel and Christine D. Worobec, eds, *Russia's Women: Accommodation, Resistance, Transformation* (Berkeley, CA, 1991). Other texts dealing directly with the issue of women's roles in Soviet society include Wendy R. Goldman, *Women, the State and Revolution: Soviet Family Policy and Social Life, 1917–36* (Cambridge, 1993), and Dorothy Atkinson, Alexander Dallin and Gail Warshofsky Lapidus, eds, *Women in Russia* (New York, 1978).

29 Buckley, *Women and Ideology*, p. 115.

30 James Riordan, *Sport in Soviety Society* (Cambridge, 1977), p. 64.

3 Participants and Spectators

1 *Pravda* (13 July 1937), p. 6.

2 Robert Edelman, *Serious Fun: A History of Spectator Sports in the USSR* (Oxford, 1993), p. 64.

3 *Pravda* (25 June 1937), p. 6. See also Victor Peppard and James Riordan, *Playing Politics: Soviet Sport Diplomacy to 1992* (Greenwich, CT, and London, 1993), p. 44.

4 On 24 June the Basques comfortably defeated Lokomotiv 5–1 and, a few days later, beat Dinamo 2–1. See *Pravda* (25 and 28 June 1937). After drawing 2–2 in Leningrad, the Basques returned to Moscow to meet Dinamo again before competing against Spartak.

5 *Pravda* (13 June 1937), p. 1.

6 In their attempts to undermine traditional 'bourgeois' sports, the Proletkultists produced a book entitled 'New Games for Children'. These included such theatrically conceived activities as 'Rescue from the Fascists' and 'Helping the Proletarians'. See James Riordan, *Sport in Soviet Society* (Cambridge, 1977), p. 102.

7 Riordan, *Sport in Soviet Society*, p. 106.

8 Riordan, *Sport in Soviet Society*, p. 96.

9 *Spartakiada*, 1 (1928), p. 7.

10 Boris Gromov, 'Think of the Spectator', *Spartakiada*, 2 (1928), p. 4.

11 *Spartakiada*, 2 (1928), p. 7.

12 P. E. Hall, 'Sport', in *Playtime in Russia*, ed. Hubert Griffith (London, 1935), p. 189.

13 Hall, 'Sport', pp. 191–2.

14 Edelman, *Serious Fun*.

15 Edelman, *Serious Fun*, pp. 53–4.

16 Edelman, *Serious Fun*, p. 54.

17 Edelman, *Serious Fun*, p. 54. Riordan has also drawn attention to another riot which took place on 24 July 1937. This followed a particularly ill-disciplined game between Dinamo Leningrad and Dinamo Moscow, in which three of the Leningrad players were seriously injured. From that point onwards, major Soviet soccer matches always had a ring of soldiers separating the fans from the pitch. See Riordan, *Sport in Soviet Society*, p. 133.

18 For a full analysis of the implications of Stakhanovism, see Lewis H. Siegelbaum, *Stakhanovism and the Politics of Productivity in the USSR, 1935–41* (Cambridge, 1988).

19 Riordan, *Sport in Soviet Society*, p. 133.

20 This cartoon is also reproduced in Edelman, *Serious Fun*, p. 54.

21 Peppard and Riordan, *Playing Politics*, pp. 27–48.

22 See Peppard and Riordan, *Playing Politics*, pp. 27–48.

23 *A Pageant of Youth* (Moscow, 1939), unpaginated. A British writer and supporter of the Soviet regime, George Sinfield, also adamantly extolled the virtues of amateurism in Soviet sport, although he did acknowledge the 'compensation for time from work factor'. See George Sinfield, *A Nation of Champions: All About Soviet Sport 3*, in the series 'Russia Has a Plan' (1941), and George Sinfield, *Soviet Sport* (Watford, 1945).

24 First published in the literary journal *Krasnaya Nov*, Olesha's *Envy* gained positive responses from both Gorkii and Lunacharskii. Other critics, however, found its message potentially ambiguous and were unsure whether it condemned or glorified the bourgeois past. For an analysis of the text, see Andrew Barrett, *Iuri Olesha's Envy* (Birmingham, no date).

25 Yurii Olesha, *Envy*, trans. J. C. Butler (Moscow, 1988), p. 150.

26 Olesha, *Envy*, p. 150.

27 Olesha, *Envy*, p. 151.

28 *The First Exhibition of Leningrad Artists*, exh. cat., Russian Museum, Leningrad (1935). Illustrated between p. 36 and p. 37. The work is also briefly mentioned in *Iskusstvo*, 3 (1935), p. 15.

29 Vladimir Petrovich Sysoev, *Aleksandr Deineka* (Moscow, 1989), vol. I, p. 132.

30 *First Exhibition of Leningrad Artists*, exh. cat. (Leningrad, 1935), cat. nos 106 and 107. Also see *Iskusstvo*, 3 (1935), p. 8.

31 'Two of [the players] are represented mid jump, at the height of their leap, which gives the whole painting the character of a slow motion movie scene degrading the overall effect of the work'. *Iskusstvo*, 3 (1935), p. 8.

32 Sarah Wilson, 'The Soviet Pavilion in Paris', in *Art of the Soviets: Painting, Sculpture and Architecture in a One-Party State, 1917–1992*, ed. Matthew Cullerne Bown and Brandon Taylor (Manchester, 1993). Also see Mariya Kristina Tsopf, 'The Soviet Pavilions at the International Exhibitions 1937 in Paris and 1939 in New York', in *Agitation for Happiness: Soviet Art of the Stalin Epoch*, exh. cat., Dokumenta, Kassel, and State Russian Museum, St Petersburg (1993), pp. 60–64.

33 Samokhvalov suggested that the decision to undertake the *Soviet Fizkultura* panel was his own and that he proposed that Deineka be offered the central panel. See Aleksandr Samokhvalov, *My Creative Journey* (Leningrad, 1977), pp. 267–8. Before being despatched for Paris, Samokhvalov's panel was sent to Moscow for inspection. See I. Barsheva and K. Sazonova, *Aleksandr Nikolaevich Samokhvalov* (Leningrad, 1963), p. 28. In Paris *Soviet Fizkultura* secured Samokhvalov a Grand Prix to match the Gold Medal also awarded him for his earlier *Girl Wearing a Football Jersey*.

34 See Craig Brandist, *Carnival Culture and the Soviet Modernist Novel* (London, 1996). See also Richard Stites, *Russian Popular Culture: Entertainment and Society since 1900* (Cambridge, 1992).

35 Brandist, *Carnival Culture*, pp. 31–5. It is, of course, no coincidence that Mikhail Bakhtin, the principal theorist of this notion of the 'carnivalesque', witnessed first hand the importance ascribed to street festivals by the Stalinist authorities. Bakhtin outlined his influential theory of the 'carnivalesque' in relation to the literary work of François Rabelais in his text *Rabelais and his World*, first published in 1965, but originally written in 1940. See Mikhail Bakhtin, *Rabelais and his World*, trans. Hélène Iswolsky (Cambridge, MA, 1968).

36 International Youth Day (1924) was celebrated with a parade on Red Square consisting of a few hundred soccer players, oarsmen and athletes. The only large-scale parade held during this period took place in 1927 when an official *fizkultura* parade brought 12,000 marchers onto Red Square. See *Izvestiya* (12 June 1933), p. 1.

37 *Pravda* (13 August 1928), p. 1.

38 Ya. Brodskii, ed., *Soviet Sport: The Success Story* (Moscow, 1987), p. 20.
39 *Izvestiya* (14 June 1933), p. 1.
40 *Izvestiya* (14 June 1933), p. 1.
41 At the *fizkultura* parade of 1938, for example, participants marched past the mausoleum in a column spelling out the leader's name. See *Krasnyi Sport* (27 July 1938), p. 1.
42 Edelman, *Serious Fun*, p. 43.
43 Karen Petrone, *Life Has Become More Joyous, Comrades: Celebrations in the Time of Stalin* (Bloomington, IN, 2000), pp. 25–6.
44 *Tvorchestvo*, 3 (1938), pp. 20–21.
45 Selim O. Khan-Magomedov, *Rodchenko: The Complete Works* (London, 1986), p. 238.
46 *Krasnyi Sport* (1 August 1938), p. 3.
47 *Krasnyi Sport* (19 August 1938).
48 See *Iskusstvo*, 1 (1938), p. 96; Izabella Ginzburg, 'Some Notes on the Exhibition of Leningrad Artists', *Iskusstvo*, 2 (1938), pp. 53–4; *Izvestiya* (30 December 1937), p. 1.
49 Samokhvalov, *My Creative Journey*, p. 222.
50 Samokhvalov, *My Creative Journey*, p. 216. The stadium to which Samokhvalov referred was almost certainly the Kirov stadium built on the western tip of Krestovskii Island in Leningrad. In 1933 the marshy tip of the island was filled in to enable the stadium to be built, but the project was held up and the stadium not finally completed until 1950.
51 For more on the assassination of Kirov, see Chris Ward, *Stalin's Russia* (New York and London, 1993); Robert Conquest, *Stalin and the Kirov Murder* (London and Sydney, 1989); J. Arch Getty, 'The Politics of Repression Revisited', in *Stalinist Terror: New Perspectives*, ed. J. Arch Getty, and Roberta T. Manning (Cambridge, 1993).
52 Valentina Grigorevna Azarkovich, *Exhibitions of Soviet Art*, 4 vols (Moscow, 1965–75), vol. II, p. 138.
53 *Iskusstvo*, 1 (1938), pp. 91–2.
54 *Iskusstvo*, 1 (1938), p. 92.
55 Matthew Cullerne Bown, *Art under Stalin* (Oxford, 1991), pp. 97–8.
56 The substitution of Stalin's visage for that of Lenin almost certainly occurred in the wake of the denunciation of Stalin at the Twentieth Congress of the Communist Party of the Soviet Union in 1956.

4 *Going Underground*

1 L. M. Kaganovich, *Socialist Reconstruction of Moscow and Other Cities in the USSR*, trans. Martin Lawrence (London, 1931), p. 99.
2 David Hoffmann, *Peasant Metropolis: Social Identities in Moscow, 1929–41* (Ithaca, NY, and London, 1994).
3 Kaganovich, *Socialist Reconstruction of Moscow*, p. 22.
4 Hoffmann, *Peasant Metropolis*, p. 42.
5 Hoffmann, *Peasant Metropolis*, pp. 51–2.
6 See William K. Wolf, 'Russia's Revolutionary Underground: The Construction of the Moscow Subway, 1931–35', PhD thesis, Ohio State University, 1994.
7 See *Moscow Metropolitan: Architecture of the Moscow Metro* (Moscow, 1936), pp. 21–4; see also Mike O'Mahony, 'Representing *Fizkultura*: Sport and Soviet Culture from the First Five-Year Plan to the Great Patriotic War, 1929–45', PhD thesis, University of London, 1998, pp. 238–97.
8 Valentin Berezin, *Moscow Metro* (Moscow, 1989). Kaganovich, *Socialist Reconstruction of Moscow*, p. 58. P. Lopatin, *The First Soviet Metro System* (Moscow, 1934), p. 3.

9 A. Kosarev, ed., *How We Built the Metro* (Moscow, 1935). See also Nobuo Shimo-
 tomai, *Moscow under Stalinist Rule, 1931–34* (London, 1991), p. 122.
10 Kosarev, *How We Built the Metro*. See also 'Metro special' in *Moscow Daily News*
 (16 May 1935), p. 9.
11 *Pravda* (5 February 1935), p. 6. Over the following months many groups were given
 special tours through the system in advance of its official inauguration. In April 1935
 Pravda reported that the British Foreign Secretary, Anthony Eden, was given a
 metro tour whilst on a trip to Moscow. See *Pravda* (1 April 1935), p. 2.
12 The music and lyrics to 'The Song of the Metro Conquerors' were published in
 Pravda (15 February 1935), p. 8, whilst a second hymn, 'We have a Metro', appeared
 in *Izvestiya* on the official opening day of 15 May 1935. A little red book of poems,
 all written by metro workers, was officially put on sale at all stations from the first
 day of operation. Marches in honour of the metro were reported in the *Moscow
 Daily News* (23 May 1935), p. 5.
13 *Pravda* (14 May 1935).
14 Berezin, *Moscow Metro*, pp. 3–4.
15 E. D. Simon, *Moscow in the Making* (London and New York, 1937), p. 205.
16 Kaganovich, *Socialist Reconstruction of Moscow*, p. 56.
17 Hoffmann, *Peasant Metropolis*, pp. 129–31.
18 In the 1930s this line was built only as far as the Kurskaya station. The second
 section, extending as far as Izmailovskii Park, was built during the war and
 completed in 1944.
19 Kosarev, *How We Built the Metro*, p. 89.
20 Kosarev, *How We Built the Metro*, p. 94.
21 *Moscow Daily News* (1 May 1935), p. 7. Many more stories outlining this form of
 social transformation are outlined in Kosarev, *How We Built the Metro*.
22 Kosarev, *How We Built the Metro*, pp. 178–9.
23 *Sovietland*, 2 (1935), p. 36. Even when actual performances were not taking place,
 the tunnels were frequently bathed in music from portable gramophones.
24 Kosarev, *How We Built the Metro*, p. 179.
25 M. V. Babenchikov, *Ye. Ye. Lansere: Masters of Soviet Graphic Art* (Moscow, 1949),
 and M. V. Babenchikov, 'E. E. Lansere', *Iskusstvo*, 5 (1935), p. 97.
26 A photograph of the *Discus Thrower* was published in *Pravda* (16 May 1935). The
 two statues were also reproduced in the journal *Sovetskii Metro* (13 and 20 June
 1935), p. 4. A mural for inside the station pavilion was also planned but never
 executed. See *Moscow Metropolitan: Architecture of the Moscow Metro* (Moscow,
 1936), pp. 50–53.
27 A plaster cast of Myron's *Discobolus* was on permanent display at the Pushkin
 Museum during the 1930s. This famous work was also illustrated and highly praised
 in *Iskusstvo*, 5 (1935), pp. 17–24.
28 *Pravda* (27 January 1935), p. 6.
29 These figures are no longer present at Okhotnyi Ryad station, the niches currently
 standing empty.
30 The first article, additionally subtitled 'Synthesis in the Design of the Station
 Ploshchad Revolyutsii on the Moscow Metro', was published in *Iskusstvo*, 2 (1938),
 pp. 28–42. A second article, also entitled 'The Problem of Synthesis on the Metro'
 and subtitled 'Synthesis in the Design of Stations on the Gorkii Radius of the
 Moscow Metro', was published in *Iskusstvo*, 6 (1938), pp. 63–75.
31 *Iskusstvo*, 2 (1938), p. 29.
32 'Decorative paintings and sculptures always lose their status as independent work,
 and thus become simply ornament and decoration, varying but not adding deeper
 meaning to architectural forms. Whereas when a work is synthesized within an

architectural setting, not only does it maintain its independent content but on the contrary, it develops further within its environment.' *Iskusstvo*, 2 (1938), p. 30.

33 Dushkin's original plan proposed that these statues be bas-reliefs. Since the particular spaces for these sculptures included an awkward right-angled corner, Manizer opted instead for figures in the round. See *Iskusstvo*, 2 (1938), p. 34.

34 Sosfenov suggested that 80 statues were originally cast for the station. Today, the central vestibule contains only nine pairs, the last in the series, 'The Pioneers', appearing only on the two platforms. Thus a total of 76 sculptures can be seen in the station.

35 See Mike O'Mahony, 'Archaeological Fantasies: Constructing History on the Moscow Metro', *Modern Language Review*, XCVIII/1 (2003), pp. 138–50.

36 *Iskusstvo*, 6 (1938), p. 74.

37 Sosfenov recognized that the reference to the Gothic cathedral was indeed a crucial aspect in Dushkin's design, yet he also went to some lengths to undermine any claims of straight copying. For Sosfenov, it was precisely the reinvention of, rather than the straight reference to, the past that was important: 'A connection with past cultures can clearly be seen in the architectural forms of the station, but this similarity is not straightforward borrowing. The general impression of this famous "goth-icism" by no means limits its status as a new type of architecture. The author, starting with the roots of form, reworks these motifs to create an original and very valuable design.' *Iskusstvo*, 6 (1938), p. 72.

38 Deineka stated that 35 panels were originally designed for installation at Mayakovskaya station. Today there are only 33 panels. Of the missing two, one, depicting a Soviet flag flying in the wind, was reproduced in *Tvorchestvo*, 11 (1938), p. 15.

39 Aleksandr Deineka, ,'Metro Mosaics', *Tvorchestvo*, 11 (1938), pp. 14–17, and Deineka, Aleksandr, 'Artists on the Metro', *Iskusstvo*, 6 (1938), pp. 75–80.

40 'The resolution of the ceiling panels was dependant upon the architectural design, which considerably complicated the mosaic work and presented it with difficult and unfavourable conditions. The small area of the cupolas, elliptical in form, made the compositional work very difficult. The foreshortening proved to be a dreadful problem.' *Tvorchestvo*, 11 (1938), p. 15.

41 Indeed, direct references to powered flight are made in 21 of the panels, whilst the inclusion of birds in three more emphasizes the importance of the theme for Deineka. See Jane Friedman, 'Soviet Mastery of the Skies at the Mayakovsky Metro Station', *Decorative Arts*, VII / 2 (2000), pp. 48–64.

42 See Isabel Wünsche, '*Homo Sovieticus*: The Athletic Motif in the Design of the Dynamo Metro Station', *Decorative Arts*, VII / 2 (2000), pp. 65–90.

43 The district around the Dinamo site had long been associated with sport. The Hippodrome, Moscow's main horse-racing arena, was first built near this spot in 1883 and continued to be the main site for the sport throughout the Soviet period. Other sports facilities associated with the region at this time include the Sports Complex of the TsDKA (Red Army), situated just over a mile north of the Dinamo stadium.

44 *Iskusstvo*, 6 (1938), p. 87, and *Tvorchestvo*, 11 (1938), p. 19. In Russia, the term 'heavy athletics' is used to distinguish strength and combat sports such as weight-lifting, wrestling and boxing from 'light athletics', generally referred to in the West as track and field.

45 *Iskusstvo*, 6 (1938), and *Tvorchestvo*, 11 (1938). Amongst the various journals that included coverage of the new Dinamo station were *Moscow Daily News* (September 1938) and *Krasnii Sport* (23 October 1938).

46 *Iskusstvo*, 6 (1938), pp. 70–71.

47 *Iskusstvo*, 6 (1936), p. 38.

48 Amongst the works she produced on this theme were: *R. I. Gerbei in the Role of Tybalt*, from *Romeo and Juliet* (1939); *Spanish Dance* (1946) and *A. A. Lapaura in Faust* (1956). In 1945 she also produced bas-relief statues based on the subject of dance for the Okhotnii Ryad station on the Moscow metro.

49 Of these three works, *Dancer* and *Girl on a Beam* can still be seen in Gorkii Park. *Female Discus Thrower* was illustrated in *Iskusstvo*, 6 (1935). Unfortunately, it has subsequently been removed from Gorkii Park. During the same period, a fourth bronze, *Male Discus Thrower* by Matvei Manizer, whom Yanson-Manizer had married in 1926, was also positioned in the park. This was illustrated in *Krasnyi Sport* (13 May 1937), p. 6. This latter work can still be seen in Gorkii Park.

50 Karen L. Kettering, 'Sverdlov Square Metro Station: "The Friendship of the Peoples" and the Stalin Constitution', *Decorative Arts*, VII / 2 (2000), pp. 21–47.

51 The decision to represent only seven of the eleven Soviet Republics (Azerbaizhan, Kirgizia, Tadzhikistan and Turkmenistan were all left out) understandably confused Sosfenov. See *Iskusstvo*, 6 (1938), p. 67.

52 Simon, *Moscow in the Making*, p. 204.

5 *The Last Line of Defence*

1 See Vladimir Petrovich Sysoev, *Aleksandr Deineka*, 2 vols (Moscow, 1989) vol. I, p. 35.

2 See Alan Clark, *Barbarossa* (London, 1995), p. 30.

3 British attitudes towards sport in the early twentieth century are discussed in Derek Birley, *Playing the Game: Sport and British Society, 1910–45* (Manchester, 1995).

4 See John J. MacAloon, *The Great Symbol: Pierre de Coubertin and the Origins of the Modern Olympic Games* (Chicago, 1981).

5 See Allen Guttmann, *Games and Empires: Modern Sports and Cultural Imperialism* (New York, 1994), pp. 141–56.

6 James Riordan, *Sport in Soviet Society* (Cambridge, 1977), p. 48. Also V. U. Ageevets, *Lesgaftovtsy* (Leningrad, 1986).

7 Riordan, *Sport in Soviet Society*, p. 37.

8 Riordan, *Sport in Soviet Society*, pp. 128–30.

9 Riordan, *Sport in Soviet Society*, pp. 130 and 139.

10 See Stephen White, *The Bolshevik Poster* (New Haven, CT, 1988), pp. 119–30.

11 The exhibition included 410 posters produced by more than 200 artists including Deineka, Deni, Moor and the Stenberg brothers. See Valentina Grigorevna Azarkovich, *Exhibitions of Soviet Art*, 4 vols (Moscow, 1965–75), vol. II, pp. 405–6.

12 Victor Peppard has claimed that the soccer match in Olesha's *Envy* is almost certainly based upon a match played on 21 May 1927 between a mixed Moscow team and a team of German workers called 'Saxony'. This provided a rare early encounter between Soviet soccer players and international opposition. Moscow finished up 4–1 victors. See Victor Peppard, 'Olesha's *Envy* and the Carnival', in *Russian Literature and American Critics*, ed. Kenneth N. Brostrom (Ann Arbor, MI, 1984), p. 183.

13 Yurii Olesha, *Envy*, trans. J. C. Butler (Moscow, 1988), p. 159.

14 Olesha, *Envy*, p. 159.

15 Olesha, *Envy*, p. 159.

16 Deineka also introduced the goalkeeper into his sketches for the mosaic ceiling at Paveletskaya metro station produced in 1940. In the end, however, he did not use this design. See *Iskusstvo*, 6 (1980), p. 18.

17 Lyrics reproduced and translated in James von Geldern and Richard Stites, eds, *Mass Culture in Soviet Russia: Tales, Poems, Songs, Movies, Plays and Folklore, 1917–53* (Bloomington, IN, 1995), p. 236. The significance of the border and border

guard is also discussed in Vladimir Paperny, *Architecture in the Age of Stalin: Culture Two* (Cambridge, 2002), pp. 48–9.

18 The sporting subject was certainly regarded as important. The presence of the huge-scale painting *Soviet Fizkultura* by Yurii Pimenov has been discussed earlier in chapter Three. Another sculptural work entitled *Two Fizkulturniki* by Yanson-Manizer, exhibited the previous year at the *Industry of Socialism* exhibition, was also sent to New York. See Vera Vasilyevna Yermonskaya, *Yanson-Manizer* (Moscow, 1961), p. 7.

19 I. Shmidt, *Iosif Chaikov* (Moscow, 1977), p. 26.

20 Shmidt, *Iosif Chaikov*, p. 27.

21 In early 1937 an exhibition of Surikov's works was shown at the Tretyakov Gallery in Moscow. At the same time *Iskusstvo* dedicated a whole issue to the nineteenth-century artist renowned for his battle paintings. See *Iskusstvo*, 3 (1937). By producing a large-scale battle painting on the theme of the *Defence of Sevastopol*, Deineka was also referring directly to the town's most famous monument. In 1905 a circular pavilion was built on a prominent site in the town to house another painting entitled the *Defence of Sevastopol*, this time in honour of the Crimean War. See G. I. Semin, *Sevastopol: A Historical Outline* (Moscow, 1955), pp. 165–7, and Pyotr Garmash, *Sevastopol* (Simferopol, 1968), p. 32.

22 See *Iskusstvo*, 3 (1936), p. 98.

23 The inclusion of ranks of rifles also inevitably recalls execution scenes by Goya and Manet. The inclusion of this figure could also conceivably be a reference to the Soviet soldier Aleksandr Matrosov, who reportedly threw his body onto a German machine gun in order to prevent it shooting his own troops. This self-sacrificial gesture was soon recounted in countless popular songs and on film. See Richard Stites, *Russian Popular Culture: Entertainment and Society since 1900* (Cambridge, 1992), p. 99.

24 Riordan, *Sport in Soviet Society*, p. 156, and Robert Edelman, *Serious Fun: A History of Spectator Sports in the USSR* (Oxford, 1993), p. 82.

25 Andy Dougan, *Dynamo: Defending the Honour of Kiev* (London, 2001).

26 George Sinfield, *Soviet Sport* (Watford, 1945), p. 19.

27 Sinfield, *Soviet Sport*, p. 19

28 Sinfield, *Soviet Sport*, p. 19.

29 Riordan, *Sport in Soviet Society*, p. 154.

6 *Aiming for World Supremacy*

1 Robert Edelman, *Serious Fun: A History of Spectator Sports in the USSR* (Oxford, 1993), pp. 87–91.

2 James Riordan, *Sport in Soviet Society* (Cambridge, 1977), p. 165.

3 Riordan, *Sport in Soviet Society*, p. 364.

4 Riordan, *Sport in Soviet Society*, p. 163.

5 Vladimir Petrovich Sysoev, *Aleksandr Deineka* (Moscow, 1989), vol. i, p. 243.

6 M. Sitnina, 'A. Deineka "Relay Race on the B Ring Road"', *Khudozhnik*, 7 (1963), p. 31. Also quoted in Sysoev, *Aleksandr Deineka*, p. 243.

7 Matthew Cullerne Bown, *Socialist Realist Painting* (New Haven, CT, 1998), p. 223.

8 Cullerne Bown, *Socialist Realist Painting*, p. 221.

9 Cullerne Bown, *Socialist Realist Painting*, p. 254.

10 *Sovetskii Sport* (10 January 1948), p. 3.

11 *Izvestiya* (15 February 1948), p. 3.

12 *Pravda* (20 February 1949), p. 3.

13 See Vern Grosvenor Swanson, *Soviet Impressionism* (Woodbridge, 2001), p. 103.

14 In the decade following the war, seven skyscrapers were built to surround the city of Moscow. See Vladimir Paperny, *Architecture in the Age of Stalin: Culture Two* (Cambridge, 2002), pp. 89–91. See also Alexei Tarkhanov and Sergei Kavtaradze, *Architecture of the Stalin Era* (New York, 1992), pp. 117–44, and Catherine Cooke, 'Socialist Realist Architecture: Theory and Practice', in *Art of the Soviets: Painting, Sculpture and Architecture in a One-Party State, 1917–1992*, ed. Matthew Cullerne Bown and Brandon Taylor (Manchester, 1993), pp. 102–4.

15 Mukhina's famous monument was re-erected in Moscow on its return from the Paris *Exposition Internationale* of 1937. See N. V. Voronov, *Vera Mukhina* (Moscow, 1989), p. 172.

16 Yanson-Manizer's work, entitled *Speedskater*, was produced in 1949. An aluminium casting of the work, dating from 1956, can be found in the collection of the Russian Museum in St Petersburg.

17 See Swanson, *Soviet Impressionism*, pp. 107 and 109, and Cullerne Bown, *Socialist Realist Painting*, p. 321.

18 See Vera Vasilevna Yermonskaya, *Yanson-Manizer* (Moscow, 1961), p. 8. See also Avgusta Ivanovna Komoliets, *Yanson-Manizer* (Moscow, 1970).

19 Edelman, *Serious Fun*, pp. 121–3.

20 Edelman, *Serious Fun*, pp. 121–2.

21 Riordan, *Sport in Soviet Society*, pp. 178–9.

22 Cullerne Bown, *Socialist Realist Painting*, pp. 363–6.

23 See William C. Fuller, 'The Great Fatherland War and Late Stalinism, 1941–1953', in *Russia: A History*, ed. Gregory L. Freeze (Oxford, 1997), p. 337.

24 Ivan Matsa, *A. Deineka* (Moscow, 1959); Andrei Dmitrievich Chegodaev, *Aleksandr Deineka* (Moscow, 1957).

25 The term was first proposed by the Soviet art critic Aleksandr Kamenskii in 1969 to refer retrospectively to certain works produced between 1957 and 1962. See Cullerne Bown, *Socialist Realist Painting*, p. 389.

26 Platon Pavlov, 'The work "Gymnasts of the USSR" by D. Zhilinskii', *Iskusstvo*, 6 (1980), pp. 20–22.

7 *Towards the Bitter End*

1 D. Belyaev, 'Stilyaga', *Krokodil* (10 March 1949), p. 10.

2 James Riordan, *Sport in Soviet Society* (Cambridge, 1977), p. 176.

3 Dina R. Spechler, *Permitted Dissent in the USSR: Novy Mir and the Soviet Regime* (New York, 1982), p. 147. The term 'fathers and children' was based on the title of Ivan Turgenev's novel of 1862, which explored the youth protest culture of the 1860s.

4 Published in *Krokodil* (20 December 1958), p. 5.

5 *Pravda* (28 July 1957), p. 1. See also *Opinions on the VI World Festival of Youth and Students for Peace and Friendship, Moscow, July 28–August 11, 1957* (Budapest, 1957).

6 The exhibition was extensively covered in the press. Examples include Pavel Sokolov-Skalya's critical article published in *Vechernaya Moskva* (5 August 1957), p. 2.

7 See Vladimir Slepian, 'The Young vs. the Old', *Problems of Communism* (May–June 1962).

8 See Michael Scammell, 'Art as Politics and Politics in Art', in *Non-Conformist Art: The Soviet Experience, 1956–1986*, ed. Alla Rosenfeld and Norton T. Dodge (New York and London, 1995), pp. 49–50.

9 Yevgenii Barabanov, 'Art in the Delta of Alternative Culture', in *Forbidden Art: The Post-War Russian Avant-Garde*, exh. cat., Art Center, Los Angeles (1999), p. 31.

10 *Portrait of Melamid's Wife* accompanied *Portrait of Komar's Wife and Child* as one of a pair of works produced at roughly the same time, to the same dimensions and in the same style. See Regina Khidekel, *It's the Real Thing: Soviet and Post-Soviet Sots Art and American Pop Art*, exh. cat., Frederick R. Weisman Art Museum, Minnesota (1998), p. 32.

11 Both Komar and Melamid had been working for the Soviet Youth Pioneers on the Avenue of Cosmonauts in the winter of 1972. See Khidekel, *It's the Real Thing*, p. 13.

12 Riordan, *Sport in Soviet Society*, pp. 217–24.

13 *Iskusstvo*, 2 (1980), pp. 44–5; *Iskusstvo*, 6 (1980), p. 23.

14 *Iskusstvo*, 3 (1981), p.74.

15 Representations of sport were illustrated or discussed in *Iskusstvo*, 1 (1980); *Iskusstvo*, 2 (1980); *Iskusstvo*, 8 (1980); *Iskusstvo*, 9 (1980); *Iskusstvo*, 10 (1980); *Iskusstvo*, 11 (1980). In addition, a special Olympic Games edition was published in June, with ten articles all dedicated to the sports theme in art and architecture, *Iskusstvo*, 6 (1980).

16 Interview with Grisha Bruskin in Renee Baigell and Matthew Baigell, eds, *Soviet Dissident Artists: Interviews after Perestroika* (New Brunswick, NJ, 1995), p. 316.

17 *Grisha Bruskin: Life is Everywhere*, exh. cat., State Pushkin Museum of Fine Arts, Moscow, and State Russian Museum, St Petersburg (2001), p. 123.

18 Robert Edelman, *Serious Fun: A History of Spectator Sports in the USSR* (Oxford, 1993), p. 222.

19 Edelman, *Serious Fun*, p. 222.

20 In 1986 the IOC allowed professional sportsmen and sportswomen to compete in the Olympic Games.

21 See Laura Mulvey, 'Reflections on Disgraced Monuments' in *Architecture and Revolution: Contemporary Perspectives on Central and Eastern Europe*, ed. Neil Leach (London and New York, 1999). Mulvey's article engages with the film *Disgraced Monuments* made by herself and Mark Lewis in 1993, which explores the fate of several public monuments in the wake of the collapse of the Soviet Union.

22 Amongst the other statues placed alongside Chaikov's *Football Players* were: Sergei Orlov, Nikolai Shtamm and Anatolii Antropov, *Monument to Yurii Dolgorukii* (1954), small version; Marina Ryndzyunskaya, *A Stakhanovite Girl of the Cotton Fields* (1940); and Vera Mukhina, *Monument to Gorkii* (1952).

23 Joad Raymond 'Under the Skin of Ideology', in *The Aesthetic Arsenal: Socialist Realism under Stalin*, ed. Miranda Banks (New York, 1988) p. 73.

Select Bibliography

Principal Journals Consulted
Brigada Khudozhnikov
International Journal of the History of Sport
Iskusstvo
Izvestiya
Journal of Sport History
Krasnyi Sport
Metrostroi
Moscow News
Pravda
Sovetskii Metro
Sovetskii Sport
Soviet Land.
Soviet Travel
Spartakiada
Tvorchestvo

Texts
The Aesthetic Arsenal: Socialist Realism under Stalin (New York, 1988)
Ageevets, V. U., *Lesgaftovtsy* (Leningrad, 1986)
Agitation for Happiness: Soviet Art of the Stalin Epoch, exh. cat., Dokumenta, Kassel, and State Russian Museum, St Petersburg (1993)
All-Union Exhibition of Young Artists Dedicated to the 20th Anniversary of the VLKSM, exh. cat., State Russian Museum, Leningrad (1938)
Apter-Gabriel, Ruth, ed., *Tradition and Revolution: The Jewish Renaissance in Russian Avant-Garde Art, 1912–28* (Jerusalem, 1977)
Antonova, Irina, and Jorn Merkert, *Berlin–Moscow, 1900–1950*, exh. cat., Pushkin State Museum of Fine Arts, Moscow (1996)
Art and Power: Europe Under the Dictators, 1930–45, exh. cat., Hayward Gallery, London (1995)
Artists of the RSFSR during the Last Fifteen Years (1917–1932): Painting, Graphics, Sculpture, exh. cat., Moscow (1933)
Arvidsson, Claes, and Lars Erik Blomqvist, eds, *Symbols of Power: The Esthetics of Political Legitimation in the Soviet Union and Eastern Europe* (Stockholm, 1987)
Autumn Exhibition of Moscow Painters, exh. cat., Moscow (1935)
Azarkovich, Valentina Grigorevna, *Exhibitions of Soviet Fine Art*, 4 vols (Moscow, 1965–75)
Baigell, Renee, and Matthew Baigell, *Soviet Dissident Artists: Interviews after Perestroika* (New Brunswick, NJ, 1995)
Barsheva, I., and K. Sazonova, *Aleksandr Nikolaevich Samokhvalov* (Leningrad, 1963)
Bauer, Raymond, *The New Man in Soviet Psychology* (Cambridge, MA, 1959)

Berezin, Valentin, *Moscow Metro* (Moscow, 1989)

Birley, Derek, *Playing the Game: Sport and British Society, 1910–45* (Manchester, 1995)

Bonnell, Victoria E., *Iconography of Power: Soviet Political Posters under Lenin and Stalin* (Berkeley, CA, and London, 1997)

Bourdieu, Pierre, 'Sport and Social Class', *Social Science Information*, XVIII / 6 (1978)

Bowlt, John E., *Russian Art of the Avant-Garde: Theory and Criticism, 1902–1934* (London, 1988)

Brodskii, Ya., ed., *Soviet Sport: The Success Story* (Moscow, 1987)

Buck-Morss, Susan, *Dreamworld and Catastrophe: The Passing of Mass Utopia in East and West* (Cambridge, MA, 2000)

Buckley, Mary, *Women and Ideology in the Soviet Union* (New York, 1989)

Bunt, Cyril G. E., *Russian Art from Scyths to Soviets* (New York and London, 1946)

Cantalon, Hart, and Richard Gruneau, eds, *Sport, Culture and the Modern State* (Toronto, 1982)

Chen, Jack, *Soviet Art and Artists* (London, 1944)

Chernyshevsky, N. G., *What Is To Be Done?: Tales About New People*, trans. Benjamin R. Tucker (London, 1982)

Chlenov, A., *I. M. Chaikov* (Moscow, 1952)

Clark, Katerina, *The Soviet Novel: History as Ritual* (Chicago, 1981)

Condee, Nancy, ed., *Soviet Hieroglyphics: Visual Culture in Late Twentieth-Century Russia* (Bloomington, IN, 1995)

Conquest, Robert, *Stalin and the Kirov Murder* (London and Sydney, 1989)

Cooke, Catherine, *Russian Avant-Garde: Theories of Art, Architecture and the City* (London, 1995)

Cullerne Bown, Matthew, *Art under Stalin* (Oxford, 1991)

—, *Socialist Realist Painting* (New Haven, CT, 1998)

—, and Brandon Taylor, eds, *Art of the Soviets: Painting, Sculpture and Architecture in a One-Party State, 1917–1992* (Manchester, 1993)

A. Deineka Exhibition, exh. cat., State Russian Museum, Leningrad (1936)

Dougan, Andy, *Dynamo: Defending the Honour of Kiev* (London, 2001)

Dream Factory Communism: The Visual Culture of the Stalin Era, exh. cat., Schirn Kunsthalle, Frankfurt (2003).

Edelman, Robert, *Serious Fun: A History of Spectator Sports in the USSR* (Oxford, 1993)

Edmondson, Linda, ed., *Women and Society in Russia and the Soviet Union* (Cambridge, 1992)

El Lissitzky: Architect, Painter, Photographer, Typographer, 1890–1941, exh. cat., Abbemuseum, Eindhoven (1990)

Elliot, David, ed., *Aleksandr Rodchenko*, exh. cat., Museum of Modern Art, Oxford (1979)

Engineers of the Human Soul: Soviet Socialist Realist Painting, 1930s–1960s, exh. cat., Museum of Modern Art, Oxford (1992)

Fedotova, Alla Grigorevna, *Painting of the First Five-Year Plan* (Leningrad, 1981)

Fifteen Years of the RKKA: Painting, Sculpture, Graphics, exh. cat., Leningrad (1933)

First Exhibition of Leningrad Artists, exh. cat., State Russian Museum, Leningrad (1935)

The First Russian Show: A Commemoration of the Van Diemen Exhibition, Berlin 1922, exh. cat., Annely Juda Fine Arts, London (1983)

Fitzpatrick, Sheila, ed., *Cultural Revolution in Russia, 1928–31* (Bloomington, IN, 1978)

Forbidden Art: The Post-War Russian Avant-Garde, exh. cat., Art Center, Los Angeles (1999)

Fülöp-Miller, Réné, *The Mind and Face of Bolshevism: An Examination of Cultural Life in the Soviet Union* (New York and London, 1927)

Geldern, James von, *Bolshevik Festivals, 1917–20* (Berkeley, CA, 1993)

—, and Richard Stites, eds, *Mass Culture in Soviet Russia: Tales, Poems, Songs, Movies, Plays and Folklore, 1917–53* (Bloomington, IN, 1995)

Getty, J. Arch, and Roberta T. Manning, eds, *Stalinist Terror: New Perspectives* (Cambridge, 1993)

Gleason, A., R. Stites and P. Kenez, eds, *Bolshevik Culture* (Bloomington, IN, 1985)

Golomstock, Igor, *Totalitarian Art in the Soviet Union, the Third Reich, Fascist Italy and the People's Republic of China* (London, 1990)

—, and Alexander Glezer, *Unofficial Art from the Soviet Union* (London, 1977)

Gray, Camilla, *The Great Experiment: Russian Art, 1863–1922* (New York and London, 1962)

The Great Utopia: The Russian and Soviet Avant-Garde, 1915–32, exh. cat., Guggenheim Museum, New York (1992)

Grierson, Roderick, ed., *Gates of Mystery: The Art of Holy Russia*, exh. cat., Victoria and Albert Museum, London (Cambridge, 1993)

Griffith, Hubert, ed., *Playtime in Russia* (London, 1935)

Grisha Bruskin: Life is Everywhere, exh. cat., State Pushkin Museum of Fine Arts, Moscow, and State Russian Museum, St Petersburg (2001)

Gronskii, I., and V. Perelman, eds, *The Association of Artists of Revolutionary Russia: Recollections, Articles, Documents* (Moscow, 1973)

Groys, Boris, *The Total Art of Stalinism: Avant-Garde, Aesthetic Dictatorship and Beyond*, trans. Charles Rougle (Princeton, NJ, 1992)

Guerman, Mikhail, *Soviet Art, 1920s–1930s* (Moscow and Leningrad, 1988)

Günther, Hans, ed., *The Culture of the Stalin Period* (London, 1990)

—, and Evgeny Dobrenko, *Sots Realist Canon* (St Petersburg, 2000)

Guttmann, Allen, *Games and Empires: Modern Sports and Cultural Imperialism* (New York, 1994)

Haines, Anna J., *Health Work in Soviet Russia* (New Haven, CT, 1928)

Hargreaves, Jennifer, ed., *Sport, Culture and Ideology* (London, 1982)

Hilton, Alison, *Russian Folk Art* (Bloomington, IN, 1995)

Hoffmann, David L., *Peasant Metropolis: Social Identities in Moscow, 1929–41* (Ithaca, NY, and London, 1994)

—, *Stalinist Values: The Cultural Norms of Soviet Modernity, 1917–41* (New York, 2003)

Ilič, Melanie, ed., *Women in the Stalin Era* (Basingstoke, 2001)

James, C. V., *Soviet Socialist Realism: Origins and Theory* (London, 1973)

Kaganovich, L. M., *Socialist Reconstruction of Moscow and Other Cities in the USSR*, trans. Martin Lawrence (London, 1931)

The L. M. Kaganovich Moscow Metro (Moscow, 1935)

Kanin, David B., *A Political History of the Olympic Games* (Boulder, CO, 1981)

Karginov, G., *Rodchenko* (London, 1979)

Kassof, Allen, *The Soviet Youth Program: Regimentation and Rebellion* (Cambridge, MA, 1965)

Kenez, Peter, *The Birth of the Propaganda State: Soviet Methods of Mass Mobilization, 1917–29* (Cambridge, 1985)

Khan-Magomedov, S. O., *Rodchenko: The Complete Works* (London, 1986)

—, *Pioneers of Soviet Architecture: The Search for New Solutions in the 1920s and 1930s* (London, 1987)

Khidekel, Regina, *It's the Real Thing: Soviet and Post-Soviet Sots Art and American Pop Art*, exh. cat., Frederick R. Weisman Art Museum, Minnesota (1998)

Komoliets, Avgusta Ivanovna, *Yanson-Manizer* (Moscow, 1970)

Kondakov, N. P., *The Russian Icon*, trans. Ellis H. Minns (Oxford, 1927)

Kosarev, A., *The History of the Moscow Metro* (Moscow, 1935)

——, ed., *How We Built the Metro* (Moscow, 1935)

Lahusen, Thomas, and Evgeny Dobrenko, eds, *Socialist Realism without Shores* (Durham, NC, and London, 1997)

Lavrentev, A. N., *Foreshortenings: Rodchenko* (Moscow, 1992)

Leyda, Jay, *Kino: A History of the Russian and Soviet Film* (New York, 1960)

Lobanov-Rostovsky, Nina, *Revolutionary Ceramics: Soviet Porcelain, 1917–27* (London, 1990)

Lodder, Christina, *Russian Constructivism* (New Haven and London, 1983)

London, Kurt, *The Seven Soviet Arts* (London, 1937)

Lopatin, P., *The First Soviet Metro System* (Moscow, 1934)

Loukomskii, G., *A History of Modern Russian Painting, 1840–1940* (London, 1945)

Lozowick, Louis, *Modern Russian Art* (New York, 1925)

Luchishkin, Sergei, *I Love Life: Written Memoirs* (Moscow, 1988)

Marsh, Rosalind, ed., *Women in Russia and Ukraine* (Cambridge, 1996)

Matsa, I. L., *Soviet Art of the Last Fifteen Years: Materials and Documents* (Moscow and Leningrad, 1933)

—, *A. Deineka* (Moscow, 1959)

Morton, Henry, *Soviet Sport: Mirror of Soviet Society* (New York, 1963)

Moscow Metropolitan: Architecture of the Moscow Metro (Moscow, 1936)

The Museum of the Academy of Arts (Moscow, 1989)

Nikiforov, Boris, *Aleksandr Deineka* (Moscow, 1937)

Odom, William E., *The Soviet Volunteers: Modernisation and Bureaucracy in a Public Mass Organisation* (Princeton, NJ, 1973)

Olesha, Yurii, *Envy*, trans. J. C. Butler (Moscow, 1988)

O'Mahony, Mike, 'Representing *Fizkultura*: Sport and Soviet culture from the First Five-Year Plan to the Great Patriotic War, 1929–45', PhD thesis, University of London, 1998

—, 'Archaeological Fantasies: Constructing History on the Moscow Metro', *Modern Language Review*, XCVIII / 1 (2003)

Ouspensky, Leonid, and Vladimir Lossky, *The Meaning of Icons* (New York, 1982)

A Pageant of Youth (Moscow, 1939)

Pages from our History, Painting, Sculpture and Poetry (Moscow, 1988)

Paperny, Vladimir, *Architecture in the Age of Stalin: Culture Two* (Cambridge, 2002)

Peppard, Victor, and James Riordan, *Playing Politics: Soviet Sport Diplomacy to 1992* (Greenwich, CT, and London, 1993)

Perelman, V. N., ed., *The Struggle for Realism in the Fine Arts during the 1920s* (Moscow, 1962)

Petrone, Karen, *Life Has Become More Joyous, Comrades: Celebrations in the Time of Stalin* (Bloomington, IN, 2000)

Riordan, James, *Sport in Soviet Society* (Cambridge, 1977)

—, *Sport, Politics and Communism* (Manchester, 1991)

Roberts, Peter, *George Costakis: A Russian Life in Art* (Ottawa, 1994)

Roman, Gail Harrison, and Virginia Hagelstein Marquardt, *The Avant-Garde Frontier: Russia Meets the West, 1910–1930* (Gainesville, FL, 1992)

Rosenberg, William G., ed., *Bolshevik Visions: First Phase of the Cultural Revolution in Soviet Russia* (Ann Arbor, MI, 1984)

Rosenfeld, Alla, and Norton T. Dodge, eds, *Non-Conformist Art: The Soviet Experience, 1956–1986* (New York and London, 1995)

Ryzhkov, K., *The Moscow Metro* (Moscow, 1954)

Samokhvalov, Aleksandr, *My Creative Journey* (Leningrad, 1977)

Semashko, Nikolai, *Health Protection in the USSR* (London, 1934)

Shmidt, I., *Iosif Chaikov* (Moscow, 1977)

Siegelbaum, Lewis H., *Stakhanovism and the Politics of Productivity in the USSR,*

1935–41 (Cambridge, 1988)

—, and Ronald Grigor Suny, eds, *Making Workers Soviet: Power, Class and Identity* (New York, 1994)

Simon, E. D., *Moscow in the Making* (London and New York, 1937)

Sinfield, George, *Soviet Sport* (Watford, 1945)

Sjeklocha, Paul, and Igor Mead, *Unofficial Art in the Soviet Union* (Berkeley, CA, 1967)

Slepian, Vladimir, 'The Young versus the Old', *Problems of Communism* (May–June 1962)

Sobolevskii, N., *Sculptures and Monuments in Moscow* (Moscow, 1947)

Soviet Art of the 1920s and 1930s, exh. cat., State Russian Museum, Leningrad (1988)

The Soviet Comes of Age, By Twenty-Eight of the Foremost Citizens of the USSR (London, 1938)

Soviet Propaganda Plates from a Chicago Private Collection, exh. cat., Art Institute, Chicago (1992)

Spechler, Dina R., *Permitted Dissent in the USSR: Novy Mir and the Soviet Regime* (New York, 1982)

Starostin, Andrei, *Football in the USSR* (Soviet News Booklet 33) 1958.

Stites, Richard, *Revolutionary Dreams, Utopian Vision and Experimental Life in the Russian Revolution* (Oxford, 1989)

—, *Russian Popular Culture: Entertainment and Society since 1900* (Cambridge, 1992)

Strizenova, Tatyana, et al., *Costume Revolution: Textiles, Clothing and Costume of the Soviet Union in the Twenties* (London, 1989)

Strugatskii, Natan, *Aleksandr Samokhvalov* (Leningrad, 1933)

—, *The Exhibition 20 Years of the Red Army and Navy in Posters and Popular Paintings*, exh. cat., Leningrad (1938)

Swanson, Vern Grosvenor, *Soviet Impressionism* (Woodbridge, 2001)

Sysoev, Vladimir Petrovich, *Deineka, 1899–1969* (Moscow, 1972)

—, *Aleksandr Deineka*, 2 vols (Moscow, 1989)

Tarkhanov, Alexei, and Sergei Kavtaradze, *Architecture of the Stalin Era* (New York, 1992)

Taylor, Brandon, *Art and Literature under the Bolsheviks, 1917–1932*, 2 vols (London, 1991–2)

Taylor, Richard, *The Politics of Soviet Cinema, 1917–1929* (Cambridge, 1979)

—, and Ian Christie, eds, *Inside the Film Factory: New Approaches to Russian and Soviet Cinema* (New York and London, 1991)

—, and Derek Spring, eds, *Stalinism and Soviet Cinema* (New York and London, 1993)

Tikhomirov, A., *The Red Army and Navy in Soviet Painting* (Moscow and Leningrad, 1938)

Tolstoy, Vladimir, Irina Bibikova and Catherine Cooke, *Street Art of the Revolution: Festivals and Celebrations in Russia, 1918–33* (London, 1990)

Tumarkin, Nina, *Lenin Lives! The Lenin Cult in Soviet Russia* (Cambridge, MA, 1983)

Tumarkin Goodman, Susan, ed., *Russian Jewish Artists in a Century of Change, 1890–1990* (New York and Munich, 1995)

Tupitsyn, Margarita, *The Soviet Photograph, 1924–1937* (New Haven, CT, 1996)

—, *El Lissitzky beyond the Abstract Cabinet: Photography, Design, Collaboration* (New Haven and London, 1999)

Tyrannei des Schönen: Architektur der Stalin-zeit, exh. cat., Vienna Oesterreichisches Museum (1994)

The USSR Academy of Arts: Sculpture, Painting, Graphic Arts, Stage Design, Decorative Arts (Leningrad, 1982)

Voronov, N. V., *Vera Mukhina* (Moscow, 1989)

White, Stephen, *The Bolshevik Poster* (New Haven, CT, 1988)

Wingfield, Mary Ann, *Sport and the Artist: Ball Games*, vol. 1 (Woodbridge, 1988)

Yablonskaya, M. N., *Aleksandr Aleksandrovich Deineka* (Leningrad, 1964)
——, *Women Artists of Russia's New Age*, trans. Anthony Parton (London, 1990)
Yermonskaya, Vera Vasilevna, *Yanson-Manizer* (Moscow, 1961)
Youngblood, Denise J., *Movies for the Masses: Popular Cinema and Soviet Society in the 1920s* (Cambridge, 1992)
Zimenko, Vladislav, *The Humanism of Art* (Moscow, 1976)
Zinger, Leonid Semenovich, *Aleksandr Samokhvalov* (Moscow, 1982)
Zotov, A., *Soviet Sculpture, 1917–57* (Moscow, 1957)

Acknowledgements

This project has been assisted at various stages of its development by a number of research funding bodies. These include the British Academy, the University of London Central Research Fund and Sotheby's. However, the project was completed whilst on a research leave grant from the Arts and Humanities Research Board. My thanks are extended to a number of people who have made a major contribution to this project. Sarah Wilson of the Courtauld Institute has provided invaluable inspiration and advice in formulating and developing this work. Without her constant help and support this project would not have been completed. Brandon Taylor of the University of Southampton has also offered considerable advice, guidance and assistance throughout the project and has willingly read and made suggestions on several draft versions of this work. I would particularly like to mention the innumerable members of staff in the various libraries that I have consulted. These are principally, the Courtauld Institute, the British Library, the School of Slavonic and East European Studies, the Society for Cultural Relations with the USSR, the New York Public Library, the State Russian Library and the library of the State Russian Museum. For the Russian libraries, in particular, I would like to extend my thanks for a great degree of patience and forbearance on the part of the library staff. In Russia my progress was assisted by many individuals working in the State Russian Museum, the Museum of the Academy of Arts, the Tretyakov Gallery, the Museum of Fizkultura at the Lenin Stadium in Moscow and the Lesgaft Institute of Fizkultura in St Petersburg. These include Professor Mikhail Guerman, Tanya Kalugina, Lyudmila Marts and Natalya Rozenvasser. Tom Garza also facilitated the hospitality of the Moscow Linguistics University. Thanks should also be extended to Toby Clark for numerous discussions on Russian culture, whilst Julian Graffy of the School of Slavonic and East European Studies facilitated access to countless Soviet movies at a crucial point in my research. More recently my colleagues at the University of Bristol have offered much support and guidance, not least of all through the activities of CREECS (Centre for Russian and East European Cultural Studies). Here I would particularly like to thank Birgit Beumers for her constant help and boundless energy and enthusiasm. I also thank Stephen Bann for his advice and assistance in getting this project off the ground. A mention must also go to my students who have endured my speculations on much of this material and whose questions and analysis of some of the material presented in this book have helped me to formulate and reformulate my ideas.

Above all else I thank my wonderful wife Claire for contributing more than she will ever know: patience, support, guidance (both academic and emotional) and, most of all, a love beyond all deserving.

Photographic Acknowledgements

The author and publishers wish to express their thanks to the below sources of illustrative material and/or permission to reproduce it:

Collection of the artist (Grisha Bruskin): 71, 72, 73, 74; photo courtesy of the artists (Komar and Melamid): 67; reproduced from *Izvestiya*: 9 (12 August 1928), 29 (30 December 1937); Kursk District Picture Gallery (A.A. Deineka), Kursk: 59; photos Latvian National Museum of Art, Riga: 10, 45; Alexander Lavrentiev, Moscow: 4, 26, 27, 41; photo from the Archive of the Lesgaft Institute of Fizkultura, St Petersburg: 6; Minsk Art Museum: 64; photos Museum of Fizkultura, Moscow: 17, 47; drawing Mike O'Mahony: 30; photos Mike O'Mahony: 31, 32, 33, 34, 35, 36, 40, 52, 53, 63, 75; photo Perm State Art Gallery: 22 (Inventory N P-641); private collections: 61, 68, 69, 70; photo Russian State Library, Moscow: 54; photos Shchusev State Museum of Architecture, Moscow: 37, 38; photo courtesy of Springville Art Museum, Salt Lake City, Utah: 61; photos © 2005 State Russian Museum, St Petersburg: 8, 12, 16, 19, 28, 29 (as reproduced in *Izvestiya*, 30 December 1937), 42, 43, 44, 48, 50, 51, 56, 62; photos State Tretyakov Gallery, Moscow: 3, 11, 13, 20, 39, 46, 49, 55, 57, 60, 65; whereabouts unknown: 2 (reproduced in *Izofront*, 1931), 21 (reproduced in *Iskusstvo*, 4, 1933); collection of Neil K. Rector: 67; Jane Voorhees Zimmerli Art Museum, Rutgers, The State University of New Jersey (loan from the collection of Norton and Nancy Dodge): 70.

Index